TRUE TALES FROM
BURBANK

TRUE TALES FROM
BURBANK

WESLEY H. CLARK AND MICHAEL B. McDANIEL

Published by The History Press
Charleston, SC
www.historypress.com

Copyright © 2018 by Wesley H. Clark and Michael B. McDaniel
All rights reserved

Front cover: Mike McDaniel collection.
Back cover, top: Burbank Historical Society; *middle*: Burbank Historical Society; *bottom*: Paul E. Wolfe, Burbank Historical Society.

First published 2018

Manufactured in the United States

ISBN 9781467140454

Library of Congress Control Number: 2018945786

Notice: The information in this book is true and complete to the best of our knowledge. It is offered without guarantee on the part of the authors or The History Press. The authors and The History Press disclaim all liability in connection with the use of this book.

All rights reserved. No part of this book may be reproduced or transmitted in any form whatsoever without prior written permission from the publisher except in the case of brief quotations embodied in critical articles and reviews.

To Roland "Pete" Peterson and Willard "Mister Fred" Fredericksen, two of the best teachers at Burbank High, from two grateful Bulldogs.

CONTENTS

Preface	9
Acknowledgements	11
1. Burbank's Earliest Years	13
2. Boom and Bust	51
3. World War II	97
4. From Truman to Nixon	127
5. The Disco Decade	165
Bibliography	191
Index	195
About the Authors	207

PREFACE

Burbank is a surprising place! Included herein are tales about a lioness on the roam in the Verdugo Hills; the night Burbank politics invaded *The Tonight Show with Johnny Carson*; backyard film vaults; growing mushrooms in old, underground sewage treatment facilities; gun duels in the streets; the shadowy and mysterious Night Riders; fiery spooks; cowgirls; visiting druids; crank colonies; pervasive garlic smells; the Battle of the Bustlines; vertical take-off craft; Mickey Mouse gas masks; Burbank making the electric clocks run badly; filming the Bible; and broadcasting Mexican music to New Zealand—in addition to other odd stuff.

When we completed our previous two books about Burbank, *Lost Burbank* (The History Press, 2016) and *Growing Up in Burbank: Boomer Memories from The Akron to Zodys* (The History Press, 2017), we realized that we weren't really done telling the story of the place. Thanks to fourteen years of collecting material for our Burbankia website (www.wesclark.com), we knew we still had a lot of material left. What's more, we knew we could approach it from another angle. The first book was a sort of historical account of Burbank, highlighting history, people, lore and cultural attractions. The second book examined growing up there. This book is a collection of interesting Burbank tales arranged chronologically. The only criteria for inclusion here is that the stories contain human interest and some humor and give readers an idea of what Burbank was like prior to the 1980s.

In a *Los Angeles Times* piece from 1944, it's mentioned that writer George Lynn Monroe couldn't begin to cover Burbank's story in 50,000 words. Neither could we, which is why we needed three books and more than 140,000 words!

Preface

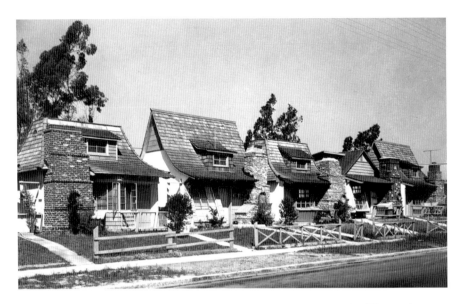

The five adorable little houses on the 300 block of North Hollywood Way. They no longer look quite this cute. *Paul E. Wolfe, Burbank Historical Society.*

This is not a dry, facts-laden volume. If you want that, other books supply the what and when of Burbank (see the bibliography). This book, like the others, is meant to be lighthearted and entertaining. However, in order to flesh out the entire story, there are some sad tales here as well. One Burbanker we know once stated that Burbank was like Mayberry in *The Andy Griffith Show*. Well, perhaps. But our tales do not quite make for a carefree sitcom; let's face it, life isn't like that.

We think that, with three books to our credit, it must be obvious that we love Burbank and think it a special place. Mike was born, raised and still lives there. After being raised in Burbank, Wes has been a resident of other states. Virginia, his present home state, has a recorded history going all the way back to 1607. The Revolutionary War and Civil War periods are especially compelling eras of national importance. And yet…it is with Burbank history that he is especially interested. Why? Consider it addressing an unfilled niche.

And, after all, do we *really* need another book about the American Civil War? Enjoy!

Wes Clark and Mike McDaniel
Summer 2018

ACKNOWLEDGEMENTS

As was the case with our previous books about our hometown, a number of fine people contributed and must be noted. Laurie Krill, our acquisitions editor at The History Press, provided constant help and encouragement on this book. Rick Delaney was our publisher's eagle-eyed copyeditor. Wes's wife, Cari Clark, again provided critical readings, professional editing and commentary. Her eye for detail and her red pen have made this a much better book than it would have been.

We must again mention Sue Baldaseroni, Penny Strickland Rivera, Susie Hodgson and Betty Penrod at the Burbank Historical Society. Thank you for the photo usage and allowing us to dig through your file cabinets. The Gordon R. Howard Museum on 115 Lomita Street is well worth a visit for any Burbanker.

Burbankers Don Bilyeu, Marti Baldwin, Pam Zipfel Kirkwood, Eldridge Ballew Keller, Darryl Eisele, Dwain Ray, Joseph Brown, Joanne Sears Lewis, Jim Voigt, Carol Hill Olmstead, Bruce Foreman, Elinor Penry deSosa, James McGillis, Lorene Foreman Branson, Kelly Clark Ludlum, Eric Rosoff, Cathi Fitzpatrick, Curt Conant, Elizabeth Boysen Sirk, Ron Gibson, Richard Taylor, Jonathan Doe, Melanie Santamaria and Marilu Howard all contributed fun stories that first appeared on our Burbankia website or in some other Burbank-related media. Thank you! Barry Epstein has also been an amazing watchdog for Burbank-related tales. Lyla El-Safy provided unique information about the long-forgotten Burbank Military Academy. The authors also thank Tim Conway and Barefoot Ted McDonald for

Acknowledgements

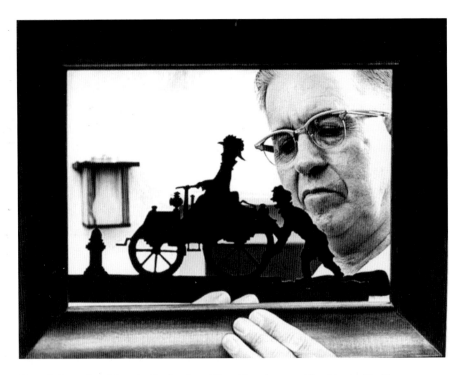

One of the authors' favorite Burbankers, Vern Sion, inspects his whimsical hobby handiwork. He also helped to build the original USS *Enterprise* prop for television's *Star Trek*. *Mike McDaniel collection.*

information on Freedom Hill and the Henry family, and Michael Gonzales of the 45th Infantry Division Museum in Oklahoma City and Greg Harrison (writing on AbandonedRails.com). Once again, Corey Fredrickson (BHS, '74) has been a valuable tipster, researcher and enthusiasm-generator. We still love you, man!

Readers will note that, as with *Lost Burbank*, we quote extensively from George Lynn Monroe's excellent *Burbank Community Book*, published in 1944. This out-of-print, public domain book is delightful; we encourage readers to seek out the full work on the Burbankia website.

1
BURBANK'S EARLIEST YEARS

Burbank was a far different community prior to 1920 than it is today; it was mainly rural. While industry began to be established by the time the 1920s arrived, the city was still basically a farming community; alfalfa, cantaloupe and grape vineyards reigned supreme. William Coffman, a former postmaster of Burbank, said of 1915, "Yep, in that year you could climb up on one of the hills here in Burbank and look clear across the San Fernando Valley, and there were farms and vineyards and orchards everywhere you looked. There were no sidewalks…except along San Fernando Boulevard, and they were wood."

How rural was Burbank in this period? In 1910, the major sport of idlers and scofflaws in Luttge's store was shooting birds off of the telephone wires along San Fernando Boulevard. *That* rural.

Let's begin our Burbank tales in the middle.

THE CENTER OF TOWN

There can be little argument that the historical center of Burbank is the intersection of San Fernando Boulevard and Olive Avenue, where the Burbank Block Building was erected (and still stands). The first city council meetings took place here. This building, with its distinctive cupola, appears frequently in old photographs that represent Burbank. This is the very heart

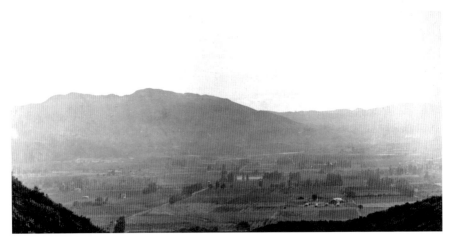

DeLos Wilbur's very rural image of Burbank as seen from the Verdugo Hills in 1917. *DeLos Wilbur.*

of town, and when one eats one's cheeseburger in the historic Burbank Bar & Grille, one thinks of what interesting late nineteenth-century meetings and transactions must have taken place there.

But pull up the U.S. Geological Survey's website page for Burbank, the legally incorporated place (ID 2409939, feature class = civil), and a set of coordinates are given at the bottom: 34.1879654, -118.3234148 (or 34°11'16.7" N, 118°19'24.3" W). Entering this into Google Maps shows a point atop a rocky wall near an off-ramp about one hundred feet from the parking lot of the Burbank Animal Shelter on North Victory Place. Why? This is, according to the U.S. Geological Survey (and therefore the federal government), the center of the polygon that is Burbank, bounded by Glendale, Sun Valley, North Hollywood and the Los Angeles part of Toluca Lake.

Now that we've dispensed with *that* bit of trivia…

BETTER THAN TURKEY, CYPRUS, DELAWARE OR MARYLAND!

From the *Los Angeles Times*, May 7, 1887:

> *FAST GROWTH. More buildings for the town of Burbank. This new town seems to have felt the boom fever, only it has not required the music*

> and eloquence of auctioneers to show forth its advantages. It only requires one visit to the new and wonderfully situated town to enrapture one's self and create within a feeling of not only buying one lot, but to purchase a number of them, and build immediately a home. The water is the very purest, coldest and best, taken from the adjoining lagoon.... The gentlemen who compose the Providencia Land Company have now in contemplation the erection of a fine business block, to surpass anything in the county. Keep your eye on Burbank.

The authors don't know where that lagoon was, but the rhapsodic prose swelled with time. From a promotional article from the *Los Angeles Herald*, October 2, 1887, we read:

> One sees a fertile valley dotted with beautiful cottages, around which cluster flowers more fragrant and beautiful than those of Turkey, and here, too, grow oranges sweeter than those of Cyprus, peaches finer in flavor than those of Delaware, pears more luscious than those of Maryland, and grapes that vie in beauty and excellence with those that cling to vines which creep and trail

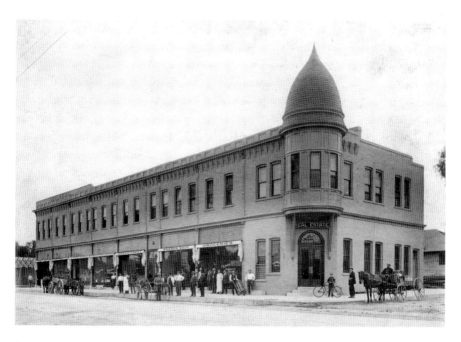

Some of the locals pose in front of Burbank's Brick Block Building in 1911. It still stands (without the distinctive corner section). *Burbank Historical Society.*

along the castled Rhine. Over the mountains the forest has thrown an emerald vale, and along the valley's margin threads a silver stream. In the distance the city's domes and spires stand out in bold relief, and over all is an ever blue sky so purely clear that at night the stars seem strangely near.

Yes, they were talking about Burbank!

HOW DID THE RESERVOIR BREAK?

One of the earliest articles to be found about Burbank in the *Los Angeles Times* involves a mystery described on October 27, 1887: the inexplicable rupture of the main reservoir in town, described as being about a mile east of the center of Burbank at the base of the Verdugo foothills. The reservoir had a total capacity of about 1.7 million gallons of water; when the rupture occurred there were about 1 million gallons held in the reservoir. The wall was constructed of stone and cement; the break in the wall was a clean cut that led to no inconvenience to residents, who were unaware of the break. The question was, however, what made the reservoir burst of its own accord? Some speculated that the break was due to a blast, and some of the visual evidence seemed to suggest this. On a previous occasion, there were signs that somebody had attempted to dig under the wall; this was repaired before the damage occurred. But there was no water war going on at the time. The Providencia Land and Water Company, which owned the structure, had no apparent enemies. The company was wary and offered no explanations.

How important was water in those early ranching days? In 1917, one Burbank rancher shot another three times when an attempt was made to run water across his ranch. In 1918, a verdict of assault with a deadly weapon with intent to murder was found against another Burbank rancher in a dispute over an irrigation ditch.

STOP THE PRESSES!

Just how sleepy a place was Burbank in its earliest days? The following excerpts from various 1889 issues of the *Burbank Times* (which adoringly referred to Burbank as "God's footstool"), arranged in order of sensation, gives you a clue:

Burbank's Earliest Years

Mrs. E.H. Bundy, Mrs. R.A. Marshall and Mrs. R.M. Wren went to Pasadena on a visit yesterday.

A temporary fence has been put up to protect the young hedge around Dr. Burbank's place on Second Street.

Henry Obear thinks that if worse comes to worst that he would make a good hired man—he used the shovel most dexterously Saturday.

The flax which is growing so profusely all around town has gone to seed; it will soon be time to gather the poultices.

No trouble to find the streets and avenues of Burbank for the signs are all up and bear neat letters.

We have several times aired the question of a cemetery for Burbank, but there has not yet been any action taken. We hope our people will attend to this.

Burbank wants—and needs—a good blacksmith; we want a man who will pay attention to his work. Such a man could be kept busy nearly all the time.

A gang of Chinamen are picking wild horehound in the river bottom below the Ostrich Farm; they dry the leaves, which are used to prepare a cough remedy. There are thousands of tons of wild horehound in this vicinity.

We warn all persons against swimming in the Laguna on the Providencia rancho, for the sides and bottom of the lake are lined with bull-rushes and weeds and one is likely to become entangled in them.

Saturday evening a man ran over one of the fire hydrants on Front Street, with a large wagon, and broke off the pipe. Superintendent Weaver fixed up the break in a short while.

E.B. Flack had one of his fingers severely mashed Wednesday by a large boulder falling upon it. He is not feeling like a prize fighter just now.

Mr. Stacy, who has a fine place on the road from Burbank to Glendale, was in town Wednesday; one day this week while going home from Burbank he shot a large coyote from his buggy; the animal came within ten feet of him.

Monday a band of cattle was driven through Burbank for Los Angeles. One of the band got stuck in the irrigating ditch near Second Street [San Fernando Boulevard] and died. The body was left there, and on Tuesday someone skinned the carcass and took away the hind quarters. The remainder was buried.

Verona Baldwin, who has won an unenviable notoriety, passed through this valley on her way to the Napa insane asylum last Saturday. Her wrongs and sufferings worked on her mind until insanity resulted. Her story is a sad one and she is greatly to be pitied.

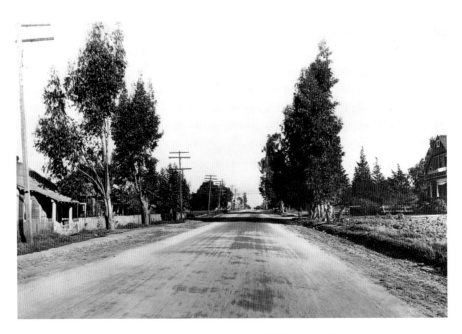

An unpaved San Fernando Boulevard in 1910. *Burbank Historical Society.*

(Verona Baldwin was the cousin of iconoclastic California tycoon Elias Jackson "Lucky" Baldwin, whose sexual escapades were a favorite topic of local newspapers. Verona was seduced by Baldwin. She later shot "Lucky" in the left bicep and was committed to an insane asylum. She later became a brothel madam in Denver.)

LAND OF SEA BREEZES

From the way they marketed Burbank in the early days, you'd think they were trying to sell oceanfront property (our boldface markings). From the *Burbank Times* of March 30, 1889:

> *The San Fernando Valley, in the very center of which spread the broad acres of PROVIDENCIA, and on its sightliest eminence stands the bright, new, prosperous town of BURBANK....Daily the* **salt breeze** *sweeps inland bearing healing on its wings, purifying and tempering the heated air of the valleys.*

> *The attractions for invalids are:*
> 1st—*Almost continual sunshine, making it possible to live out doors;*
> 2nd—*Equitable temperature, without sudden changes or extremes of heat or cold;*
> 3rd—**Bracing sea breeze** *every day, gentle, but exhilarating;*
> 4th—*Less than an hour's ride to the ocean side.*
> 5th—*An elevated plateau, where there is a dry and rarified atmosphere;*
> 6th—*Natural scenery unsurpassed in grandeur and interest, and the varied allurements of forest and stream to lovers of sport.*
>
> *Persons who are suffering from general disability and nervous prostration, whose constitutions are racked by the atrocious climatic changes of the Eastern States, will find the genial, even warmth, and get the stimulating, vital air they so much need. Such will find no enervating influence in the heat which enables them to gather figs, oranges, etc., in the day time, nor lurking chills in the bracing air that makes night's slumber so refreshing. Consumptives and those afflicted with diseases of the air passages, will surely benefit in this locality.*
>
> *The invalid is tempted to exercise by the balmy air and* **beauties of sea** *and land. The appetite is stimulated by the luxuries of the table; citrus fruits, fresh from the trees; all varieties of the other fruits in rotation, profusion and perfection; green peas, strawberries, etc., in every month of the year.*

THE TASTY BURBANK VILLA HOTEL

The publicity machine was working full time on behalf of the Burbank Villa (later Santa Rosa) Hotel, too, as evidenced by this text in an 1889 *Burbank Times*:

> *The Burbank Villa is as beautiful a structure as one would care to see. It is so substantially built, so tasty in design, finely arranged, and so elegantly furnished that it is a fitting monument to its owners—Dr. D. Burbank and J.W. Griffin. Money has not been spared to make it first class in every particular, and to give guests what satisfaction they require. Gas and hot and cold water is in every room of the house, and here are numerous baths and toilet rooms. Nothing is wanting, and when a person beseats himself in the charming dining room his appetite becomes remarkably keen, and—he*

never tires of singing the praises of the justly famed Burbank Villa.... The rates are exceedingly reasonable, much below those of Los Angeles, and is just the place for those wishing a nice, cosy summer home.

THE ADVENTURES OF CONSTABLE FAWKES

Constable H.B. Fawkes was a busy guy. In an 1890 article from the *Burbank Times*, we read that a Mrs. Turner, who ran a boardinghouse in Burbank, was having problems with customers who were in the habit of skipping out and not paying her. One fellow claimed that he had left the money for her before leaving—this wasn't true. So Mrs. Turner swore out a warrant for his arrest. Constable Fawkes found his quarry in San Bernardino and hauled him back for trial. The man was found guilty and fined fifteen dollars.

On a prior occasion in 1889, our intrepid lawman noticed a hobo riding on the brake beam of a train. As Fawkes approached the tramp, the man pulled a gun—a .44-caliber Hopkins & Allen revolver. Unintimidated, Fawkes drew his own gun and took the man under arrest. The hobo was fined twenty dollars. It turned out that the man, after fetching a bag from a Wells Fargo office, was a walking arsenal who may have been planning a train heist with three other men. The man lamely claimed that he was a sheepherder. In 1890, Constable Fawkes arrested "Prince Otto" Kieslich (an adventure described later in this book).

One might think that Constable Fawkes was held in universal regard in Burbank, but no. In 1891, one hundred residents signed a petition to have him removed from office; apparently this didn't happen. (In that same year, Fawkes filed a malicious mischief charge against a prisoner for destroying part of the jail while attempting to break out.) In 1892, he was involved as a witness in the trial of a "murderous" Chinese railroad worker in Burbank who had assaulted a "burly Hibernian" foreman with a heavy piece of wood to the head, causing a severe wound. Later in the 1890s, Fawkes became embroiled in the family legal cases, one member suing another, brother pitted against brother, father against son. (These legal battles are described more fully in *Lost Burbank*.) In 1898, Fawkes filed for bankruptcy.

H.B. Fawkes was mentioned in a 1927 *Los Angeles Times* article about an old jail door discovered behind a wall in a building in Los Angeles; he was described as a Los Angeles resident and one of the carpenters working in the building. His last mention was in 1928 in an article about the death of his brother J.W. Fawkes.

A FAWKES FAMILY MYSTERY

A July 29, 1897 *Los Angeles Times* piece noted the sad case of ten-year-old Frank Fawkes of Burbank (the son of Howard Fawkes—likely the same as our Constable H.B. Fawkes). He was examined for insanity and committed to the Highland Insane Asylum (a.k.a. Patton State Hospital) in San Bernardino. The description of the unfortunate lad's complaint: he was under the delusion that someone was constantly pursuing him with the intent to do him injury. We can't help but think that, Frank being a member of the tumultuous Fawkes family, perhaps someone actually was.

But wait. In the records for San Bernardino County, there is an entry for a *nineteen*-year-old Frank Fawkes as having died of peritonitis on the same date as the *Times* article, July 29, 1897. (The gravestone at Grandview Cemetery in Glendale confirms that he was not ten, but eighteen.) The attending physician was M.B. Campbell, who is cited as being the asylum director. What's going on here?

A TRICKY TRAMP

A whimsical incident was described in the *Los Angeles Times* on November 18, 1891:

> *A TRAMP'S TRICK: HOW HE REPAID A RANCHER FOR HIS KINDNESS*
> Southern California tramps are becoming too rapid for the grangers of this section if one can judge from the manner in which a Burbank farmer was "done up" on Chandler's ranch the other day. A tramp who had evidently taken every degree in the order put in an appearance at the kitchen door and in plaintive tones asked for something to eat. He was dirty and ragged and his thin face showed that he had not eaten a square meal in many hours. The farmer and his good family were just setting down to their midday meal and as there was much more than enough for two the poor tramp was given two big plates heaped full of the kind of food that makes healthy people. For thirty minutes the tramp was so busy with his two plates that he hardly took time to breathe. When he finally finished and was about to be asked to chop some wood he headed the granger pair off by pointing to their vineyard nearby and remarking: "Of course I've had enough to eat,

but I noticed them beautiful grapes down thar as I come by and if you don't object I'd like to go back and eat a few before I do any hard work in the way of chopping wood and such."

The kind-hearted farmer and his wife consented as they had more grapes than they knew what to do with. Of course the tramp did not return, and nothing more was thought of him until three days later, when a wagon was seen to drive up to the vineyard and a man began loading pumpkins and grapes on the wagon. The farmer watched him a few minutes from the house when he made up his mind to go down and see what it meant. The man with the wagon paid no attention to the farmer, and went on with his loading just as if he owned the place.

"See here," yelled the Farmer, "do you know who this place belongs to?"

"No, and I don't care a fig."

"Well, it belongs to me, and you are loading your wagon with my produce without permission."

"Your permission be hanged. I've just bought and paid for these pumpkins and grapes, and I don't know what you have got to do with it."

"I haven't sold you a single grape, and if you don't unload those pumpkins and grapes mighty quick I'll unload you," and the old man peeled his coat and prepared for war.

The man with the wagon saw that something was wrong, and he came down from his high horse and explained that he was on his way home from Los Angeles to Newhall, when a man came out of the vineyard and asked him if he did not want to buy some grapes. "My name is Johnson and I am a constable at Newhall and when this man offered to sell me some grapes I told him that I wanted a load of pumpkins for my horses, and would take a few grapes. He fixed his price, and we were just loading my wagon when you came up. I thought, of course, that he owned the place, but if he is your hired man and has no right to sell your stuff I will unload and you can give me my money back."

Just at this moment a man was noticed to jump up from behind a grapevine nearby and start off on a dead run. "There he goes," said Johnson, and the farmer saw the man who sold his pumpkins and grapes for the first time. One glance at the rapidly retreating figure convinced him that it was none other than the tramp he fed three days before.

"That's a thief," yelled the farmer, "and we must catch him," and both he and the constable started in hot pursuit. The tramp was fleet of foot, however, and had it not been for a young man at the ranch house who mounted a horse and joined in the chase, the probabilities are that the tramp

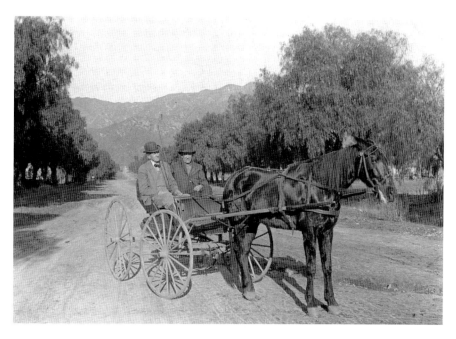

Andrew L. Wilbur (*left*) and a friend take a buggy ride on Olive Avenue, 1917. *DeLos Wilbur.*

would have escaped. As it was, he gave them a run of two miles and only surrendered when the constable came up and covered him with a pistol.

He handed over the money and thought he was to be let off, but the constable could not see it in that light, and handcuffing him he was taken on to Newhall and locked up. He will be tried in the Superior Court of this city, and it is more than likely that he will go to jail for several years, as it has transpired that for three days he sold grapes to almost every one that passed the vineyard.

It should be noted that in those early days, not all tramps were harmless fruit thieves. On November 16, 1914, deputy city marshal Luther Colson was inspecting "the Willows," a hobo encampment near the railroad tracks at what is now Victory Place and Lake Street, when he was shot. Colson returned fire, and the gunmen fled. When Colson attempted to return downtown he collapsed and was taken to a Burbank hospital, where he later died of his wounds. Marshal Luther Colson was the first Burbank lawman to die in the line of duty.

BURBANK'S FIERY SPOOK

In 1891, Burbank was the home of some bizarre atmospheric/electrical phenomena that frightened the locals and seemed to take on human attributes. Commonly referred to as a "spook," it first made its appearance on San Fernando Road in 1889 and subsequently appeared a number of times afterward, seen by many people. It must have been strange enough to cause general consternation, since the *Los Angeles Times* reported that it badly frightened both people and horses almost to death, while it "cut up antics." The description of the phenomenon is unusual in the extreme:

> *The thing is an immense fiery ball about the size of a two-bushel basket, and has wings shaped like those of a bat. When first seen, it seemed to be struggling to get out of the earth almost under the horses' feet, and as soon as it freed itself from the dust and hard earth, it rose gracefully and sailed around the wagon several times, coming within a few inches of the driver's head several times. The driver felt no heat, or if he did he was so frightened that he does not remember. After inspecting the wagon and its driver to its heart's content, it sailed off toward the railroad track, and was noticed dancing along the tops of the coaches of a passing train. It went the full length of the train and came back to the San Fernando Road. When it reached a point a few feet ahead of the farmer's team, it seemed to fold its immense wings, double itself up, and roll along the road.*

Additional text described the spook as becoming "weary" and making its way to some homes, where it flitted around the roofs. Its departure was dramatic: it rose several hundred feet into the air and disappeared into the Verdugo Hills. The spook only appeared on excessively hot nights and was described as being brighter than electricity and moving at a much slower pace than chain lightning or the fireballs that rise from swamps.

What could it have been, and why don't Burbankers see it anymore?

THE PERILS OF FREIGHT HOPPING

A January 2, 1891 piece in the *Los Angeles Herald* describes the perils of freight hopping:

LOST HIS FOOTING AND FOOT. The Accident Which Befell a Burbank Boy. On Wednesday afternoon last, as freight train No. 24 was running through Burbank station at the rate of about ten miles an hour, a thirteen-year-old boy named Tom Ellis attempted to board one of the cars. He missed his footing, however, and was thrown to the ground, several of the cars passing over his right foot, mangling it horribly. The injured limb was temporarily attended to by Dr. Allen, of San Fernando, and yesterday morning the boy was brought to this city and conveyed to the Sisters' hospital, where Dr. Ainsworth, the company's surgeon, successfully amputated the injured limb.

PRINCE OTTO AND MISS CARHART

This sensational tale, which appeared in 1891 issues of the *Los Angeles Herald*, had Burbankers "all agog."

When the owners of Carhart, Hacker & Co., of White Plains, New York, moved into Burbank, their arrival made a splash. It took sixteen railroad cars to carry their fine horses, furniture and other household effects, and they purchased six hundred acres of land and settled into the town's new hotel, which they purchased. (This is possibly the Burbank Villa, built by David Burbank in 1889.) Of the company, the paper reported, "The new firm will also breed Holsteins on a large scale. A carload of fine-bred Holsteins are now on their way to Burbank. There are thirteen Holsteins, all of whom were imported from Holland. It is also the intention of Carhart, Hacker & Co. to breed Shetland ponies and Normans, in addition to trotting horses. They start out with forty brood mares, many of them of fashionable breeding."

The firm's handsome and affable German horse breeder/coachman/superintendent/gardener, Otto Kieslich, made a name for himself with his free spending and grand ways. He was about thirty. He made suggestions that he and the eldest daughter, Miss Mary Carhart, a charming, sixteen-year-old heiress, would soon marry. This, however, was unknown to her mother. The April 13 *Herald* reported, "Mrs. Carhart would probably not have given the matter a moment's thought, had she heard of it, the idea being apparently too preposterous for consideration. A few days ago, however, that lady was considerably surprised and annoyed to find that her foreman presumed to be on terms of what to her appeared to be undue

intimacy with her eldest daughter, and she at once proceeded to put a check on his aspirations by discharging him from her employ on Saturday morning last."

Otto, called "Prince Otto" by the newspaper reporters (in reference to an 1885 novel of that name written by Robert Louis Stevenson) was equal to the challenge. In April 1891, after convincing Mary to elope with him, he outfitted a buggy and obtained the use of the fastest horse available, and, in the dark of night, the lovers fled Burbank. A Swede employed at the ranch excitedly announced to Mrs. Carhart that he had met Mary and Kieslich driving down the road at a rapid pace, but when he endeavored to stop them, Kieslich drew a revolver and threatened to blow his brains out unless he stood out of their way. Mother Carhart dressed quickly and, in a buggy of her own, gave chase, but not before sending a message to Constable Fawkes apprising him of the situation and asking for help.

Constable Fawkes overtook Mrs. Carhart and, with the assistance of a Los Angeles policeman, caught up with and took Prince Otto and Mary Carhart into custody in Los Angeles. They were charged with disturbing the peace. A distraught Mary Carhart cried bitterly and hung on the arm of her lover. Prince Otto swore that nothing in the world would prevent him from marrying Mary Carhart. The paper noted that it was apparent to all that Mary was desperately in love with Prince Otto, would go wherever he went and refused to leave him even for an instant. Prince Otto made bail, having taken with him some gold for the journey.

Prince Otto's plans fell apart when it became evident that he was already married and had a child by the marriage. It turned out that the opportunistic cad had deserted his family in New York. When she learned of the attempted bigamy of her husband, Mrs. Kieslich, a Roman Catholic, told the media that she absolutely refused to consider a divorce.

Mary Carhart and her mother reconciled, and the *Herald*'s last piece about the tale ended with this: "Prince Otto is in constant communication with Miss Mary Carhart, the young woman he once tried to elope with, and they exchange their letters by means of a well-known lodging house keeper of this city. Mr. Kieslich will soon have his divorce, and then the *Herald* readers will learn the sequel of the romance."

The authors do not know if a divorce and a subsequent marriage ever happened.

Burbank's Earliest Years

THE CACTUS NEEDLE CORPSE

One of the more mysterious early Burbank stories covered by the *Los Angeles Times* involves the January 1892 discovery of a nude male corpse found near San Fernando Boulevard and the Los Angeles River "in the vicinity of Burbank"; it was riddled with and bloodied by cactus needles. According to reports, the man dug a number of holes in the hard clay with his fingers and buried his clothes and other belongings near the little frame home of a family who were awakened by his scratchings by the side of the house. The wife supposed at first that the noise was being made by an animal but then heard the man distinctly say, "I can't find it." Badly frightened, she awakened her husband, telling him that "some kind of animal that could talk was digging under their house." The husband investigated and saw the nude man take off at a high rate of speed through some cactus patches. His body, badly torn, was found about four miles away. The coroner found that the man was in the final stages of pneumonia and, apparently delirious with a high fever, underwent a psychotic episode causing him to paw in

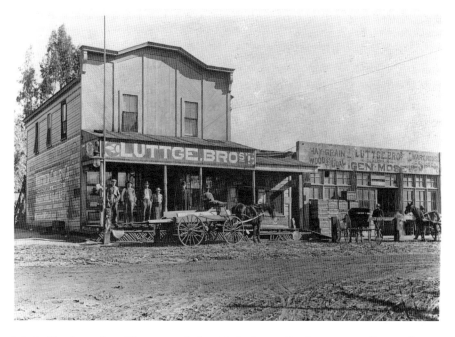

It looks like the set for a Western movie, but it's the Luttge Brothers store on Orange Grove Avenue and San Fernando Boulevard, 1905. George Luttge stands third from left. The only streetlight in town can be seen just left of the "L." *Burbank Historical Society.*

the dirt and dash his head upon the ground. Nobody in the neighborhood could identify him, and no identification was found among his belongings in the holes.

The article noted, "He passed through places that would cause a man with thick clothing and heavy boots to shudder and then turn back, and it is a wonder that he did not drop with exhaustion and loss of blood and pain long before he did." The poor unknown man was buried in a potter's field in Los Angeles.

THE BURBANK BRANCH

The main railroad line though Burbank, running mostly north and south, has been in place since 1874. The railroad line running alongside Chandler Boulevard is called the Burbank Branch, and its story is here, reprinted from the abandonedrails.com website:

> *The 21-mile Burbank Branch, built in 1893, was basically a low-density bypass of the Southern Pacific Coast Line in the San Fernando Valley region of Los Angeles. Originally, consideration was given for this line to serve as the main route through San Fernando Valley; however, its sharp curves limited speed along the line, prompting Southern Pacific to build another track across San Fernando Valley, this one with nary a curve between Burbank and Chatsworth. Thus, this line served as a true branch for the entirety of its life.*
>
> *The Southern Pacific offered passenger service along its route using gas-electric passenger cars up until 1920, when competition from the Pacific Electric Red Car service forced Southern Pacific's hand. However, the branch was re-opened to passenger service briefly during World War II, carrying wounded soldiers to the Veterans Administration hospital located on the line.*
>
> *With freight service along the line diminishing, the line was severed as a through-route, most likely in the late 1980s. Final doom for the line came in 1991 when the entire route was purchased by Los Angeles' Metro Transit Authority. During the following year, Southern Pacific began phasing out service along the line to the last few remaining customers; now only those at the endpoints of the line (Burbank to North Hollywood, and Chatsworth to Canoga Park) see limited service.*

The existing, unused railroad track from the main line ends at the intersection of Chandler Boulevard and Mariposa Street. In a commendable nod to the area's railroad heritage, the city erected a nice statue of a railway worker near the intersection on what is now called the Chandler Bikeway.

By the way, Chandler Boulevard, a major thoroughfare in Burbank and the San Fernando Valley, is named for Harry Chandler (1864–1944), the publisher of the *Los Angeles Times* from 1917 to 1944 and, at one time, the largest private landowner in the United States.

COMMEMORATED IN STREET NAMES

George Lynn Monroe, in the *Burbank Community Book* (1944), describes how some Burbank streets were named. (The names in boldface are street names in Burbank.)

> *As the big ranchos were broken up the small farmers began to flock in, in increased numbers. When the town of Burbank was first laid out and put on the market the valley section was sold in 20, 30 and 40-acre tracts. Later five and ten-acre tracts were available. These were the days when the Fischers, the* **Luttges***, the Radcliffs, the Dufers, the* **Clarks***, the* **Myers***,* **Sheltons***, Storys, Sprinkles, the Buffingtons, the* **Lamers***, the Gowers, the* **Parishes***, the* **Reeses***, the* **Peytons***, the Forbes, the* **Doans***, the McConnells, the Kirkpatricks, the* **Sparks***, the* **Grismers** *were common names among the farming population. Many of these names are still with us both in life and in the names of the city's streets.*

The authors wonder: Isn't it past time to name Lockheed View Drive (near the Starlight Bowl) something else? There's no Lockheed to be viewed anymore. We're all for history, but there is a necessity for practicality, too.

WATER WARS

George Lynn Monroe, in the *Burbank Community Book*, describes a situation that strikes the authors as seeming a lot like the plot of Roman Polanski's *Chinatown* (1974):

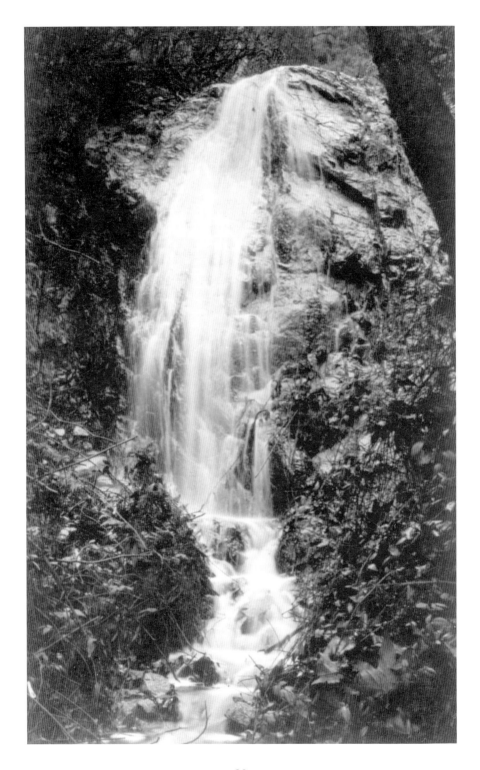

Burbank's Earliest Years

It was during this period [the early 1900s] *that the water problem, which had been brewing for some time, reached an acute stage. A court decree giving the City of Los Angeles the right to all the water from the Los Angeles River watershed threatened grief for the small farmers who depended upon the water pumped from their wells for raising their crops. On the basis of the court order the big city attempted to enforce their claim to the water by stopping the farmers from using it, even from their own wells.*

As a picture of the situation along about that time John D. Radcliff, who owned and operated a ranch in the locality of the present Glendale Airport, came home from market one day to find officials from the sheriff's office waiting to serve papers on him based on the court order restraining him from pumping any more water from his well. He refused to accept service and the order was thrown on the ground at his feet. In response to threats of putting him in jail if he didn't stop his pumps, John told them that when he went to jail his wife would see that the pumps were kept going. And if his wife was sent to jail the children would stay at home and keep the pumps going, inferring that the entire family would have to go to jail before the pumps would be stopped.

This seemed to be the tenor of the farmers in general—they insisted upon keeping their pumps going in defiance of the order of the court. There seems to have been no attempt to carry the enforcement of the order any farther than serving the papers on the ranchers.

Whether or not it had anything to do with Los Angeles easing up on its tendency to force the issue on the farmers, T.D. Buffington tells of this gesture from "Teddy" Roosevelt, President at the time [1901–09], *in behalf of the farmers: To build the Owens River aqueduct, Los Angeles had to get a bill through Congress granting a right-of-way over the public domain. Before he would sign the bill, it is claimed that "Teddy" exacted a promise from the beneficiaries that they would quit persecuting— through the threat of prosecution—the farmers who were depending upon the water they were pumping from the ground for their irrigation—which meant their livelihood.*

Opposite: The Sylvan Falls on the property of the old Country Club, 1920s. *Doris Vick collection.*

JOSEPH WESLEY FAWKES

Readers of our first book, *Lost Burbank*, will be familiar with the name J.W. Fawkes, the inventor of the "Aerial Swallow" (later known as "Fawkes' Folly"), the 1911 monorail scheme to revolutionize rapid transit in Southern California. Before that, the reporters at the *Los Angeles Times* certainly became familiar with his disagreements and various legal hassles with members of his family in the late 1890s. (In 1896, he threatened to blow up his poor mother with dynamite.) What sort of man was J.W. Fawkes? Your authors conclude, something of a nut.

In an article by Jan Heminway in the August 4, 1964 *Southland Magazine*, Fawkes is described thus: "Born during the Civil War, Fawkes grew up during a period when transportation was also developing. He loved speed. In smartly tailored clothes, and sporting a waxed mustache, he raced around in a carriage drawn by a pair of spirited horses with two Dalmatian dogs running behind….He wrote poetry and painted in oils and dreamed."

The Dalmatians accompanied Fawkes on quail hunts. Heminway continues:

> *Even though he owned a car in the early days, he preferred his carriage with the proud horses. It was 1912 before the first paved highways were built in California, and through long use the mud and dust had assumed the shape of a rutted roadbed. Automobile travel was uncertain and often humiliating. Yet, when the town decided to pave Olive Avenue, then little over two miles long, he fought it. His property lay along Olive, and macadam was hard on a horse's hoofs! Each time they moved to accomplish it, he defied them with an injunction. He lost when work was started one Friday night and kept going in day and night shifts, reaching the finish line before the court opened on Monday morning.*

An eccentric, irascible figure, to be sure. A suggestion of his personality and negative celebrity might be glimpsed from this piece in the November 27, 1918 *Los Angeles Herald*:

> *Burbank's Noted Dog License Fight Ends—Burbank's famous dog license fight has been concluded in the superior court, a jury in Judge Monroe's department returning a verdict in favor of City Marshal O.S. Greenwood in the $10,000 damage suit instituted by J.W. Fawkes, a resident of*

Burbank's Earliest Years

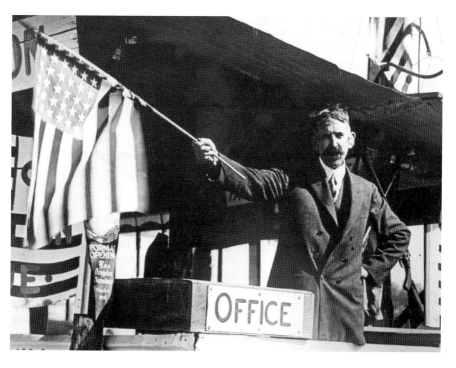

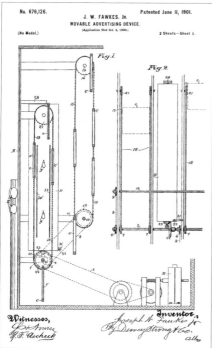

Above: Joseph Wesley Fawkes, in a detail from a circa 1924 larger image. Note the shotgun behind his left elbow. Is he expecting trouble? *Mike McDaniel*.

Left: J.W. Fawkes's patent no. 676,126 for a moving advertisement system, the precursor to the ones used in today's shopping malls. *U.S. Patent and Trademark Office*.

the suburban city. Fawkes alleged he had been falsely imprisoned by Greenwood when he refused to pay for a dog license.

Still, the man had his strengths. In 1901, Fawkes was granted a U.S. patent for an electrically illuminated advertising sign. Examining the patent (no. 676,126) is enlightening. It involves a sort of motor-driven roll of advertising backlit by incandescent lights. Does this sound familiar? It appears to be the grandfather of those modern shopping mall signs that change designs every ten seconds or so. The next time you see one, think of Joe Fawkes of Burbank.

CARBOLIC ACID GARGLE

The *Los Angeles Times* of July 3, 1902, reported that a fellow named Captain White, who owned a fine ranch south of town, narrowly escaped death. How? He mistook carbolic acid for spirits of ammonia and ingested the same, severely burning his mouth.

The article doesn't explain why one would want to swallow spirits of ammonia (a.k.a. smelling salts), but it helpfully goes on to mention that if one should accidentally ingest carbolic acid, then Epsom salts in teaspoonful doses should be taken.

Burbank was clearly a different place to live in 1902 than it is today.

CHILD DRINKS GASOLINE

Fourteen days later, the *Los Angeles Times*, ever on the lookout for ingestion mishap stories, mentioned that "Little Pauline," a fifteen-month-old child of E.R. Ertle in town, drank some gasoline and also narrowly escaped death. She was described as being in a precarious condition, but the physician in attendance thought that she might recover. The *Times* didn't mention in subsequent editions whether or not the tot survived.

Burbank's Earliest Years

HOW JAMES J. JEFFRIES GOT INTO THE CATTLE BUSINESS

George Lynn Monroe, in the *Burbank Community Book* (1944), tells the story of how the former world's heavyweight champion also became Burbank's first international businessman. It wasn't a matter of hard-nosed business as much as it was the desire to help a dying friend.

> [James J. Jeffries] *operated for a number of years one of the most successful dairy stock ranches in the country. There is a measure of human interest in how Jim got into this kind of business after retiring from the prize ring. It was through a desire for helping a friend out of a trying situation.*
>
> *This friend, O'Connor by name, came to him one day and told about his doctor telling him he had but a short time to live, and advising him to go to Arizona, which might prolong his life for a year or more. Said he had a ranch of 107 acres out in Burbank, upon which was a mortgage of $8,000; that the mortgage was past due and the holder of the note was on the verge of foreclosing. Pleaded with Jim to pay him $2,000 for his equity, assuming the other $8,000 obligation. This he said would help him get to Arizona and ease somewhat his declining days.*
>
> *Looking over the ranch Jim decided to take a $2,000 chance on the proposition, not so much that he wanted the ranch but he wanted to help his friend out. His friends charged him with being crazy to load himself with 107 acres of sand and sagebrush with an $8,000 mortgage on it. The ranch had a fine well on it, which Jim considered as the most valuable thing about it.*
>
> *Only ten acres of the ranch was in cultivation. He had the rest of it developed and planted it practically all in alfalfa. There came a time when the market price of the alfalfa was so low that it didn't pay the cost of producing it. Looking for an outlet for his predicament he decided to buy a bunch of cattle and let them eat up the alfalfa. At first his herd was made up of a nondescript lot of uncertain vintage. Concluding that it cost no more to raise a thoroughbred than a nondescript, Jim disposed of the stock on hand and started to develop a herd of thoroughbreds of the Holstein variety.*
>
> *It wasn't long until he was sending thoroughbred bulls to Mexico and South America at $1000 per head. Twenty-five of them were sent to South America and 15 to Mexico. In the meantime he was raising heifers and cows of the record-breaking and prize-winning proportions, a cow producing 38 pounds of butterfat a week in the former and grand championships at the fair and stock shows in the latter classifications.*

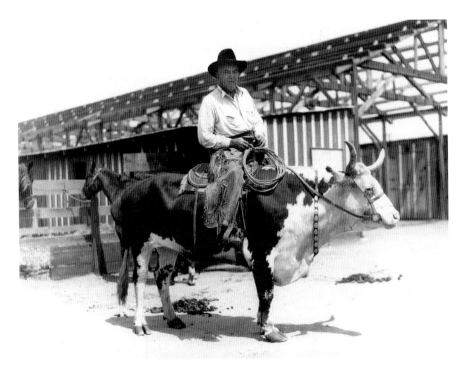

James J. Jeffries rides a bull, 1920s. *Burbank Historical Society.*

Life was good for James J. Jeffries at his ranch and barn complex until 1941, when tragedy struck. The *Madera Tribune* from February 5, 1941, reported the sad news:

> WIFE OF JEFFRIES KILLED BY AUTO—*Struck by Machine Crossing Boulevard*
> BURBANK, Feb. 5. *James J. Jeffries, former world heavyweight champion, was recovering today from the hardest blow of a lifetime of hard ones. He collapsed when he was called to Burbank emergency hospital to identify the body of his wife, who was struck by an automobile. Mrs. Frieda Jeffries, 69, was killed when she stepped from a curbing into the path of an automobile driven by John Albert Christerson. She was attempting to cross Victory Boulevard from her home to the Jeffries Barn, where the 65-year-old former ring hero operates a boxing stable.*

(Note: She must have been trying to cross Buena Vista Street, not Victory Boulevard. The Jeffries ranch and barn straddled Buena Vista Street.)

Burbank's Earliest Years

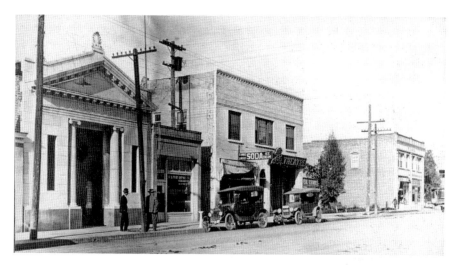

A 1917 image of San Fernando Boulevard showing the neoclassical Farmer & Merchants Bank building. The building to the right with the theater sign still stands; DeLos Wilbur's car is parked in front. Evidence of horses can be seen in the street. *DeLos Wilbur.*

BURBANK'S PEPPER TREES

In George Monroe's *Burbank Community Book* is a description of Burbank's pepper trees: "In its earlier days Burbank was known far and near for its streets lined with pepper trees. Most of these were planted by the original Townsite Company, the pepper tree having, evidently been chosen as a sort of 'theme' tree. Most of the avenues on the hill section of the city were lined with these trees and presented a beautiful appearance."

However, the trees had enemies. As reported by the *Healdsburg Tribune* in 1889, "the pepper trees at Burbank, Los Angeles County, have been killed by gophers."

WASTING AWAY IN BURBANK

From the February 18, 1907 *Los Angeles Times*:

> *MURDER FOILED, TRIES STARVING. BURBANK WOULD BE ASSASSIN WASTING AWAY. Chained to Cot at County Hospital—*

Refuses Food and Says Water Is Too Heavy—Doctors Think Him Not Dope Fiend but Just Crazy—Relative Visits Him.

Having failed to kill his sister's family at the Stancliff ranch near Burbank, Fred Strader is trying to starve himself to death at the County Hospital. For several days he has refused water, saying it was "too heavy." He said he wanted light water. Yesterday he decided not to take any more food. Chained by the feet to a cot in the insane ward, the man seems to be wasting away. His arms are no thicker than a little girl's.

In spite of the fact that six bottles containing chloral, strychnine, morphine, opium and other varieties of "dope" were taken from him after he tried to slaughter the Stancliff family, the physicians at the County Hospital do not believe that he is a "dope fiend" or that he was full of "dope." They think he was just plain crazy. The County Hospital people are informed that two of Strader's brothers died insane. Alpha Stancliff, who was shot in the forehead by Strader, visited him Friday at the hospital and tried to find out why the man wanted to kill them all. She could get no satisfaction from Strader.

The patient will reply to questions of the simplest kind, only after they have been repeated to him two or three times. When asked why he wanted to kill his sister's family, why he wants to starve to death, or why the water is too heavy, he only stares dully. There is a great danger of Strader getting away. At least there would be if he wasn't kept chained to the foot of the bed. Ever since being brought to the hospital, he has been trying to escape.

The boy, William Stancliff, the nephew of Strader, who shot his uncle with a small rifle to protect his mother and sisters from Strader's murderous revolver, will not be prosecuted. Strader will be examined for insanity some day this week. At the examination an effort will be made to find out why he took six bottles of poison out to Burbank on the day of the shooting.

"There is a great danger of Strader getting away. At least there would be if he wasn't kept chained to the foot of the bed." That's an interesting journalistic style: frightening in the first sentence, then reassuring in the second.

Burbank's Earliest Years

HERE COMES THE HERD!

From *Your Burbank Home,* published around 1929 by the Burbank Merchants' Association:

> *The great unsold portion of the Providencia Land Company reverted to the cattle and sheep land they had been when owned by Dr. Burbank. Dr. Burbank, before his sale, had operated this vast 9,000 acres as a sheep range and cattle ranch....Even as late as 1908, when Burbank had grown large enough again to support a newspaper, to attract a bank, and to build a high school, great herds of sheep used to be driven down San Fernando Boulevard. The Burbank Review in its issue of May 3rd of that year, speaks of the largest herd seen in some time passing through town. It was necessary for Ralph Church to shut all the doors and windows of his little pioneer bank when he saw a herd approaching, to keep its dust from completely stopping business.*

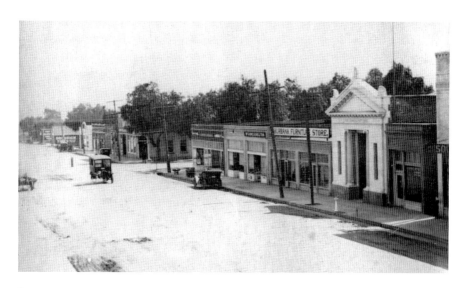

San Fernando Boulevard, looking southeast, 1917. Some of Burbank's famous pepper trees can be seen on the Olive Avenue cross-street. *DeLos Wilbur.*

A SPLENDID DAY

The September 1911 arrival of the Pacific Electric trolley line connecting Burbank to Glendale and thence to Los Angeles ("Forty-Five Minutes to Broadway!") was a very big deal. How big? Burbankers went all-out. A barbecue was held that involved long lines (an estimated ten thousand people took part), 7,000 pounds of boned beef, 200 gallons of coffee and 300 packages of crackers, wafers and cookies. It started at 11:00 a.m. and ran until 3:00 p.m. Bands played, high school girls sold Burbank pennants and a display of Burbank agricultural products was arranged featuring a 150-pound pumpkin, a 50-pound watermelon, 65 bunches of Tokay grapes and 17 other varieties of grapes, strawberries and corn—all grown on the ground without irrigation. Sideshows, sports (the "Boston Bloomer Girls" played a baseball game), tug-of-war games, long political speeches from local elected officials and merry-go-rounds were also endured or enjoyed.

There was a bit of a kerfuffle involving women's suffrage, however: a group of women who wanted to distribute anti-suffrage literature were disallowed from doing so, until it was pointed out that some women were involved in pro-suffrage activities.

Not a bad day for a community called, at the time, a "sixth-class city."

RACING THROUGH TOWN

His name is known only to older folks these days, but Barney Oldfield, the celebrated race-car driver and the first man to drive a car at sixty miles per hour, was a driver whose name was "synonymous with speed in the first two decades of the 20th century" (*Encyclopedia Britannica*). On July 4, 1913, Burbankers crowded San Fernando Boulevard to watch what was billed as "the greatest automobile race ever known," when Oldfield and forty-nine other drivers sped through town on their way to Sacramento from Los Angeles.

Oldfield took third place in his Fiat; he was having chain trouble and decided not to push his car too much.

Burbank's Earliest Years

BURBANK HIGH SCHOOL ATHLETICS IN THE OLD DAYS

The following is an excerpt from the June 1916 *Ceralbus*:

> *American football is a new sport at B.U.H.S., being adopted only last year. At the time of its adoption there was only one student in the whole school who knew the game to any great extent. It was necessary therefore, to give each player private instructions: to point out the good and bad of the game, and go through the drilling numerous times in order that each player could gain as much as possible in a very short time. This hard training with that which we gained at the opening of school, September 17, 1915, was not without results, as will be noticed. Our first game was with the Baraca class of the Presbyterian Church, of Glendale, on our grounds, October 8, 1915. The teams were unevenly balanced, advantage being in our opponent's favor. This advantage however did them little good for our men were much faster and had they been more experienced, a defeat would not have resulted. As it was, we were defeated by the score of 9-0. The second game was with our old enemy, the San Fernando squadron on our grounds, October 22, 1915. The final score when the game ended, 8 to 0, in our favor.*

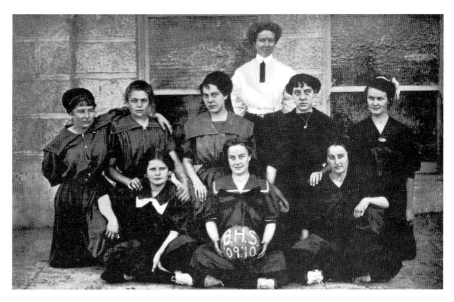

Why so glum? The 1909–10 Burbank High School girls' basketball team. *Burbank Historical Society*.

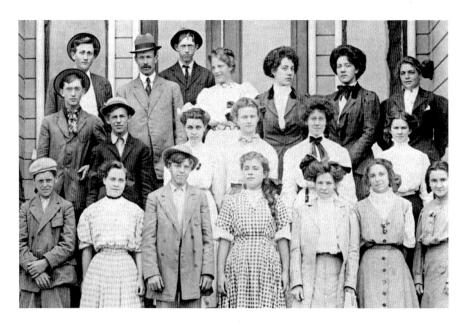

The Burbank High School student body, with their two teachers, in 1909. We like the gal with the wild Bulldog hair third from right, front row. The boy at left, middle row, looks especially academic. *Burbank Historical Society.*

> *We were unsuccessful in our Basketball this year. Practically every game played resulted in our defeat and finally the team disbanded.*

Quitters.

A COLONY OF CRANKS: THE HENRY FAMILY OF FREEDOM HILL

Freedom Hill was the home of a philosopher/pamphleteer named Leroy "Freedom Hill" Henry (1860–1932); it also was the center of a host of self-named "cranks" who gathered there to discuss life, happiness and philosophical issues starting in about 1913 and ending about 1930, when the family started to have financial difficulties. Leroy Henry was married to Eora C. Beach, who died in 1899. Interestingly, his career as a crank coincided with his status as a widower. According to a Los Angeles medical occupational register, Leroy Henry is listed as an 1893 graduate of the Medical College of Indiana.

Burbank's Earliest Years

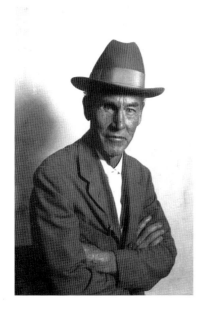

Chief crank Leroy "Freedom Hill" Henry (1860–1932), circa 1927. His glass eye is apparent. *mondomonkey.com*.

Henry maintained a press at Freedom Hill and printed a series of booklets about his philosophies and "brain ticklers." The publications were prefaced by comments like "PRICE TWENTY FIVE CENTS WHICH IS TOO MUCH IF YOU DON'T READ IT AND NOT ENOUGH IF YOU DO." Another example: "Dear Comrade: If you like this booklet, lend it to your poor friends and tell your rich friends to buy a copy. If you don't like it, keep quiet, and consult a specialist on mental diseases. I am an insane specialist and I can readily tell whether any one is just right in his mind. If you agree with my notions, then you are all right. If you don't agree with me, then I know you are crazier than I am." Henry gave the address of the press as "Freedom Hill Pressery, RFD A, Burbank, California."

Where was Freedom Hill in Burbank? Technically, it wasn't. It was in modern Sunland, in the Shadow Hills district about three miles northwest of the Burbank boundary line. The hill at the north end of what is now Helen Avenue seems to be the site. Burbank is mentioned often, however, as this area was served by the Burbank post office.

The following article from the *Los Angeles Times* of September 9, 1917, explains some of what went on at Freedom Hill:

> *CRANKS ENJOY LIFE OF EASE. Colony of Care-free Mortals at Camp Fire. Each Scorns Bed and Sleeps on Mother Earth. "Relaxation and Forget All" is the Watchword.*
>
> *Eighteen miles northwest of Los Angeles, near Roscoe, a colony of cranks has been enjoying the next-to-nature life during the past week under the watchful eye of Dr. Leroy Henry, chief crank of the bunch. The word "cranks" is not inappropriate because the folks themselves call themselves such and their present stunt is the "second annual campfire of California cranks." Moreover, the colony had its rendezvous at Camp "Don't-Give-a-Durn" located at "Freedom Hill." Evidently the conventions are not observed to the letter and*

"have a good time" seems to be the mainspring of the outing. The cranks have been enjoying the simple life for more than two weeks. They started their free-and-easy relief from city distractions on August 31, and, unless all signs fail, stakes will be pulled tonight. Two sessions daily have been held, one at 2 o'clock and the other at 7 o'clock, each lasting a full two hours. The speeches have been only ten minutes short of one hour in length and the rules of the camp forbade a discussion of the main topic. Incidentally there have been music and some recitations. Each crank has his or her own blankets and food and such a thing as a bed is taboo. No, indeedy; old Mother Earth is good enough. Dr. Henry announced in the beginning that repose would be upon "garden beds softened with pick and rake," and it has been so. Dr. Henry, who gets his mail at Burbank, invited his friends to wear washable clothes "and for a few days to live the simple, relaxed life under the trees with the birds and stars and intellectual friends." He also told them: "Tone up your inner life and adjust the wheels in your head so your soul, if you have one, will have as good a chance to grow as your potatoes and bank account." Dr. Henry added that he was strong for "the deeper life."

Freedom Hill Henry's various pamphlets from his Burbank Pressery make interesting reading. A passage from one will suffice to give the general tone of his philosophies:

The difficulty is that my friends do not understand that I am a peculiar crank. Nature has made an entirely different set of laws and regulations for me; just for me alone and not applicable to any of you. I am governed by a peculiar mystical system; a system that is invisible, intangible, undemonstratable, unprovable, and unbelievable. I am especially protected by the gods, so that no harm can come to me. Nothing ever happens to me but what I deserve. I never get stung unless I go too close to a wasp's nest. I never get sick unless I need to. Nobody is ever unjust to me. Nobody steals anything from me but what I can get along without. I never lose an eye that I have to have.

(Due to a medical mishap, Freedom Hill Henry had one glass eye.)

Freedom Hill Henry's son Harper Beach Henry (1895–?), the inventor of the so-called Azonic Language, was briefly described in our book *Lost Burbank*. After we published it, we became aware that in the late 1940s, Harper Henry also planned and ran a utopian colony off the coast of Panama. By 1956, the experiment was apparently ended. Harper Henry had a daughter named Azonia, perhaps named after his invented language.

Burbank's Earliest Years

SIEGE AT THE THOMPSON RANCH

Reading the various *Los Angeles Times* articles about Burbank, one gets the impression that the boys in the newsroom were always ready for some odd, diverting story—and Burbank seemed to readily supply them. Take the April 1916 saga of William and Ida Thompson, two "elderly folks" (they were actually in their early fifties) who lived "about two miles from the town" (within today's city boundaries). They became a "source of terror" to their neighbors and passersby for their habit of occasionally shooting at people with weapons from a household arsenal of revolvers, shotguns and rifles. (According to one visitor, loaded revolvers were hung on pegs by each door.) Why would a couple turn to violence in this fashion?

According to the couple, it was required for self-protection from tramps, who made their lives miserable. According to local law enforcement officers, the couple would threaten anyone who came near the place. On one occasion, a motorist broke down in front of the dwelling, and William Thompson ordered him to move. The motorist made the mistake of informing the farmer that a roadway was public property. William opened fire, and "before the third shot had left his smoking pistol the truck was moving with celerity, the driver having discovered it was in pretty fair repair, after all."

A local Lunacy Commission (yes, there was such a thing) issued a complaint charging them with insanity. When two detectives approached the house to apprehend the couple, they were driven away with automatic weapon fire. Various attempts to draw the couple out by talk and even by the intervention of a (reluctant) son were unsuccessful. Wary of ambushes, the couple had developed a warning system: whenever William exited the house to supervise his Japanese workers, he'd give a blast on the whistle to signal to his wife that he was okay. She would respond with a bang on the cowbell to signal that she, too, was safe. If a passerby on the highway was spotted, Mrs. Thompson would bang on the cowbell repeatedly, immediately bringing her husband back to the house.

The lawmen determined that the couple, being declared insane, were to be taken by strategy and not gunfire or force. So, one morning, when William Thompson went outside to feed the horses, he discovered that they had been led away. Thompson jumped into his car to inform the local constable (who couldn't have been on his side, as he must have realized), and a car manned by four deputy sheriffs gave chase. "As the cars drew together at racing speed the farmer brandished his gun. Deputies Dewar and Coutts made a flying leap, landing in the car of the fugitive safely. They

seized him." But not before Thompson sank his molars into the arm of Deputy Coutts. Nevertheless, Thompson was apprehended and taken to Los Angeles County Hospital. One down, one to go!

At least six lawmen gathered around the Thompson house to take Ida, who was now reinforced by the presence of her son Earl. One deputy called out that William wanted to see her at the hospital. No dice. She demanded proof. A note was given to her, written by her husband, urging her to surrender. She called it a forgery and ordered the besiegers to depart, backing up her words with a gun and strong language—the lawmen withdrew. Finally, William Thompson, in shackles, was presented. "What's wrong, Bill?" she shouted. "Oh, nothing much," came the reply, "except that I am a dangerous lunatic and they have got it proved on me." After some parley, Ida surrendered.

When the lawmen finally entered the house after the three-day siege they discovered that the elderly couple wasn't playing around. The revolvers were found at the doors, and an attic containing two rifles, a shotgun, ammo, extra bullets, powder and cartridge reloading equipment was found—in addition to food supplies sufficient for several days.

The couple was taken to the psychopathic ward for observation prior to their arrest. As they were taken away, William Thompson wore his black felt hat with attached clockwork gears (by which he demonstrated that gears were on the outside as well as the inside of his head)—possibly a bad choice of headwear if one wanted to prove that he was not insane.

The Lunacy Commission judged that the Thompsons originally became insane some years back, when, in a home invasion, tramps attacked Ida Thompson, beat her and tied her up in a closet. She was sane enough, however, to demand a jury trial. She calmly represented herself. The jury, after a short deliberation, reversed the Lunacy Commission's findings and she was declared sane. William also demanded a jury and was found sane. Both were acquitted. The judge, however, had some final words: "You should read the Lord's Prayer every day and equip yourself with the Golden Rule instead of a shotgun." The judge also said that the last days of William's life would be sweeter and better if he forgot old animosities and made a genuine effort to live in harmony with his neighbors.

The newspaper record is silent on whether or not the Thompsons beat their weapons into plowshares, but William Thompson later moved to Glendale and died in 1937. Records show that his wife, Ida, lived in Massachusetts as late as 1955.

FILMING THE BIBLE IN BURBANK

In November 1919, Burbank's first motion picture studio, Sacred Films Inc., was founded by Episcopal reverend Harwood Huntington. Its specialty was the production of films illustrating biblical stories in a nonsectarian way; hundreds of churches and colleges were reportedly interested in the productions. The plans were ambitious (at least, as announced to the media): the scope of the movies would encompass the Creation in *Genesis* to Jesus's ascension in the New Testament and would take four to five years to film, cost upward of $27 million and involve more than 100,000 characters. To authentically reproduce biblical scenes, the studio secured the services of Edgard James Banks, PhD, a noted archaeologist. He oversaw the construction of a Babylonian temple on the studio's Burbank parcel of land (formerly owned by Oliver J. Stough and reputedly 3,600 acres) used for filming. On May 21, 1922, the *Los Angeles Times* reported that the studio planned to build an exact replica of the ancient Temple of Solomon, the interior of which would be used for office and auditorium space and the exterior, presumably, used in filmed productions. It was never built. Harwood Huntington died in 1923, and the fate of movies made by Sacred Films is unknown to the authors. Did any survive?

A 1922 map shows the headquarters of Sacred Films as being at the intersection of Sixth Street and Myrtle Avenue. Myrtle no longer exists; the closest modern-day spot is the intersection of Sixth and Amherst Drive—as it turns out, about four hundred feet from the *Wonder Years* house!

A QUIET DAY IN BURBANK

Here's another cinematic mystery: Without citing a source for the assertion (a newspaper, perhaps), the 1975 *Burbank History* by Jackson Myers drops an interesting fact: "'A Quiet Day in Burbank,' a 1,000 foot film, was shown from Summer 1919, on to point out interesting features of Burbank." Elsewhere in the book is a repeat with an interesting detail: "The film 'A Quiet Day in Burbank' was shown at the Rose Theater on August 16, 1919, and in other towns."

Two questions arise: (1) Where was the Rose Theater? Not in Burbank, as far as the authors or anyone at the Burbank Historical Society know. (2) Does this film still exist? The authors made a concerted effort to track it

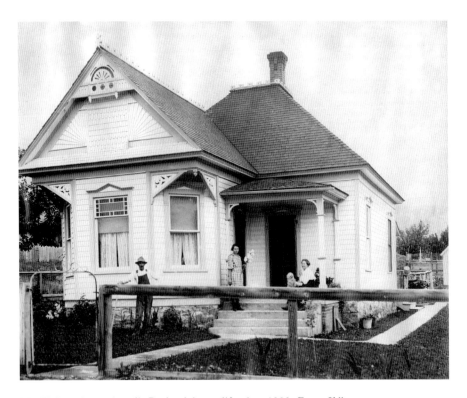

The Kellogg home: bucolic Burbank home life, circa 1900. *Fermer Kellogg.*

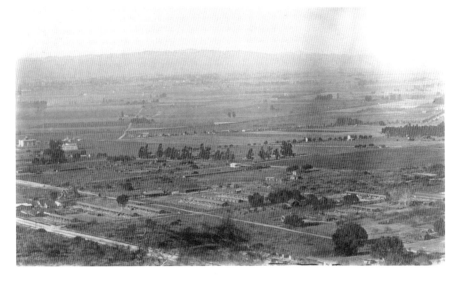

An image of Burbank, circa 1919. Burbank Union High School is the white building at left; a chicken farm is in the foreground. Lockheed would later be built at the upper right. *Burbank Historical Society.*

down. We have queried three private movie collectors in the Burbank/Los Angeles area; the UCLA Film Archive; Dennis Bartok, an author of a book about film collecting; the Museum of Modern Art film archives in New York City; the Academy of Motion Picture Arts and Sciences (AMPAS) Film Archive; the Eastman Museum in Rochester, New York; the Moving Image Section of the Library of Congress; and the International Federation of Film Archives (FIAF). All report that not only do they not possess it—they've also never heard of it!

A Quiet Day in Burbank must be lost, perhaps a pile of vinegary white powder in a film can somewhere—the fate of many a movie on nitrate film stock.

2
BOOM AND BUST

If there's one word that could characterize Burbank in the decade of the 1920s, it's *boom*. From 1920 to about 1929, the population jumped 672 percent, making Burbank one of the fastest-growing cities in America. During this era, Burbank achieved national prominence, as it became the home of Lockheed, First National Pictures (later Warner Bros.) and, in 1940, Disney Studios. Photographs of the business district of San Fernando Boulevard from the era reflect a strong and thriving local economy. Streets started to get paved; in 1920, there were but 5 miles of paved roads in town. By the end of the decade, this number reached 153 miles. Outhouses were banned in 1922. By 1929, the city had installed approximately $10 million worth of street improvements, ornamental lights and sewer lines. One publication asked, "With such a record to its credit, is it little wonder then that residents of Burbank are Boosters?" Indeed.

But what goes up often comes down; this chapter also contains stories from the hardscrabble decade of the 1930s, when the Great Depression robbed wage earners of their livelihoods and a section of Burbank became a "Hooverville." At this time, a wry theory of evolution arose: "Rags make paper, paper makes money, money makes banks, banks make loans, loans make poverty and poverty makes rags."

True Tales from Burbank

VALHALLA-ASK YOUR MORTICIAN

What follows is some grandiloquent prose from a 1920s Valhalla Cemetery promotional pamphlet:

> *Valhalla, the hallowed beauty spot of San Fernando Valley, is an everlasting memorial to the love and reverence for those who have passed on. Here is no cemetery in the ordinary sense of the word…no jumble of weather-stained and neglected tombstones, many of them over-grown with weeds. Instead, one great, inspiring monument of marble and mosaic, rising to a height which dominates the valley, and serves as a fitting monument to all. The great PORTAL OF VALHALLA, serene in beauty which will endure through the ages, stands, marking and glorifying the last resting places of your loved ones, a perfect expression of eternal life conquering death. Stately trees and shrubbery frame it. Lovely pools reflect its splendor. No wonder that thousands come to marvel at this realization of an ideal memorial park.*
>
> *Of first consideration in the selection of a family memorial is the condition of the soil. It is of paramount importance that it be dry. It requires little imagination to picture the burial of a loved one in muddy clay and on sloping land that is subject to continual seepage and erosions. Oftentimes one is carried away by outward appearances. Don't be misled—investigate the soil. Ask your Mortician this important question: Is the Cemetery property that I am about to bury my beloved in Dry?*

Lofty prose, but, in fact, the story of the development of Valhalla Cemetery is one of fraud and criminal mismanagement. It began in 1923 with the incorporation of the Osborne-Fitzpatrick Finance Company, run by C.C. Fitzpatrick and John R. Osborne. They bought sixty-five thousand acres of land for the future cemetery and began high-pressure sales to potential investors, some of whom were elderly. Among the sales pitches were bogus claims of the future unavailability of cemetery space as Los Angeles expanded. Worse, cemetery plots were resold multiple times. By 1924, cemetery investors had begun to grow suspicious, and the situation was eventually brought to the attention of the Los Angeles district attorney. Lawsuits were initiated, and the federal government became involved. In June 1924, the feds began an investigation; by December, they had charged Osborne, Fitzpatrick and others with using the mail to defraud investors. In August 1925, Osborne and Fitzpatrick were found guilty of ten charges

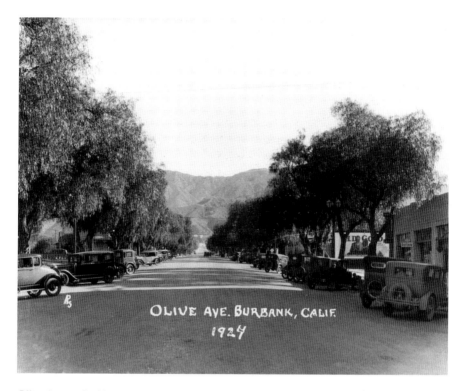

Olive Avenue looking toward the hills, 1924. An Old Gold cigarette ad can be seen at right. *Burbank Historical Society.*

of fraud and sentenced to ten years each in a federal penitentiary. They filed appeals and went free on bail. But, after June 1927, when the U.S. Supreme Court declined to hear their case, Osborne and Fitzpatrick were escorted to Leavenworth Federal Prison in Kansas. They were released in 1930 and, incredibly, returned to leadership positions at Valhalla with John E. Osborne, John R.'s responsible and law-abiding father.

In 1931, four lot holders filed for the appointment of a receivership to manage Valhalla; in 1932, Osborne (the son) filed suits against stockholders for slander. In 1935, Osborne (the father) committed suicide—he was buried at Valhalla. The State of California eventually required Osborne and Fitzpatrick to sell Valhalla, and in 1950, Pierce Brothers purchased the now-thriving cemetery business. In 1991, Valhalla was bought by Service Corps International, a major mortuary company. In an excellent article about Valhalla's early days, historian Hadley Meares writes, "The company-sanctioned story of Valhalla is now the tale of the Portal of the Folded

Wings. Perhaps it is for the best—in spite of all their duplicity, Osborne and Fitzpatrick succeeded in building a cemetery more associated with heroes and heroines than with shady plots and dirty deeds."

WATT MORELAND GIVES A PEP TALK

The Moreland Motor Truck Company was an important early industrial player in Burbank; it opened a new factory in Burbank in June 1920. On that occasion, general manager Watt L. Moreland issued some inspirational prose titled "All Together." This is what corporate speech sounded like in the 1920s:

> *I want now with all the strength and emphasis possible to express my appreciation and thanks to all those who, by their encouragement, their faithful work and interest, have helped to put this organization where it now stands. Times have changed. The days of working for each other have gone by. Now it is a case of working with each other for a mutual purpose. There's a striking difference expressed in those two little words "for" and "with." I want, hope and believe every employee of the Moreland Motor Truck Co. will feel that we are all working together, with each other, for the*

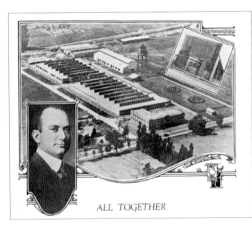

Above: A proud Watt Moreland and Moreland's new Burbank plant in 1920. *Burbank Historical Society*.

Right: Moreland's festival was in high 1920s style! *Burbank Historical Society*.

greatest good of the organization, which means at the same time the greatest good for each individual mother's son, or daughter, of us. That's the true spirit of co-operation and true co-operation means general and individual success. Let's go.

THE LAND OF POCO TIEMPO

As described by the *Los Angeles Times* in a piece that ran on July 3, 1921, the Memorial Fund Spectacle, also known as the Land of Poco Tiempo ("the Land of Pretty Soon"), was certainly big: "all roads led to Burbank," as there were fifteen thousand participants by day and more than twenty thousand by night. Many camped out in the Verdugo Hills to await the opening of the event. The occasion was a great, three-day celebration and spectacle held in the Woodland Heights section of town (more or less the Benmar subdivision) by the Burbank Memorial Association to raise $125,000 for a memorial temple to America's war heroes. It was never built. The pre-publicity was sensational; on the evenings before the event, an airplane with an eight-foot star (illuminated with thirty-two electric lights) suspended beneath it flew around Los Angeles emphasizing the slogan "Follow the Star." An electric star forty feet high was erected over the entrance.

There was a rodeo ("a real dyed-in-the-wool wild west show") in a twenty-five-acre arena described as "the greatest and most spectacular ever seen in Southern California." The *Times* writer included this puzzling statement: "Human life within the big arena was the cheapest thing on the grounds." Did he mean it in terms of Roman gladiatorial contests, or simply that there were a lot of people present? It seemed gladiatorial, as trick horse riders were injured: "Casualties were many....A fractious steed tossed one gent over his left ear and then completed the performance by prescribing three somersaults over his rider's body, who, at the emergency hospital, was identified as Jack Moore." A rodeo clown "had a couple of inches of steer horn drilled into his back." There were singing cowboys. There were chariot races. And there was even a live, blow-by-blow reproduction of the July 2 Jersey City, New Jersey boxing match between Jack Dempsey and Georges Carpentier. Prominent Burbanker and former heavyweight title holder James J. Jeffries served as the referee.

Overhead, World War I reenactments were performed by army, navy and civilian flyers: battles in the clouds, bombing expeditions, parachute drops

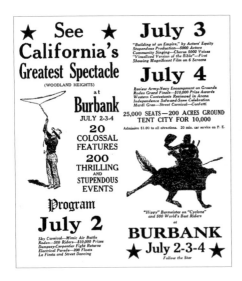

Newspaper art for the 1921 Burbank Spectacular. *Los Angeles Herald, California Digital Newspaper Collection* (Reformatted).

and reconnoitering, hazardous stunts in midair. At another point in the "Sky carnival" (involving, reportedly, hundreds of aircraft), Major E.H. Wilson flew loops, glided down to within a few feet of the grandstand, waved a California flag and gave the state governor a snappy military salute.

A Mission Village was constructed at the site with concession stands designed in early California architecture; a statue of Juan Rodríguez Cabrillo (the first to navigate the California coast) was unveiled as part of the festivities. Pretty Spanish dancing girls and troubadours were in attendance. And during the evening, an electrical pageant was held; this featured a procession of one hundred miniature illuminated floats representing cities and towns in the state. Meanwhile, electrically illuminated planes flew overhead.

Four battalions of the National Guard marched in a parade, and a historical pageant entitled "The Building of an Empire" was held featuring five hundred motion-picture actors enacting twenty episodes of California history. If all that wasn't enough, the premiere showing of the sacred film *The Visualized Version of the Bible* appeared on six enormous screens placed at points within the arena, and a Mardi Gras ball ended the festivities.

"Big doin's in town!" as Wes Clark's mother would say. But here's the funny thing: the authors have yet to find any photographic evidence of this colossal event—as least, none marked as such. Were there no photographers present? And why wasn't the memorial temple ever built? What happened to the proceeds?

Sacred Films, a Burbank company mentioned earlier, was almost certainly the producer of the biblical epic shown at this event.

THE WHITNALL HIGHWAY

> **"Oh Fig-gle Sticks!"**
> **No More Castor Oil!**
> Fig-gle Sticks are little bars of taffy, bran and figs combined, making a delicious confection and a perfect
> **Roughage**
> Sold by leading grocers
> and
> Genevieve Jackson, Burbank, Cal.

An ad for Genevieve Jackson's Fig-gle Sticks that appeared in the September 25, 1921 *Los Angeles Times*. *Wes Clark collection.*

With those gigantic power transmission towers, it stands out in Burbank, that's for sure. It almost looks…rural. And, "Highway?" What highway? As one might guess from the generally underwhelming nature of the place, there were plans for it that didn't happen.

It's named for George Gordon Whitnall, a former Los Angeles director of city and county planning who, in the early 1920s, envisioned a high-capacity road stretching from Newhall through the San Fernando Valley and into a two-mile tunnel running under Griffith Park to Hollywood. The first section of it opened in 1927 on the intersection of Whitnall Highway and Cahuenga Boulevard, just past the Burbank boundary line. But, partially as a result of homeowners' complaints, the effort stalled in the 1930s. In 1959, a new master plan was adopted by the state legislature that included a Whitnall *Freeway* (more or less the same name but a different path). This was intended to connect Burbank with Malibu and the Pacific Coast Highway. Once again, land was purchased and homeowners complained; by 1975, the whole thing was called off. Sections of the Whitnall Highway remained, however, cutting an odd diagonal path through residential streets arranged on a slightly canted east–west grid.

In the 1990s, the City of Burbank established parks under the power lines (nothing could be built there), sensibly named Whitnall Highway Park North and Whitnall Highway Park South.

GENEVIEVE JACKSON FIGHTS CONSTIPATION

In the early 1920s, the Genevieve Jackson Company (located on Front Street more or less to the right of the modern light-rail station) produced high-fiber foods that no doubt caused constipated Burbankers some relief: Fig-gle Sticks (taffy, bran and fig), Honey Brannies (wheat, bran, agar-agar and honey), Sweet Brannies (bran and agar-agar) and, for diabetics, Dia-Biskits (parched bran with agar). "No More Castor Oil!" announced the

ad for Fig-gle Sticks—based on the sour looks from various cinematic Little Rascals who were fed this oil, this must have been a blessed announcement! The company also produced dehydrated lemons and oranges for shipment east, where the pectin and acids were extracted. Genevieve Jackson—"well-known dietician"—gave health talks in Los Angeles from time to time.

SILVERSMITHING

In 1923, a nationally known, eighth-generation silversmith, Porter Blanchard, opened a studio on the corner of Magnolia Boulevard and Maple Street. He was associated with the Boston Society of Arts and Crafts as well as the Arts and Crafts Society of Los Angeles. Blanchard produced flatware and hollowware, and in the 1930s, he moved his shop to Pacoima, where he manufactured gold and silver telephones for movie stars and the wealthy. Blanchard's work is now displayed in several museums; he died in 1973 in Burbank.

"THE METROPOLIS OF KNOWLEDGE"

Real estate entrepreneur Ben Marks's plans for Burbank and his Benmar Hills development were nothing if not lofty. In a 1920s promotional pamphlet, he asked the question, "Did you know that the site of what may become the world's greatest university is only eleven miles from Broadway, Los Angeles?" He troweled it on even thicker on the next page:

> *Panorama of Benmar Hills—Noble Site for a University—Millions of dollars should soon be available for the project. A large fortune has been assigned to a group of men who have agreed to act as Trustees of an endowment fund thus created to finance the construction and maintenance of this great institution.... The Great University will be non-sectarian and non-political. It will be one of the few tuition-free centers of learning in the world, complete in every phase of higher instruction. The massive structures destined eventually to rise around about its spacious campus will include a wonderful College of Music, a perfectly appointed College of Arts and Drama, a two million dollar Museum, an Auditorium to seat 3400 people,*

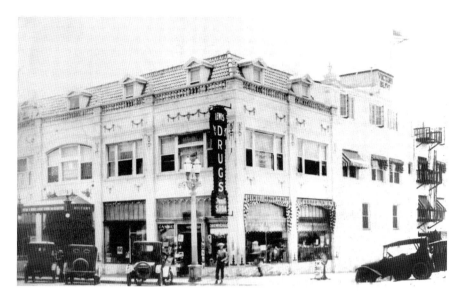

The Victory Theater in the Victory Building, 1920s: Burbank's leading theater, which "provides good, clean entertainment for the entire family, featuring only the best in pictures at popular prices." Located on the corner of San Fernando Boulevard and Angeleno Avenue. *Burbank Historical Society.*

> *a complete Library, as well as a Stadium and Gridiron second to none in the United States....But that is not all. This magnificent University is to be at the heart of what nature, coupled with the determination of able men and women, should cause to be the most beautiful, tranquil and flourishing community in all the world....Assuredly Benmar Hills will be a fit and proper setting for the world's greatest center of education, music and art.*

George Lynn Monroe described the plans:

> *His program included a University of International Relations which would draw from far and near those in search of things associated with things of a cultural nature—music, art, literature and things which go with them. Elaborate architectural drawings and blueprints were provided, including music, art and science buildings, and a veritable Hollywood Bowl up in one of the canyons. The main boulevard leading to the institution was to be two hundred feet wide, beautiful parks on each side with a background of $50,000 residences. A twenty-acre section of the land was donated to the city as a Civic Center, with the proviso—which the city authorities accepted— that any more public buildings erected by the city should be built on the tract.*

True Tales from Burbank

In another pamphlet, Ben Marks is described in visionary terms:

> *Seven years ago a man stood on the slopes of the green Verdugo hills north of Burbank. Below him, sweeping down across rolling acres to that great ribbon of interstate travel, San Fernando Road, lay a beautiful property rich in the lore of California's golden beginning....Eight leagues of land, stretching from the Arroyo Seco to Rancho Ex-mission San Fernando, including Sundale, Garvanza, Highland Park, Eagle Rock, York Valley, Casa Verdugo and BURBANK constituted not only the first great Spanish land grant in California, but one of the largest ever made during the Spanish occupation. Something of the sunlit background of the rolling acres at his feet must have impressed itself on the mind of the man who stood looking down across the beautiful San Fernando Valley, because there took form in his mind that day the vision of a city-to-be—a residential community more generous in its conception, and more beautiful and attractive than any other community development of the southland....In his heart was born the determination that his time, his fortune, and his ability should be unfalteringly and unswervingly dedicated to the building of that community.*
>
> *Ready—after seven years of continuous planning—for you who have come to that period in your lives when you want your home among the right kind of people in a physical environment free from all those undesirable elements that have taken root in so many older communities.*

Well! With the *right* kind of people living there, what could go wrong?

A lot. Funding and promotions and the failed moves of the University of Southern California (USC) and, later, the University of California at Los Angeles (UCLA), to the site gave way to the financial havoc of the Great Depression. The Benmar development became, in Monroe's words, a "pain in the neck." The Burbank Chamber of Commerce eventually stepped in and sorted things out, and the land allocated for the "Greatest University in the World" eventually became a pleasant residential neighborhood. All that is left of Ben Marks's grand scheme is a series of street names that reflect academic references: Cambridge Drive, Tufts Avenue, Andover Drive, Eton Drive, Stanford Road, Groton Drive, Birmingham Road, Uclan Drive, Amherst Drive, Cornell Drive, Dartmouth Road, Hampton Road, Harvard Road and University Avenue.

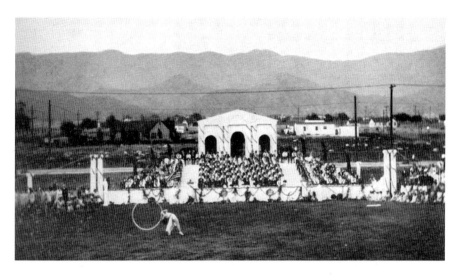

In 1929, the graduating class of Burbank High School held its ceremony outdoors for the first time. A Greek theme—and a bendy dancer with a huge hoop—was evident. *Mike McDaniel collection.*

WHO WERE THE BURBANK NIGHT RIDERS?

The *Los Angeles Times* of January 14, 1925, contains mention of an alarming death threat tacked to the rear door of the Burbank grocery business of Jay Henry: "You are warned. You and yours. This will be your last night spent in peace. We have you marked and will get you. Our organization, The Night Riders, have visited you. All is ready. We will visit your store once again and then we will do our deadly work. Don't raise any alarm or your suffering will be greater. Last warning. Death will come soon. The Night Riders."

At first, Henry considered it a joke until he recalled that his wife had been insulted by a stranger who suddenly appeared at his home; he notified the Burbank chief of police. The police investigated and apprehended the stranger, who claimed not to be connected with any so-called Night Riders. He was released, since there was no evidence.

The *Times* reported on January 18 that Desmond Selby, a sixteen-year-old nephew of Jay Henry, found a note pinned to the seat of his automobile (the contents of the note, alas, were not reported). After investigation, the Burbank police concluded that "the notes are being written by a boy or gang of boys who have been reading too many lurid detective stories and are seeking an outlet for their overwrought imaginations in the series of threats."

The intersection of Olive Avenue and San Fernando Boulevard looking toward Orange Grove Avenue, 1936. The French Fashion Shop is having its annual spring clearance, and the Sparkletts Water ("Refreshing—Palatable—Healthful") truck is parked at right. *Burbank Historical Society.*

Fair enough. But the Night Riders were mentioned in the pages of the *Times* again on March 2, 1927, this time in conjunction with an alarming story about the initials "NR" slashed into the shoulder of a pretty sixteen-year-old Burbank High School student named Mary Garard. She claimed that this was done by two men in a lonely cabin in Kagel Canyon, about five miles northwest of Burbank. But in a subsequent article, the girl admitted that the story was a hoax and that the branding was done with the girl's consent by her sweetheart, Tony Santi, in a scheme designed to force her parents to allow them to marry. (No, we don't understand the logic, either.) The story ends with Santi being held for trial for statutory offenses.

Did the Burbank Night Riders actually exist? We think not.

WHEN DRUIDS DANCED IN THE STREETS

The Ancient Order of Druids, founded in England in 1781, is a fraternal organization that still exists but is not so well known in the United States these days. However, they certainly made their mark in Burbank from June 15 to 18, 1925, when almost six hundred of them and their wives descended upon the town and headquartered themselves at the Hotel Elizabeth. The occasion was a California state convention, and the city bedecked San Fernando Boulevard in bunting and banners to welcome the crowds. A parade led by the city's municipal band marched along Olive Avenue, Third Street, Magnolia Boulevard and other thoroughfares. Night exercises (speeches) at the City Park were followed by fireworks and dancing in the streets. Frankly, some of the activities were a bit puzzling. A *Los Angeles Times* article mentioned that "a large class of candidates was worked for Burbank Circle, the degree work being exemplified by the Grand officers." Musical performances were also part of the festivities: there were piano duets, Russian and Greek dancing and a soprano solo by Marya Trapani Swift accompanied by Billie Burke, fourteen years later the *Wizard of Oz*'s "Glinda, the Good Witch of the North."

Tea was served, these being genteel druids.

Burbanker Billie Burke, a longtime resident of the Santa Rosa Hotel (which stood where the post office on Olive Avenue stands today) was a sharp lady. Among her memorable quotes: "Age is something that doesn't matter, unless you are a cheese." "To survive there [Hollywood], you need the ambition of a Latin-American revolutionary, the ego of a grand opera tenor and the physical stamina of a cow pony. By the time you get your name up in lights you have worked so hard and so long, and seen so many names go up and down, that all you can think of is: 'How can I keep it here?'"

BUSINESS WILL PICK UP. IT ALWAYS DOES.

The following piece is from the April 13, 1925 *Los Angeles Times*:

> *BURBANK, April 12—Despite the poorest of business prospects here, there is one man who seems to have faith in the future of Burbank and will start his business here as soon as he can move into a new $20,000 building that is to be built to house his enterprise. Notwithstanding the fact that there*

True Tales from Burbank

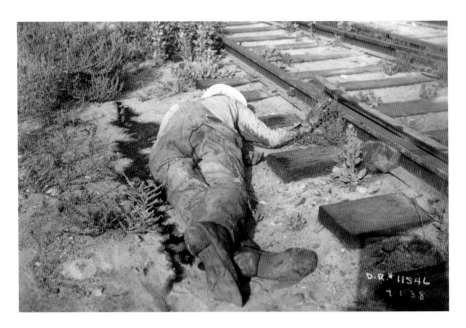

The peril of riding boxcars or malingering near the tracks: a dead hobo found near the railroad tracks somewhere in Burbank, 1938. *Mike McDaniel collection.*

> hasn't been a death in Burbank since March 18, last, M. Munger of Los Angeles was in town yesterday and closed a deal to enter the undertaking business in a new structure that is to be erected for him by George Luttge. Munger has more than the ordinary man's faith in the opportunities and the profits of his calling. He says that as long as persons continue to step on the gas, smoke pipes in bed, look down unloaded pistols or flirt with death at grade crossings the undertaking business will prosper.
>
> He expects to begin operation in about a month.

THE 1927 BURBANK CANYON FIRE

The following is from a page on the Burbank Fire Department website that is no longer on the Internet:

> *Authorization from the City Council for 14 additional paid firemen on May 31, 1927 brought the Fire Department from a partly paid mostly volunteer Fire Department to a paid Fire Department with a holdover of*

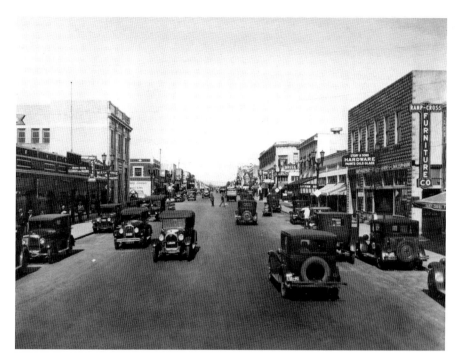

Burbank boomtown before the Great Depression: San Fernando Boulevard and Olive Avenue, 1927. *Burbank Historical Society.*

some volunteers. *The last record of a volunteer responding to a fire was in June of 1928. The authorized strength of the fire department in 1927 was 19 men. The Fire Department reached a milestone in its early history with an almost purely paid Department, three new stations, and two new pieces of apparatus.*

In 1927 a major brush fire occurred in the Verdugo Mountains above Burbank. A fire began before noon on Saturday, December 3. A resident of La Crescenta was burning grape trimmings from his vineyard in Haines Canyon in the San Gabriel Mountains. He lost control of the windswept fire. The fire jumped Foothill Blvd and spread into the Verdugo Mountain range. The fire burned all that day on the La Crescenta side of the ridge. Burbank Firemen and Volunteers climbed to the ridge to set their defense against the oncoming fire.

At 1:30 am, December 4, the fire came over the ridge and over the would be defenders. The fire spotted a considerable distance beyond the main body of the fire, with embers being driven by a down canyon wind. The fire burned into Sunset Canyon destroying 100 homes. The firemen had laid

2200 feet of 2½ inch hose up the canyon floor from a swimming pool at the Sunset Canyon Country Club. The fire was so intense that the hose line had to be abandoned and the firemen had to flee for their lives. The next day the canyon floor had a coupling every fifty feet with the ash of hose in between. Firefighters and equipment from Los Angeles County, Los Angeles City, and the City of Glendale participated in the firefight. The fire was brought under control only when the wind shifted.

RADIO STATION KELW IS ON THE AIR!

Real estate businessman Earl L. White, an early Magnolia Park booster, managed to establish his own radio station in Burbank (the San Fernando Valley's first), call sign KELW (*K* is the FCC prefix for a station west of the Mississippi, and *ELW* signifies Earl L. White). He initially broadcast at 780 kilocycles and, later, at 1310 kilocycles on the AM band. (In 1927, radio stations in the United States could choose their own frequencies and power.) KELW's studio was located at 3702 Magnolia Boulevard, near the intersection with Hollywood Way. The first broadcast was held on Lincoln's birthday, February 12, initially with only 250 watts of power. This was later increased to 1,000 watts in the daytime and 500 watts in the nighttime. KELW ran until 1937, when its license was deleted; the studio building was demolished in the late 1980s or early 1990s.

What sort of programming was broadcast from this pioneer Burbank radio station? Program guides through the years list the fare:

> *The initial broadcast featured addresses by City of Burbank dignitaries. Outdoor concerts were held in the Portal of the Folded Wings Shrine to Aviation at Valhalla Cemetery; these were broadcast live.*
> *Early-morning two-hour Spanish language programs were hosted by Pedro Gonzalez (an early Tejano music performer) and his Los Madrugadores (fittingly, "The Early Risers"). Sponsored by Folger's Coffee, these could be received as far away as New Zealand, thanks to atmospheric conditions. Imitation prizefights were staged in the studio; these included duck sounds. KELW promoted itself as the official broadcasting station for the Federated Church Brotherhoods of California, so religious broadcasting was offered. (The station also provided Sunday Glendale First Baptist Church and Episcopal services.)*

Back in the 1920s and 1930s, Earl L. White's radio station KELW sent sparky Burbank broadcasting as far as New Zealand! *Mike McDaniel collection.*

American Legion Post 150 broadcast news and programs of legion activities.
Keomoku Lewis, a Hawaiian baritone, gave recitals with the California String Quartet (formerly known as the Times Aloha String Quartet).
A Memory Lane hour was featured in conjunction with Pioneer Day.
Sigurd Frederiksen and assisting artists gave a recital of music of various European and Scandinavian composers.
The Criterion Quartet performed numbers by Frimi, Schertzinger and Speaks, and Kreisler's "Old Refrain" was sung as a duet.
Earl Meeker, baritone, and Dubin, Russian tenor, performed duets.
Lloyd S. Nix, former Los Angeles City prosecutor, spoke for fifteen minutes every Wednesday and Friday. He reportedly combatted the radiocasting of Reverend Robert P. Shuler ("Ye who like pyrotechnics can sit on the fence"). Whatever that meant.

All of the programming was free save for the price of the radio. It sounds like fun listening. And that's not all; radio station KELW also sponsored some fun activities in town, as described as follows.

THAT'S ENTERTAINMENT

On February 20, 1927, daredevil flyer Finley Henderson performed a remarkable stunt in Magnolia Park sponsored by Earl L. White, proprietor of Burbank radio station KELW. From a height of one thousand feet, Henderson dived between two telegraph poles, clipping off the wings of the plane, and crashed into a bungalow with the fuselage at about sixty miles an hour. To protect himself during this dangerous stunt, he equipped himself with football shoulder pads and shin guards, a baseball umpire's breast pad and a catcher's mask. He not only survived this horrific stunt but also emerged from the wrecked bungalow smoking a cigarette and modestly claiming to the thunderstruck spectators, "The stunt is easy if you know how to do it." (Henderson accomplished the trick once for motion pictures.)

Nevertheless, that June, when it came time for him to repeat the performance at an air rodeo in Glendale, a U.S. deputy marshal and two representatives of the U.S. Department of Commerce, Aeronautics Branch, issued a summons and a writ of injunction preventing the stunt. They cited safety concerns (for the spectators) that seem, to modern eyes, to be completely reasonable.

Lockheed from the air, 1928. Turkey Crossing is clearly visible (where the railroad tracks cross San Fernando Boulevard). The Empire China Company kilns can be seen, and that grid of trees is where McCambridge Park is now. Burbank High School is at the center upper edge. In general, we are looking at what is now the Empire Center. *Burbank Historical Society.*

But the 1927 Glendale Air Rodeo still held some interest for Burbankers: local girl Virginia Huddleson, age seventeen, took second place, defeating eleven others, in the parachute-jumping contest. She would have taken first place, but she didn't land in the designated field, as did the first-prize winner.

BOOTLEG BOOZE ON OAK STREET

On October 30, 1927, the *Los Angeles Times* ran an article about a police raid on an illegal liquor plant on Oak Street. Just after midnight, the place was raided by eight Burbank policemen; the malefactors fled through the walnut trees surrounding the old farmhouse as bullets from one of the cops "rained about them." The facility was described as one of the largest distilling plants ever found in the San Fernando Valley, with a capacity of eleven thousand gallons of raw and finished product; the main copper boiler had a capacity of three hundred gallons. When the police arrived, the boiler was hot, indicating that operations had been carried out into the night. The police were tipped off by a newsboy who had become suspicious of the actions of the home's caretaker.

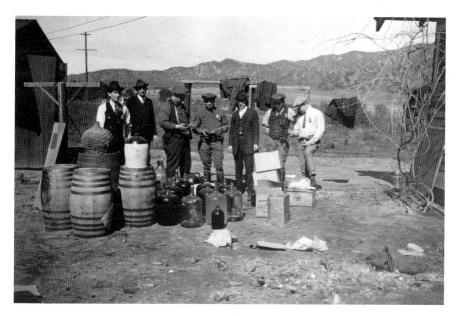

The Burbank Police Department, always on the lookout for illegal booze production, busts up an operation, 1930s. Note the pile of broken glass in foreground. *Burbank Historical Society*.

The Marcel Curl was *the* popular hairstyle for women in the 1920s and 1930s. *Mike McDaniel collection.*

THE CLEANEST PLACE IN TOWN

A pamphlet from the late 1920s extolled Burbank's industries: "Look down into a steaming vat of soap three stories deep—a potential supply of 750,000 cakes of Woodbury's Facial Soap. Watch this being fashioned into familiar shapes and skillfully wrapped and packed by lightning-fast fingers. See creams, lotions, pastes and other beauty aids…nearly a hundred of them… made in this great factory and you have an idea of the scope of the Andrew Jergens, Co."

KIDNAPPING HOAX

Children want attention, right? For example, Eldon Waters, a ten-year-old boy from L.A. was, according to the *Los Angeles Times* in September 1928, found near the Southern Pacific railroad tracks in the west part of Burbank bound hand and foot and wearing a soiled pillowcase over his head. His story was that he had been kidnapped on his way to school, bound with his head covered, then dumped in Burbank after being told that his kidnappers

The 1924 John Burroughs Junior High School basketball team. Those shorts look uncomfortable—as well as ridiculous. *Burbank Historical Society.*

would return for him. The Burbank police immediately suspected a lie but were unable to get the boy to recant his story. He eventually did—he was simply a runaway.

BURBANK'S SHRUBBERY ARMY

The following story comes from George Lynn Monroe's *Burbank Community Book*. His tone betrays some skepticism.

> *Following the Sunset Canyon fires of December 3, 1927, recorded elsewhere in this historical treatise, were disastrous floods, some of which filled houses on the upper end of Olive Avenue with six feet of mud and debris....To offset the ravages of the fire from the flood a unique experiment was indulged in....An army of tree and vegetation planters was organized with the late George Kettinger as generalissimo. There were corporal of the guards, troops, companies, battalions, regiments and divisions led by corporals, sergeants, lieutenants, captains, majors, colonels and commanding generals. A considerable*

quantity and variety of seeds of quick-growing shrubbery and other vegetation were distributed to the different sections of the army. A day was set, the different groups allotted certain sections, none of which was supposed to be too large to cover in one day. The plan was carried out without a hitch. The entire mountainside above the city was supposed to have been planted during the one day allotted. That was about the last ever heard about it.

This writer has inquired from those who ought to have known, what was the result of the experiment. Did it accomplish what it was intended to have accomplished? As far as is known nobody seems to have taken the trouble to learn if any of the seeds developed into foliage.

BURBANK: THE WHITE SPOT

The following is from *Your Burbank Home*, published around 1929 by the Burbank Merchants' Association:

Welcome to Burbank. Dear Newcomer: You honored us when you chose Burbank as your new home. That you will be satisfied beyond question we know, for Burbank is the "White Spot" of the Great San Fernando Valley....Beautiful churches has Burbank and very proper thought as to her moral training. She has wonderful provisions for her boys' work and a moral cleanliness seldom equaled....We would have you feel that you are one of us and invite you to participate with us in our efforts to make Burbank the best place in Southern California in which to live. We urge you to adopt our motto, "Bank in Burbank."

The authors are not sure what is meant by "White Spot" but feel that it does not necessarily deal with race.

GUN DUEL ON FLOWER AND VERDUGO

The February 18, 1929 *Los Angeles Times* contains an account of a deadly shootout on the streets of Burbank: "A feud of long standing between Julian Chacon, 22 years of age, and Marcelino Degado, 27, resulted fatally for the former and probably fatally for the latter last night when the two engaged in

a gun duel as they met at the intersection of Flower and Verdugo streets in Burbank, according to Burbank police reports. Chacon was killed instantly and Delgado is at General Hospital where he is not expected to live after sustaining a bullet wound in the lung."

Delgado did live and was tried for first-degree murder but waived a jury trial and was acquitted under the state's new self-defense law.

WARNERS' ROOFED OCEAN

This anecdote is taken from Monroe's *Burbank Community Book*.

> *The physical plant is considered by many to be the finest in the world. There are 22 huge sound stages, all stucco, steel and concrete construction and all of the same architectural design, although varied in size to meet specific requirements. Stage 21, for instance, is, in reality, Warners' roofed ocean. It has a 65-foot clearance from floor to rafters and can be flooded to a depth of four feet for water work. Adjoining it and connecting with it when necessary, is the outside lake, which holds 4,000,000 gallons of water and on which many fabled ships have sailed, beginning with those built years ago for* The Private Life of Helen of Troy *(1927) and* Isle of Lost Ships *(1929) including the days of the English and Spanish galleons of the Sixteenth century, built for Errol Flynn and company to use in* The Sea Hawk *(1940) and on to the modern tankers and freighters shown battling their way across the seas in* Action in the North Atlantic *(1943).*

On the subject of Warner Bros., the authors might mention a bit of sound effect you have undoubtedly heard: the "Wilhelm Scream"—yet another creative product from Burbank used in more than 360 film and television productions. It's the sound of a man, in this case Private Wilhelm from *The Charge at Feather River* (1953), being struck in the leg by an arrow. The scream was originally recorded for the 1951 Warner Bros. film *Distant Drums*, in which a man is depicted as being bitten by an alligator and dragged underwater. It's also been used for men falling off cliffs and being eaten by giant ants, so it's obviously an all-purpose distress cry. (YouTube has a good compilation of Wilhelm Screams.) When you hear it, you may think of singer Sheb "The Purple People Eater" Wooley, who is generally credited for voicing the scream. Or you may think of Burbank, where it was recorded!

Warner Bros.' Stage 21 in 1936; you can see the adjacent water tanks. *Mike McDaniel collection.*

ASHFELDT McCOY

What follows are some notes from Burbanker Marti Baldwin's mother, as told to her:

> *The first has to do with the Gregg Building which is located on the south east side of Olive Avenue. This probably took place in the mid to late 1920's or early 1930's but I am not sure. Apparently the man who owned the building did not like it when anyone parked their car on his property. He would be upset if even part of their car was over the property line and would go out and carefully pile rocks on the part of the car that was over the line.*
>
> *Another story had to do with the old John Muir building which was located across from Burbank High where the Office Depot is now. Apparently, also in the 1920s, on Halloween, some boys swiped someone's cow and somehow got it into the school and led the cow all the*

way upstairs to the cupola area at the top of the building where they left the poor thing tied up. They did not find it until the next morning when its frantic mooing caused someone to go look for the source of the sound.

My parents were married in 1937 and lived on Doan Drive. At that time, the street was not paved and there was a woman who was agitating for pavement. Her name was Mrs. McCoy and she said that she wanted the streets paved with "Ashfeldt." Consequently, they called her "Ashfeldt McCoy." Around this time, there was a huge rainstorm and the street got a large pothole in it which got larger by the day. The residents had complained about the pothole which had grown very large, and when it rained the hole filled with water so it could not be seen. The city's police car came down the street and almost disappeared in the water-filled hole. Shortly after that Mrs. McCoy got her wish and the street was paved.

BURBANK'S CHAMPION COWGIRL

Burbank once numbered among its citizens an internationally recognized champion trick rider and rodeo star, Bonnie Jean Gray. Born Verna Grace Smith in Kettle Falls, Washington, in 1891, she graduated from the University of Idaho at Moscow with a degree in music (she later did postgraduate work at the University of Chicago). While at the University of Idaho, she was the tri-state tennis champ. An accomplished pianist, Bonnie taught music for a short time. During World War I, she studied nursing at the U.S. Army's Camp Lewis in Montana. While the 1918 influenza pandemic raged, she nursed hundreds of Apache Indians as a Red Cross volunteer on the reservation at Fort Apache, Arizona. Bonnie grew up around horses and took up rodeo and trick riding. She told her disapproving parents, "If one loves a thing and does it well, why shouldn't she do it?" Tall and athletic in the saddle, astride her horse King Tut, her signature stunt in the 1920s and '30s was to jump her horse over an open car containing passengers; she was also one of the first women to ride bulls in Mexican bullfights and, in 1922, was claimed to be the first woman to perform an "under the belly crawl" on a horse.

Her 1930 Los Angeles wedding to Burbanker and fellow trick rider Donald W. Harris was unique, as it was held with all one hundred people in the wedding party mounted on horseback—even the minister. Afterward, she and King Tut leapt a car in which her new husband and bridesmaid were seated.

Celebrated rodeo trick rider Bonnie Gray and a bobcat. "Burbank, Cal" is painted on her tire cover. *Burbank Historical Society.*

Bonnie Gray was a star performer in the Elks Club rodeos held in the early 1930s on the Jeffries Ranch property on the corner of Victory Boulevard and Buena Vista Street. (James Jeffries was given a three-foot-diameter sombrero as a token of esteem for hosting the events.) She also performed in Mexico, Canada, the United Kingdom and Germany.

Bonnie Gray's later career included being a movie stuntwoman, doubling for such cowboy stars as Tim McCoy, Tom Mix, Hoot Gibson and Ken Maynard. She once earned $10,000 for a stunt involving jumping some brush and hurtling down a ten-foot cliff astride a horse; she fell backward, claiming afterward that she'd never do such a dangerous stunt again. Bonnie Gray's Burbank ranch was located where the David Starr Jordan Middle School is located now. In fact, if archaeologists ever dig up the playground, they'll find the eight horses, two mules and numerous dogs, cats and other pets she had buried there.

Gray died in Burbank in 1988, age ninety-seven. Her name and history are enshrined in the National Cowgirl Hall of Fame.

That cowgirl cleans up pretty well! Bonnie Gray, in a photo for her mother. *Ancestry.com*.

True Tales from Burbank

OUR GANG

In the 1970s and '80s, it was the bizarre practice of people (perhaps seeking notoriety of any kind) to claim that they, as children, were *Our Gang* (a.k.a. *Little Rascals*) stars. The easy dissemination of knowledge the Internet provides and the passing of time have largely put an end to this practice, but Burbank can claim one honest, bona fide Our Ganger: Douglas "Speck" Greer (also known as "Turkey Egg" due to his freckled face, which reminded *Our Gang* director Robert F. McGowan of the speckled eggs that turkeys lay). Greer appeared in seven *Our Gang* shorts, including one of the very best, "School's Out" (1930), in which pretty Miss Crabtree is introduced. His Burbank connection? "I was failing in school, but thanks to my homeroom teacher, Mrs. Dollar, at Burbank High School, I was able to graduate at age 21. I'll never be able to thank her enough for meeting with me every morning at 7:00 AM before classes to tutor me and help me to finally graduate in 1941. It was while attending high school that I studied aircraft sheet metal. This skill would help me later in life when I started my own company." (Greer's acting career—he worked alongside Mickey Rooney, Judy Garland and John Wayne—had caused academic problems for him.)

Douglas Greer went on to work for Lockheed for a time; he died at his home in Santa Cruz in 2016.

BIG GAME AND MUGS

Burbankers are used to coyotes roaming the hills, but when a young, seven-foot, 250-pound African lioness escaped from Gobel's Lion Farm in the Malibu hills and terrified residents from Calabasas to Santa Paula, it took the rifle of Burbanker Clifford Snyder to restore peace. The *Los Angeles Times* of April 5, 1930, recounts the drama that took place at 3:00 a.m., about four miles from town.

> Brought to bay by the hounds, the hungry lioness struck viciously at them when cornered in a small canyon. Eager to take their quarry alive, Snyder and [Martin] Longo made repeated efforts to catch it with a long iron rod equipped with a noose. With a swipe of its paw the beast knocked the rod from their hands and again attacked the dogs. Snyder fired a shot. The lion leaped clear of the dogs and scrambled up the canyon side. As it

Our Gang child actor Douglas "Turkey Egg" Greer as seen in "School's Out" (1930). When asked the name of Abraham Lincoln's wife, he snappily replied, "Mrs. Lincoln." *Cabin Fever Entertainment.*

Putting handles on the cups in the Empire China Shop, 1920s. *Burbank Historical Society.*

gained the top the hunter let go a volley which brought the beast to earth, fatally wounded.

The pelt is on exhibition at a service station on San Fernando Road near Orange Grove Avenue.

Martin Longo was an interesting character; he owned the gas station where the pelt was displayed. According to a July 1, 1931 *Times* article, he was threatened by a "big-jawed" racketeer who demanded he take down a sign advertising his gasoline prices (thirteen cents a gallon) or he'd be beaten up. An appeal to the Burbank police was unsatisfactory, as they stated that if the demand came from outside sources it was out of their jurisdiction. They recommended that Longo contact the sheriff. Longo, unimpressed, stated: "I come from a place where we beat each other up. I don't need a sheriff. The next guy who looks like a mug who shows up around my place and tells me how to run my business is going to be a candidate for one of these $20,000 caskets you read about in gangsters' funerals. After that, I'll leave it to the Sheriff to explain just how it happened."

Better take Longo at his word. He hunts lions.

THE GARLIC'S GOTTA GO

About the same time African big cats were prowling the Verdugo Hills, Burbank was suffering another blight: the all-pervasive scent of garlic. According to *Los Angeles Times* articles from late 1930 and early 1931, the California Vegetable Products Corporation ran a garlic dehydrating process in town that was causing a major nuisance; the garlic fumes reportedly permeated nearly every clothes closet of every home in town. (The smell also made its way into Glendale.) After "indignation meetings" were held, the company installed an apparatus to eradicate the fumes, but for some reason, it could not be made to work properly. The situation got so bad that company officials were hauled into court, fined and even threatened with jail sentences. In 1931, county health authorities ordered the dehydration plant to shut down until a stinkless way could be found to dehydrate garlic, but the California Vegetable Products Corporation eventually moved out of town.

In 1934, *Times* columnist Ed Ainsworth wrote about the incident.

Boom and Bust

When I came here five years ago on a hot afternoon you could smell garlic from where Union Air Terminal is now located to the Glendale line. One day three of us were standing on the front lawn at the high school. The other two were Jerry Ogborn, high school coach, and a visiting coach whose name I've forgotten. That was before I knew about the dehydrating plant. I looked suspiciously at Jerry and the other coach. The other coach looked suspiciously at Jerry and I. Jerry looked at both of us and grinned, so we both concluded that he had been raiding somebody's garlic patch. Then he explained. And, lest the Chamber of Commerce wring my neck let me hasten to add again that no longer does the odor pervade the atmosphere of our fair city.

The 1930s was an interesting time for produce in Burbank. In 1937, a *Los Angeles Times* article profiled E.A. Garard, a city street inspector who harvested fifteen to twenty pounds of mushrooms a day in an abandoned underground chamber on the corner of Scott Road and Andover Drive formerly used as a sewage pumping plant. (One wonders about working conditions.) His primary customers were the cafés serving the film studios. Make of that what you will.

The crew at the Burbank Lumber company, 36 North Olive Avenue, late 1930s. Some, you will notice, wear bow ties. Is that a Moreland truck? No, it's a Mack. *Burbank Historical Society*.

True Tales from Burbank

DEPRESSION-ERA WORKPLACE STRESS

The following story comes from George Monroe's *Burbank Community Book*:

> When the stock market collapsed on the New York Exchange on that fateful October day in 1929, Burbank folks knew not nor could they have dreamed what they were in for during the next series of years. For the time being the community pursued the even tenor of its way as though nothing unusual had taken place. As the months began to lengthen and things of an economic nature began to tighten, folks seeing their savings, what little they might have had, fading away with reduced, or no income on hand to replenish them, began to sit up and take notice. Reaching the point where the individuals were unable to meet the situation as individuals, the community as a whole became exercised. The City Council, under the pressure of distressed citizens, established an Employment Relief Department, placing it in charge of the late A.E. Keinath, who up to that time had been the city's Right-of-Way official. His duties were to list the unemployed on the one hand and the available jobs on the other, and try to bring the two together. However, those wanting and needing jobs increased in number while available jobs decreased in still greater proportions. It was a nerve-wracking job and his friends are inclined to think that the strain so undermined Mr. Keinath's health and contributed in a considerable degree to his subsequent death.
>
> A.W. Conrad was selected to fill the place made vacant by the death of Keinath. As the depression deepened the distress grew greater and the strenuosity of trying to connect the unemployed with employment likewise grew apace. In the course of time Mr. Conrad passed on, his death, his friends believed being at least partly due to the nervous strain which he had been under.
>
> The problem was then turned over to the Social Service Board with the late Maude King as the executive head. On the death of Mrs. King a year or two later the task of continuing the work devolved upon David Rittenhouse, at that time connected with the Social Service work. While Mr. Rittenhouse was still in charge the need of the work had so dwindled by 1944 that it became practically nil.

Thank goodness. We imagine that when word got out about that job it would be hard to fill.

It's worth mentioning that during the Great Depression a "Hooverville" (a shanty settlement inhabited by the poor) emerged in Burbank near the railroad tracks; service clubs and churches provided baskets of food to the economically distressed. Hard times, indeed.

GILMORE THE LION

One of the more colorful characters who made the Burbank Lockheed plant his home in the 1930s was Roscoe Turner, a barnstorming pilot and air racer. Turner flew a Lockheed Air Express plane and carried with him a lion cub named Gilmore (named after the oil company that sponsored Turner). The following tale is from the 1957 Lockheed publication *Of Men and Stars*:

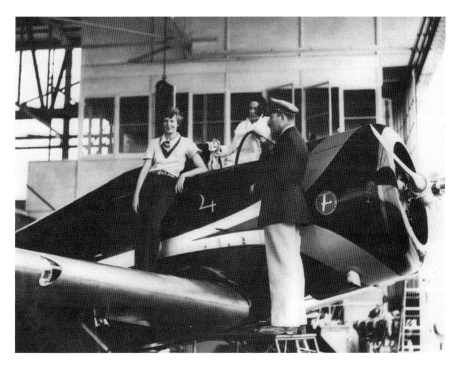

A trio of famous fliers of the 1930s at Lockheed: Amelia Earhart, Laura Ingalls and Roscoe Turner. The airplane is Laura Ingalls's. *Burbank Historical Society*.

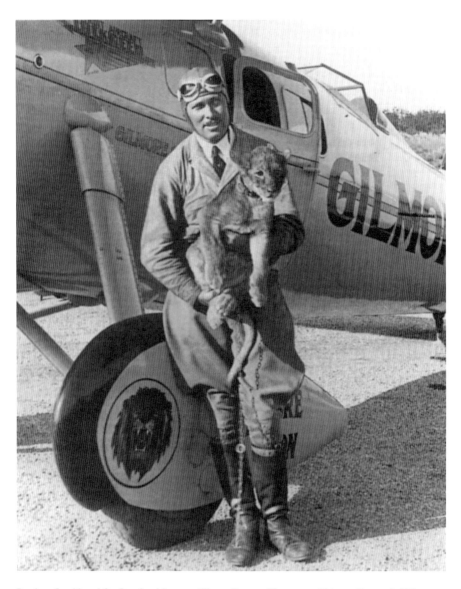

Look to Lockheed for Leadership—and lions. Roscoe Turner and his pet lion cub Gilmore. *Burbank Historical Society.*

Best known was Roscoe Turner's pet lion Gilmore, who as a cub nursed on milk warmed in a baby bottle on a small alcohol burner in [Carl] Squier's office. Turner allowed Gilmore to roam at large, but had to cage him after the lion good-humoredly chased Althea Story, now Mrs. Clarence L. Johnson, wife of Lockheed's present vice-president in charge of engineering and research, up the front staircase. The lady, then head accountant, won the race, but the experience left an indelible mark on her memory. Turner hangared his Air Express at Lockheed. Firman Gray, now California Division flight service shop superintendent, who joined the company in 1928 and first worked in the wood shop, constructed a box in the plane's cabin to house Gilmore while he and his master flew. Beneath the box was a trapdoor cut into the fuselage. Gilmore wore a parachute, and a cable from the trapdoor ran back to the control panel so that in an emergency both Turner and his pet could bail out. Fortunately no emergency ever arose. The thought of Gilmore parachuting gently onto the front lawn of a Burbank homestead is freighted with piquant overtones.

By 1935, Gilmore became too heavy and unmanageable and made no more flights with Turner.

THE TIME BURBANK'S CLOCKS BECAME OBSOLETE

This is an interesting fact from the 1967 Burbank Unified School District's *A History of Burbank*:

In spite of the depression, the Burbank City Council optimistically believed that the city would one day need more electricity than the Public Works Department could provide. In 1931, a contract was signed with the Bureau of Reclamation for 25 million kilowatt-hours per year of electricity from Hoover Dam. This electricity was on a take-or-pay basis because the city was using only 13 million kilowatt-hours per year at that time. Three years later, the entire city electrical system was changed from 50 cycles to 60 cycles. The change was necessary to use the power from Hoover Dam. A program to rewire or replace all the city's electrical motors, at a cost of about $150,000, was undertaken. The conversion was extended all the way down to electric clocks, and city workers went to homes to adjust higher priced clocks or simply to supply new clocks for lower-priced models.

United Airport, 1930. It looks primitive by today's standards, but consider: no long lines for security, no hijackers, no TSA inspections. *Burbank Historical Society.*

That's right: at the height of the Great Depression in 1934, Burbankers had to buy new electric clocks because of the power from Hoover Dam. (A fifty-cycle clock motor will run 20 percent faster on a sixty-cycle power supply.) The subject of changing power frequency from fifty cycles to sixty cycles was a big deal in Southern California at the time and was called "The Frequency Dispute." It didn't affect just clocks—it also affected the motors in washing machines and refrigerators. And the fifty-cycle power was delivered at 110 volts; the sixty-cycle power was delivered at 115 volts. This meant that light bulbs and the filaments on radio tubes burned out somewhat more rapidly. The change also affected power meters—the increased meter speed (until they could be adjusted) resulted in apparent rate jumps from 1 to 5 percent more. Edward C. Krauss wrote: "The cost of making the change will be heavy, and it will fall mainly on the taxpayers. The compensating advantages are very slight. In Pasadena, Glendale and Burbank, the public has not been informed whether the cost of changes will be borne by the city lighting departments or not."

Boom and Bust

THE BURBANK MILITARY ACADEMY

All that remains of the Burbank Military Academy, Burbank's one and only military school for youth ages six to sixteen, is the main building (repurposed into an apartment building) near the corner of Winona Avenue and Parish Place with "BMA" painted over the front door and two rather stunned-looking stone lions sitting on the ground on either side. The academy was founded in 1932, but by the time the mid-1940s rolled around, the building was in disuse and the grounds home to rusting Model A car bodies and incinerator doors, according to Burbanker Dan Waite. The 1936 edition of the *Buzzer*, the academy yearbook, tells of thirteen-year-old Theron Cummins's introduction to the school:

> *On March 15, I entered the Burbank Military Academy. It was around 5:00 P.M. At that time Cadet May was orderly. He was the first one I met. I had to laugh when I asked for Brown, because May at the time was putting on his best manners. Well, I got Brown, all right. He was out tree-climbing when I met him and I have to give him credit for being the highest in the tree....Well, we quit tree-climbing and went to bed....I met a lot of other boys, too. I got along about the way I told you, so I won't waste any more paper. But I'm getting along swell up to now.*

En garde! The Burbank Military Academy cadets demonstrate their fencing form. The Buzzer/*Lyla El-Safy*.

The Burbank Military Academy building today. All that's left is the "BMA" and the lions. *Mike McDaniel.*

Life at the BMA wasn't all tree-climbing, however. The *Buzzer* describes the academic life that started with a bugle call and mops flying as cadets made the floors spic and span before the morning inspection, when they were required to stand at attention near their bunks. Then calisthenics, breakfast, classes, lunch (but not before a hands and hair inspection), a baseball game, more classes and drill. Weekly horse riding and fencing were also scheduled for the boys. The cadets were given free time until retreat, which consisted of a flag-lowering and a march into the mess hall for the evening meal. After that, it was time for football for the older boys. Some boys took dancing classes, which included tap and ballroom dancing. (Were nearby Burbank girls drafted for this duty?) Time for study hall was allowed, and then, just after 8:00 p.m., the boys were marched off to clean their teeth. The lights were turned out as "Taps" was blown. Evening guard was posted. One eleven-year-old lad wrote, "I had the patrol from 10 P.M. to midnight….Some cadet officers would sneak up and let go with their B-B guns. I got about twelve in the place where you usually sit down."

The *Buzzer* contains photos of the boys, who look very military and snappy in uniforms with hats, ties, thick black waist belts, capes and Sam Browne belts. Some wear medals. It was all very martial while it lasted. All that is left now is the "BMA" painted over the door and the stunned lions.

DAVID BURBANK, NOT LUTHER BURBANK. DAVID.

One of the *Los Angeles Times*' pet projects has been to educate Burbankers and Los Angelinos that the city of Burbank was not named for plant wizard Luther Burbank but, rather, Dr. David Burbank, a dentist. The paper ran pieces emphasizing this in 1911, 1927, 1934, 1936, 1938, 1942, 1944, 1964, 1967, 1968, 1969, 1972, 1977 and 1979. Johnny Carson even mentioned it in a *Tonight Show* monologue. The result? In 2014, the History Channel—the *History* Channel—asserted in a documentary that the city was named for…Luther Burbank.

Observe the weariness that *Times* columnist James H. Dooley displayed in 1936: "…let us haste to repeat something we mentioned in this column once before: Burbank is NOT named for Luther Burbank, the plant wizard. We grow weary of telling strangers that the famous horticulturist's gardens are not here…the town was named for Dr. David Burbank, an early settler who owned most of the old Rancho Providencia, on which the city was built." In 1967, an even more weary *Times* columnist, Paul Coates, made a good point: "People who name their town after a dentist don't exhibit a whole hell of a lot of imagination." Of course, the city fathers didn't help things by naming a school after Luther Burbank, thereby reinforcing the mistaken identity.

We guess that this Luther/David misapprehension is far from put to rest. But we've tried—we've all tried.

(By the way, there *is* a Burbank, California, named for the plant wizard. It's a census-

An oil-painted image of Dr. David Burbank on his wedding day. Not to be confused with you-know-who. *Burbank Historical Society.*

designated place in Santa Clara County, surrounded by San Jose, 296 miles northwest of the—ahem—*real* Burbank. Its population was 4,926 in 2010 and it, too, has an Olive Avenue.)

IN BURBANK, EVEN THE PLUMBERS LOOK LIKE MOVIE STARS

Burbanker Pam Zipfel Kirkwood tells this tale about her father, Rowen Zipfel:

My father went to Burroughs when it was a junior high school and graduated from Burbank High in the winter of 1936. At the time he owned a horse, a black gelding named Ace. The family had moved to the area that was known as Roscoe (modern Sun Valley) at the time, by the railroad tracks on San Fernando Boulevard. The property had just enough room to have a corral and there was also a shed where he could keep Ace. At that time the Verdugo Hills in Burbank were mostly vineyards and wide open spaces, offering plenty of room for Dad to ride his horse. The little white Cabrini Chapel was in the hills where he rode. I vaguely remember him talking about Ace frequently escaping the corral—Dad would have to chase him down. He was a high spirited horse, but my dad could handle him and Ace respected that.

Someone who knew my father had connections with the movie studios, and, noting Dad's obvious good looks, encouraged him to get into the "biz." That's why the publicity photo was taken. I don't recall hearing that he continued to pursue that avenue much. He went to work for Story Plumbing in Burbank and eventually became a journeyman plumber and proud Union man (Local 761), spending most of his forty-plus year plumbing career with Willam A. Peet and Son Plumbing in North Hollywood.

Dad had Ace for many years, boarding him out in the valley at a friend's property and finally up at my uncle's house in Sylmar. Eventually, Ace got old and Dad was afraid he might pass away in the corral. He loved that horse so much and wanted to do right by him, so he loaded Ace into the trailer for that last trip and had him put down. I think it broke his heart. He never got another horse, but he talked about Ace for the rest of his life.

Right: Rowen Zipfel, the horse-riding plumber who looked like a movie star. *Pam Zipfel Kirkwood*.

Below: Filming a Western movie at the Burbank Depot, 1921. Cowboys prepare to pull a wedding carriage. The sign gives the mileage to San Francisco and New Orleans. *Mike McDaniel collection*.

MORE EVIDENCE THAT HOLLYWOOD IS REALLY IN BURBANK

When we think of the opulence of classic Hollywood filmmaking, we think of elaborate sets, incredible costumes and amazing jewelry. Of course, the sets almost always have false fronts, the costumes may look a little shopworn in person and the jewelry is fake—but it's the overall cinematic impression that counts. A lot of that fabulous jewelry—a museum's worth, in fact—can be found in an innocuous industrial warehouse at 129 East Providencia Avenue in Burbank. This is Joseff of Hollywood, Costume Jeweler to the Stars. (A small sign on the side is the only identification.) The firm has been in Burbank since 1938.

What sort of things are here? The fake topaz necklace worn by Ona Munson in *The Shanghai Gesture* (1941), the snake bracelets worn by Rita Hayworth in 1947's *Down to Earth* (the old Burbank train depot can be seen in the background of one sequence in this film, by the way), the leaf brooch worn by Jean Harlow in *Libeled Lady* (1936), the bird bracelets worn in *Desert Hawk* (1944), Elizabeth Taylor's fabulous serpent belt from *Cleopatra* (1963), items Lucille Ball wore in *I Love Lucy* (1951–57), Marilyn Monroe's pearl earrings from *Gentlemen Prefer Blondes* (1953), Vivien Leigh's necklace from *Gone with the Wind* (1939), Judy Garland's necklace from *Ziegfeld Follies* (1945), the faux pearl necklace worn by Bette Davis and a single pearl drop earring for Errol Flynn in *The Private Lives of Elizabeth and Essex* (1939), Grace Kelly's chandelier earrings from *High Society* (1956), an arrow-shaped brooch for Katharine Hepburn in *The Sea of Grass* (1947), a jeweled suit of armor for *The Jungle Book* (1942) and, most regal of all, Ronald Colman's crown and scepter from *The Prisoner of Zenda* (1937) and Shirley Temple's tiara from *The Little Princess* (1939). Tina Joseff, the daughter-in-law of company founder Eugene Joseff (1905–1948), now runs the business, which still makes custom jewelry for the studios.

All that incredible film history, stored in countless cigar boxes in a little building in Burbank. Who knew?

THE MARCH 1938 FLOODS

As the pop song has it, it never rains in Southern California. But when it pours, man, it pours. George Monroe, in *Burbank Community Book*, describes the aftermath of the March 1938 floods and includes a thrilling story.

Boom and Bust

The Burbank deaths were few in number, but the property damage was considerable. Many of the residents of Sunset Canyon were marooned in their homes with boulders, sand and debris filling the roadway. Water mains were washed out and the marooned had to depend on the rain for drinking water. Two hundred employees at Warner Brothers, unable to get home on account of the washed out bridges, turned one of the big stages into a hotel and spent the night there, putting on an improvised entertainment to while away the time.

Glen M. Odens, prominent Burbank business man, who was given up as lost for twenty four hours, finally turned up with one of the most thrilling stories coming out of the flood. Responding to an S.O.S. call from friends who were marooned on an island in the Tujunga wash at the junction of Strathern Avenue and Laurel Canyon Drive, he waded across one of the channels. When he attempted to return he found the channel too much swollen to risk crossing. A friend, Bob Williams, of Roscoe, in attempting to throw Odens a rope fell in the stream and was washed so far down stream that he could not get back, and came near losing his life.

Odens found himself and twelve other persons, mostly women and children, including a baby, on an island rapidly diminishing in size with waters raging on all sides. As the waters got higher and higher the refugees sought refuge in one of the houses and as the waters kept rising they sought safety on the roof. The house was struck by another house floating down the stream and the entire thirteen were precipitated into the raging stream. Only four of the party were ever heard of again. Odens and one of the others succeeded in climbing on a pedestal upon which one of the big steel

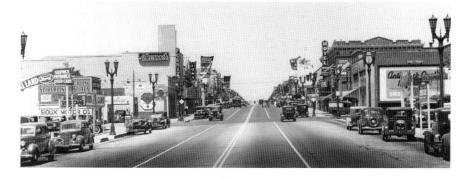

San Fernando Boulevard and Verdugo Avenue, 1936. Norwood's Furniture and the Loma Theater can be seen at left; the Savoy Hotel, when it was respectable, is seen at right. *Burbank Historical Society.*

power towers was resting. They remained on this until it began to crumble and the falling high power electric wires began to sizzle dangerously around them. Having no other choice they both ventured into the stream, hoping against hope that they could make their way to the opposite shore. The next morning Odens was found in a semi-conscious condition on the bank some distance below. The other three men saved passed through very much the same experience.

A SHORT HISTORY OF THE MORMON CHURCH BUILDING IN BURBANK

The 19,063-square-foot building formerly known as the Sunset Canyon Country Club (SCCC) from 1926 to 1939 is located on 3.9 acres of land at 136 North Sunset Canyon Drive; the architect was Mott H. Marston. Built in 1926 as a new clubhouse for the country club's nine-hole course, it became the main clubhouse in 1927 after a fire badly damaged the smaller clubhouse located farther up the canyon. The building is a five-story Spanish-style structure with two stories below ground and three above, including a bell tower. (The old bell is now in the possession of David F. King, son of former Burbank mayor Carl King, in a structure in Nauvoo, Illinois.)

One feature included in the building was a wine cellar, which wasn't unusual, except that it was built during Prohibition. A golf caddie who once worked there reported that there were wild parties in the new building; it wasn't uncommon for women to get tipsy and dance topless. It was a known speakeasy in those days. A tunnel system near the wine cellar was used as an escape route during raids. The tunnel emerged in the hills.

The club owned 2,500 acres of the mountains that were annexed by Burbank on January 1, 1926, from the County of Los Angeles. In 1928, the country club suffered a setback: a horrendous fire engulfed the Verdugo Mountains and left the hills above the golf course barren of vegetation. When the heavy rains came in 1928, they washed large amounts of mud down from the mountains, covering the course and going as far as San Fernando Boulevard. The SCCC used its reserve capital to remove the mud and fix the course; a year later, the stock market crashed. The club began suffering from loss of membership and tried to raise operating capital from its existing members, to no avail. The club folded, and the City of Burbank

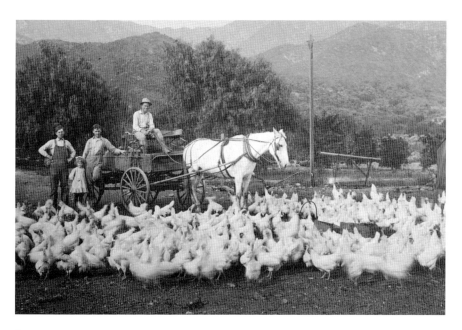

The Forsyth family poses with the chickens on their farm at Ninth Street and Magnolia Boulevard, 1903. *Burbank Historical Society.*

took over operation of the golf course in 1930. The city operated it until 1935—that year showed a $5 profit.

Shortly after 1935, the golf course and clubhouse were left vacant. The building was vandalized and had everything of use removed from the structure by people in need of such items as the Depression worsened. Eventually, homeless people began living there. In June 1939, Howard Tolman, a Burbank fireman assigned to fire prevention, was asked to inspect the building as a fire hazard. As he walked through the building, he felt that it had potential, even though it had been vandalized to a great extent. He proposed to the local Latter-day Saints (Mormon) bishop (pastor) that it would be a good meetinghouse. The church was currently meeting in the Burbank Women's Club on Olive Avenue.

At the time, several members of the local leadership thought it would be sacrilegious to hold services in the building. But the leadership decided to buy it; they asked church headquarters in Salt Lake City to inspect it and give its approval. The local leadership had a fourteen-day option to purchase the building. In the meantime, Warner Bros. decided it wanted it for an employee golf course. The church had not responded to the fourteen-day option and had only three days left. The leadership called and explained

the time problem; the church flew a man down to inspect the building. After walking through it, he flew back to Salt Lake City. With only a precious few hours left, the church wired funds in the amount of $15,000.

Shortly after the building was bought, local members began cleaning, repairing and remodeling it. In September 1939, the members took out their first permit to remodel the large lounge of the dance hall into a chapel for their meetings. Since then, the church has remodeled several areas in the building to meet its needs over the years until, in January 1985, it began a total renovation of the structure to modern standards. In 1986, services commenced again.

To this day, it is the only Mormon church with a full wine cellar—unused!

3
WORLD WAR II

The decades of the 1920s and '30s, with the arrival of Lockheed and Warner Brothers, put Burbank on the map. But it was during the period 1940–45 that Burbank became important for the survival of the nation via the aircraft Lockheed built for the war effort. Naturally, this had local impact as Lockheed's wartime peak employment of ninety-four thousand workers was reached. A 1954 publication by the Magnolia Park Chamber of Commerce described some of the changes:

> *To build these and thousands of other planes, factories were pushed out in all directions…into every available building and upstairs loft in Burbank…across the valley into Van Nuys…down into Los Angeles and Maywood…up the coast to Santa Barbara…and even into distant Texas, England, Scotland and Northern Ireland! Streets were dead-ended. Building zone restrictions were changed. Runways stretched out for larger, heavier and faster planes. Canyon drainage patterns were shifted. Dusty lanes were turned into wide boulevards crowded with interurban buses and cars jammed with aircraft workers. Underpasses were built. "Swing" and "graveyard" shifts kept Lockheed's factories running around the clock.… Seemingly overnight the entire San Fernando Valley changed from a farming dale into a bustling factory center…experiencing an industrial revolution of national defense and war production!*

These were the war years in Burbank.

Lockheed pride was evidenced by this World War II–era lunchbox with the P-38 Lighting decal. *Mike McDaniel collection.*

BUT HOW DID HE ?

The new decade was opened at the Pickwick Stables in Burbank when, in January 1940, celebrated singing cowboy and rodeo star Elmer Schumann set a world record by spending a total of two weeks in the saddle, twenty-four hours a day. He required a new mount every three hours. The *Los Angeles Times* made no mention of how he accomplished…well, you know… basic bodily needs.

THE VEGA VURBANK

From *Of Men and Stars*, a 1957 history by the Lockheed Aircraft Corporation, comes this anecdote from February 1940:

World War II

In keeping with the pattern set with the Lockheed Lightning, the British wanted an alliterative name for its Vega bomber. Courtlandt Gross suggested among others Volcano, Velociter, Vauxhall, Vindictive, Vermont, Ventura, Ventnor, Viceroy and even Vulpecula—a constellation meaning in English "The Little Fox." To his brother Robert he also suggested Vopocatepetl, Venividivici, Veribest and—brace yourself—Vurbank. "How's that for a list of beauts?" Courtlandt inquired.

The name selected was Vega Ventura, which could be translated roughly to mean "lucky star."

BURBANK PREPARES FOR AIR RAIDS

George Lynn Monroe, in his *Burbank Community Book*, describes the nervous situation that existed along the California coast after the Pearl Harbor bombing and the measures taken for defense:

The "blackout" was the first protective measure to be put into effect, the theory being that the usually brilliantly lighted cities up and down the coast would be easy marks for enemy planes, ships or submarines. The first blackouts caught the automobilists napping, with the result that numerous accidents—some fatal—took place. Then came the organization of the community into protective units to take care of anything that might happen in the realm of catastrophe. The city was mapped out into sections and blocks, with an air warden appointed to each block, whose business it was to take charge of affairs for his respective block at any time there were warnings of possible danger. One corner of the basement in the then uncompleted new City Hall at the corner of Olive and Third Street, was fitted up as air-raid headquarters. The quarters were made as light and bomb-tight as possible. A large battery of telephones were put in and a special group of citizens selected to man the headquarters, with certain ones to look after certain phases of the setup.

Sirens of considerable weird and shrieking capacity were established at strategic points throughout the city to arouse the populace when danger appeared. The Red Cross, which had already been functioning in a general way, increased its activities until today it is one of the most active chapters in the locality. It wasn't long until the womenfolk had a strenuously wide-awake Ambulance Corps operating in full force, while the menfolk were

Yet more Lockheed pride was displayed by wearing one of these "Roomy Richard" work uniforms from Maxwell's. Pipe optional, July 1941. Mike McDaniel collection.

rapidly whipping a company of home guards into functioning status. Buckets of sand with shovels nearby began to appear in the business houses along the boulevard, and some of the homes, as a protection against fire bombs. Special fire-fighting apparatus procured from the government appeared on the scene with a collection of gas masks for those who operated them. Occasional rehearsals were indulged in by combinations of all groups to get their brains and hands in working order to meet whatever the enemy might have up its sleeve for the community.

The city painted the top of its street lights black and cut down the extent of the lights so as to protect the city from enemy bombers in the skies. The war plants throughout the city were blacked out and otherwise camouflaged by one of the most elaborate systems of camouflage, in all probability, ever attempted any place. It was understood that considerably more than a million dollars were spent in this way by the government.

Likewise an equally elaborate system of smoke-screen apparatus was installed, surrounding the war plants. This consisted of smoke producing and heating apparatus of the orchard heating type, connected with drums of oil particularly developed for its smoke-making proclivities. An army of soldiers trained in their use were stationed in the community to man them. Additional contingents of soldiers were stationed in the community to be ready to handle anything that might happen in the catastrophic line. Search-lights and anti-aircraft equipment were stationed at strategic positions through-out the city and surrounding hills. Miles and miles of substantial concrete air-raid shelters were constructed in the vicinity of the most important war plants, enough to have provided shelter for the thousands upon thousands of workers in the plants.

World War II

General George Patton makes a speech at the City Hall, June 10, 1945. Based on the expressions on some of the officials, the general's last comment was either funny or vulgar. General Jimmy Doolittle stands in back. *Les Rosenthal/Burbank Historical Society.*

> *However, it was only on a comparatively few occasions when the situation reached the need of air-raid alarms, and these only when suspicious planes flying overhead were detected. These usually turned out to be friendly. It gradually became evident that the enemy was having enough troubles nearer home to concern itself with those as far away as Burbank, and the tension gradually weakened until the danger was hardly given a second thought. Burbank folks were proud of the precautions they had taken, even if they had proven not to have been needed. Proud on the theory that it was better to have them and not need them than to have needed and not had them.*

TRUE TALES FROM BURBANK

THE OLD TRAPPER'S LODGE

While the location of the celebrated Old Trapper's Lodge is, in fact, a third of a mile past the Burbank boundary and technically in Sun Valley, it was a spot Burbankers liked to visit, and so it can be covered in this book. Besides, as Mike McDaniel observed, "Is anyone really going to write a book about Sun Valley?"

The Old Trapper was John Henry Ehn (1897–1981), and yes, he was in fact an animal trapper, working in his youth in the wilds of Michigan but ranging far afield to Mexico and Canada. He once maintained correspondence courses on how to trap animals. Ehn moved his family west and, in 1941, established the low-income rental units that bore his name. What everyone remembers about this place were the colossal, occasionally lurid, folk art statues that graced the front yard, along with the Boot Hill tombstones and the Western bric-a-brac strewn about.

Note that we describe the Old Trapper's Lodge as "low-income." In fact, the place looked so unpromising that few in Burbank knew of anyone who actually ever stayed there. The brother of one friend, however, once booked a room for his well-to-do in-laws there as an evil joke. (The father-in-law was the lead counsel for the New York Stock Exchange and, later, had his own tax law practice with Fortune 500 company clients.) Dad and Mom flew out to

John Henry "Old Trapper" Ehn and his wife, Mary. *Burbank Historical Society.*

Right: "The fight between Pegleg Smith and Big Bear, Mighty Americans, sculpted by Old Trapper." *Wes Clark*.

Below: The second annual Parks and Rec "6-16" airplane model building contest entries are examined by the judges at the Olive Rec Center, June 25, 1944. "6-16" refers to the age group of entrants. The cowboy is Duff Dean from the Lord Manufacturing Company—not some Western star. *Michael McDaniel collection*.

visit the kids after instructing the son-in-law to make arrangements for them to stay at the finest hotel in town, preferably one close to the airport—the Old Trapper's Lodge was indeed close to the airport. At the end of the runway, in fact. Needless to say, when the Old Trapper's Lodge hove into view, the in-laws immediately directed the cabbie to drive them elsewhere.

The Old Trapper's Lodge is gone now. In fact, the Keswick Street location has been eliminated to make way for a business serving the airport. We are happy to report, however, that the statues and the Boot Hill items have all been moved to the campus of Pierce College in Woodland Hills, where they may still be viewed by the curious and fans of folk art. Your authors spent a pleasant hour there once.

I WAS A G.I. FOR HALLOWEEN!

A story by Eldridge Ballew Keller via the *Senior Bulldogs Newsletter*:

We lived on Myers Street, a few blocks from the railroad and Lockheed. My dad started his second career at Lockheed, and spent 20 years working there. Before the war started, he could walk to work, crossing the railroad tracks. Lockheed was camouflaged as a grape vineyard, the San Val outdoor theater was also camouflaged, but I don't remember what it was supposed to be. We had soldiers and anti-aircraft guns in various streets in our area. The soldiers weren't much older than we kids were, and at Halloween they went trick or treating with us. Can you believe that would happen in these days? My dad was a block warden, going street to street to be sure all of the windows of the houses had no light showing through.

RESCUE FROM A WELL

The following tale comes from Burbanker Darryl Eisele:

In early 1941, my parents moved from a little house on Grismer Street to a brand new house "way out in the valley" on the still-unpaved Keystone Street just off Burbank Boulevard. There were few buildings on Burbank Boulevard, and the lot between Keystone Street and Lamer Street was deep

with weeds when they moved in on April 5, 1941. It was only a couple of weeks later when my sister Marilyn (she had just turned six) fell down an abandoned well in that lot to a depth of about 20 feet, near the corner under what now is Chili John's. The fire trucks had to come from Third Street and Olive Avenue, and, when they got there, their ladders were too wide to fit down the well. My dad saved the day by tying a loop in a long rope and bringing her up.

LIFE NEAR THE RAILROAD TRACKS IN 1940s BURBANK

The following account is by Burbanker Dwain Ray:

I was born in the Burbank Hospital in 1938 and lived from 1940 to 1958 on Lamer Street across from Monterey Avenue School. My father was a Burbank fireman. Many family members worked at Lockheed. My dad's family came originally from Levan, Utah, but we were the non-Mormon branch of the family. However, a Mormon minister gave a nice funeral service for my grandfather when he died. He was eulogized as a Burbank pioneer. He owned a couple of local businesses. First the ice business and then, when electric appliances began to take over, an appliance store on San Fernando Boulevard.

My dad built all the houses and apartments on the four lots (1333, 1337, 1341, 1345 Lamer) at the end of Lamer Street where it meets Pacific Avenue. In World War II we had a still-vacant lot on the corner, so the government induced us to allow a good-sized anti-aircraft gun bunker on the property. Soldiers staffed it each day and put up with constant visits from my sister and me. My dad built the houses and apartments with his own hands on his off hours. Seven housing units in all. Complete sweat equity.

We had a view of the Lockheed plant in the background and the railroad tracks and the Burbank wash and the big parking lot (which is now filled in with homes). I will not think of living near any railroads. I remember my youth in the corner house when the night and early morning trains used to shake the house and sounded as though they were going through our living room!

I went to Thomas A. Edison grammar school because Monterey was not yet built. But I went to Monterey one year in an old house which was on the property acquired by the school district.

Burbank's first organized softball league, 1944–45. Some of the T-shirts read "LA Examiner Carrier Softball League." A couple of macho lads are shirtless. *Burbank Historical Society.*

In the summer time in the old neighborhood, everything revolved around Vickroy Park. It was the center of the universe in the Forties. Originally, the park had lots of bushes and old fashioned picnic facilities and stone structures. Then it was changed a lot in later years. We had great times in the park: band concerts, family picnics, ball games, pet shows, crafts, tether ball. I remember the old drug store and Spector's market. Ralph's at the corner of Buena Vista Street and Victory Boulevard came in where Jeffries' Barn used to be. My father was an amateur boxer and I saw him box at Jeffries Barn (owned by the late champion boxer Jim Jeffries).

In the summer time, my friends and I used to walk to Spector's and buy soda pop or Popsicles. On several occasions, I walked barefooted in the Burbank wash all the way to Glendale. I had plenty of time. I knew the wash like the back of my hand. I went up the small offshoot tunnels that came out in drains on the other side of Lockheed over by Empire Avenue. I had a special hiding place down under the tracks on the Empire Avenue railroad bridge.

I met and talked with lots of hoboes in the open space past the Empire Avenue railroad bridge. In the Forties there were lots of people travelling the boxcars as a kind of leftover effect of the depression. Hoboes used to come by the house and ask for work in exchange for food. We never feared them. Our home had no locks on the windows and we had no key for the doors. I don't even recall locking the doors when we went on vacation to the state

World War II

Seaman Third Class Herman H. Hetzel, U.S. Navy. Born in 1922 and a Burbank High graduate, he enlisted in 1942. He served aboard the USS *Liscome Bay* as the officers' cook. The ship was torpedoed in the Battle of Tarawa on November 24, 1943; Hetzel's body was never found. *Mike McDaniel collection.*

parks. We were never robbed. Both of my parents are buried at Valhalla, too. Isn't it surreal to attend a funeral and see and hear the jets taking off in the background? My grandparents are buried in Valhalla. When I was a boy, that beautiful cemetery was completely in the country surrounded by a farm and a dairy. I used to catch crawfish in the lily ponds. My dad picked up loads of cow manure at the dairy to make our new grass grow on Lamer Street.

My dad speculated in real estate. He owned a lot uptown with an old house on it and was sitting on it expecting to make money when the town mall project came into fruition. The town elected to take his property over at a low price and he was quite mad. Especially when that property became part of the current high-rise Holiday Inn.

In 1958 we moved up to San Jose Avenue below Kenneth Road. Today our old house is gone. There is a large condominium in its place. I actually thought I lived in the country when I was a boy. We, the Lamer Street Rays, had 300 chickens and a mean German Shepherd. We also had lots of surplus airplane engine boxes (used for building materials) and a victory garden. Lamer Street and Pacific Avenue were dirt roads for a long time.

True Tales from Burbank

ELMER FUDD ON STRETCHERS

Joseph Brown shares these vivid memories of living in Burbank as a boy during World War II:

My family moved to Burbank from La Crescenta, just "over the hill" in early 1942 when my father, a technical writer at Vega Aircraft (later merged with Lockheed) couldn't get enough gasoline due to World War II rationing to make the daily commute. We bought a small three-bedroom tract house at 1630 North Fairview Street for only $5,000, which wouldn't buy its garage today. The war clouds which had gathered when we lived in La Crescenta (I recall Pearl Harbor day there) had now burst wide open. Hitler was gobbling up Europe; Japan was bloodily solidifying its grip on half the Pacific, and Burbank was on a wartime footing. Batteries of anti-aircraft guns now ringed the Lockheed plant a mile from our house and blackouts were an occasional fact of life.

One night in 1942, in fact, those AA guns erupted in anger as searchlights pierced the sky. Turned out a flight of U.S. Navy planes flying at high altitude had lost radio contact with the ground. Fortunately no one was hurt before the error was discovered.

Our neighbors on Fairview Street were on a wartime footing, too. We appointed an air raid warden, rigged our homes for blackouts, and set up local first aid stations "just in case." To test the stretchers we hoped we'd never have to use, Arthur Q. Bryan, a neighbor whose career was the voice of Elmer Fudd in Hollywood cartoons, volunteered. When Bryan's 300-plus pounds didn't burst the stretchers, we knew we had made them well.

After elementary school, I enrolled at John Burroughs Junior High (later upgraded to a high school.) I walked to school each day, an exercise I didn't mind because my route took me past the back lot of the Warner Brothers movie studios. Many a day I was late getting home, preferring instead to crawl under the studio fence and live out daydreams on movie sets there. While Americans were fighting real battles overseas, I fought my own on one elaborate jungle set made up to duplicate a Pacific island battlefront. My favorite, though, was to stand at the helm of a pirate ship left over from Warner's epics of the Thirties. Errol Flynn was no better a swashbuckling captain than I was.

To augment my family allowance, I delivered the local newspaper, the Burbank Daily Review, *and mowed lawns on Saturday mornings. How well I remember the banner headline in the* Review *toward the end of my paper carrier career: "FDR Dies."*

World War II

IT'S A FACT: SUN VALLEY IS COOLER THAN BURBANK

Also from the *Burbank Community Book* comes the following tidbit:

> *According to Fred Jacobsen, Roscoe's wideawake Postmaster, Roscoe is the coolest place on a hot day in San Fernando Valley. This, with him is not hearsay or guess-so, but a scientifically demonstrated fact. To satisfy his own curiosity, and as a basis to back up his belief on the subject, Mr. Jacobsen on an unusually hot day secured a number of thermometers of identical make and type and had his collaborators to register the temperature in all sections of the valley—Burbank, Orange Cove (out Sunland way), North Hollywood, Van Nuys and Canoga Park. The thermometers were placed five feet above ground and other precautions taken so as nearly as possible to duplicate the circumstances in each locality, with the recordings taken at the same time in the day. The verdict gave Roscoe—at San Fernando and Sunland boulevards—the best of it by four degrees. That is, it was four degrees cooler in Roscoe than at any other point in the valley where the tests were made. Mr. Jacobsen attributes this to that ocean breeze which comes through Cahuenga Pass and finds its way through the Roscoe district.*

That settles *that*.

THE RISE OF WOMEN IN THE WORKPLACE

George Lynn Monroe, in his *Burbank Community Book*, describes how Rosie the Riveter came about. As always, necessity became the mother of invention—and aircraft. The last sentence is prophetic.

> *It began to be noised about, mostly from governmental production circles, that some of the industrial institutions in the east were meeting the situation by recruiting workers from the women contingent. It was noted that in Detroit automobile manufacturing circles women in increasing numbers were being put on jobs which theretofore were considered exclusively men's work. Furthermore, they were surprisingly good at it.*
>
> *The company decided to give it a trial, and began to round up recruits by the thousands among the womenfolk. At first the women were rather shy in adventuring into what had been taken for granted as masculinity's*

Above: The Still Electric Shop team: Champions of the 1943 girls' softball league. *Burbank Historical Society*.

Left: A human-interest piece that ran in the *Lockheed-Vega Star* on October 24, 1941. Earl Wallace is the short fellow, Gordon Morrison is the tall one. Both are from Oklahoma. *Mike McDaniel collection*.

sphere.....At the time of this writing it was estimated that approximately forty-seven per cent of the aviation workers, in the local airplane industry, were women. It was not expected from the beginning that the women would in short order attain the production capacity, person for person, as the men who had been engaged in this kind of work for a long time. However, as far as helping the war effort through an acute emergency the women have given an excellent account of themselves. Generally speaking the industry itself looks upon the employment of women in large numbers in what has usually been looked upon as man's job, only to meet the war emergency. At the end of the war the supposition is that the women will be allowed to return to their homes, as there will no doubt be plenty of men to fill the jobs as the country and the world gets back into what are considered as normal times.

While some of the women will probably like to continue on these jobs, it is thought that most of them will be glad of the opportunity to go back to the one job of keeping the household functioning properly, rather than permanently trying to fill two jobs at the same time—the woman's work of keeping house and the man's job of keeping industry functioning properly.

There are those who predict that the adventure which women have taken into man's domain, is going to require a new economic setup in some respects, to, in some way, offset the effects of that extra check which, by reason of the war emergency, has been added to the family income.

A WARTIME ENCOUNTER!

Joanne Sears Lewis, in the April 2007 *Senior Bulldogs News*, writes:

I remember the camouflage nets over Lockheed during World War II! I also remember the troops in camouflage who used to do their training in the old, overgrown grape vineyards that was then called the Ben Mar Hills tract along Walnut Avenue. Sometimes, not often, these soldiers came up the alley between Fairmount Road and Walnut in full camouflage, carrying guns and wearing helmets.

In those days before smog rules and recycling, we were still burning our trash in backyard incinerators. I was out one morning stuffing the concrete stove full of our trash. Suddenly I looked up, and there was a soldier—he was probably all of eighteen—all suited up and armed, walking by our back fence. My eyes popped. Our chickens clucked and flew up onto their

roost, and our ducks tried to stuff themselves into the corner of the chicken wire pen. The soldier, just as startled and embarrassed as I, lowered his eyes and slid by as softly and swiftly as he could. I stood frozen for a full two minutes before stuffing in the last of the meat wrappers and milk cartons, and putting a match to the lot.

I wasn't scared, just proud of these guys and curious about their lives in the barracks on Glenoaks Boulevard.

WALT DISNEY'S WARTIME ACTIVITIES

In *Burbank Community Book*, George Lynn Monroe describes how a cartoon and animated feature-film studio turned its talents to wartime needs.

Walt Disney, pappy of Mickey Mouse, Donald Duck, Jose Carioca, Dumbo and an assorted collection of characters who cavort across the motion picture screens of the world, took on a part-time job before the war which has become an industry all its own. It recently turned out its 1600th job and was still going strong at the time of this writing. The new "industry" was strictly non-profit, patriotic and a help to the morale of our armed forces.

It was the art of creating insignias gratis for the armed services of the United States. Many famous fighting units, on land, sea and in the air, went into action daily with these Disney characters as mascots. The first insignia created by Disney in 1939 ended its tour of duty when the aircraft carrier Wasp went down fighting. It was designed for the "Fighting Seven" Naval Air Squadron. The 1000th insignia, which was created for a United States Field Hospital unit somewhere in the European Theater of operations, consisted of Donald Duck as a medical corpsman carrying a bottle of blood plasma on his rifle. The Fighting French, Dutch, Chinese, British, Russian, Brazilian, Norwegian, and other units, as well as our own, of the Allied Nations have seen battle with Mickey Mouse, Donald Duck, Goofy, Pluto and other Disney characters and animals painted on their ships, airplanes, armored and battle equipment.

Another early request, in March, 1940, for an insignia came from Lt. E.S. Caldwell of the Naval operations office in Washington, who asked that a design be developed for a fleet of high-speed torpedo boats being commissioned for the U.S. Navy. The fleet was known as the Mosquito Fleet. Accordingly,

World War II

Lillian Kramer and Dorothy Patz of Vega admire some wartime art featuring that most belligerent of Disney characters, Donald Duck. From the *Lockheed-Vega Star*, 1942. *Mike McDaniel collection*.

the studio forwarded a mosquito streaking through the water, a tar's hat on his head, a shiny new torpedo held by his many legs. When word got around to other units, a big demand in requests were submitted. The studio later received so many requests that a long waiting list was established, and the Disney artists assigned to this work, a five-man art department, who for a time were snowed under. Tanks, torpedo boats, mine sweepers, pursuit, bombing and observation planes, uniforms, warships and other fighting equipment carried

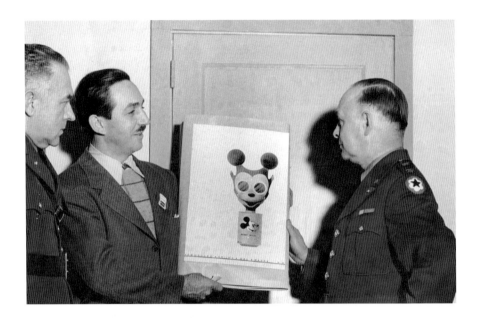

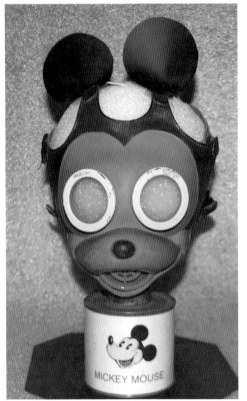

Above: Walt Disney and Army general William Porter (*right*) discuss the development of the Mickey Mouse gas mask for children, 1940s. *The 45th Infantry Division Museum, Oklahoma City, OK.*

Left: The Mickey Mouse gas mask, developed so that children would be more willing to wear one, 1940s. *The 45th Infantry Division Museum, Oklahoma City, OK.*

the art designs.... *To Brigadier General S.B. Buckner, commander of the Alaskan Defense Forces, at Fort Richardson, was sent a picture of a seal balancing the letters "ADP" on his nose. "Since the arrival of the insignia," General Buckner wrote Disney, "all the seals in the Bering Sea have been out on the ice pack balancing our initials on their noses, sneering derisively at the polar bears, expanding their chests and cavorting merrily over being chosen to represent our defense forces."*

When the then Captain Lord Louis Mountbatten of the aircraft carrier H.M.S. Illustrious, *visited the studio, he was so captivated by the insignia being designed that he asked for one for his ship. Because Lord Mountbatten is probably among the highest-rating Donald Duck fans in the British Empire, this insignia shows Donald as a heroic-sized admiral standing astride the* Illustrious.

Walt Disney sums up this work thusly: "It seems that the designs find a lot of favor because they had a tendency to knit a squadron or battalion, or whatever organization they may be drawn for, closer together. The group is just a group until there is something to pin it together and then it becomes a real machine. Other groups challenge it and the two get into fine competitive spirits. The design represents the same thing today that the kerchiefs worn by General Custer's Seventh Cavalry did in the Civil War and later in Indian fighting. The General wore one, soon everyone was wearing one. The men were proud of the scarves, held those who wore them equal, and boasted that they could lick any outfit of similar size in the world. That's the kind of spirit which we need today. If the design can help foster it, there'll be designs."

Fortunately, the Allied forces of World War II fared better than did General Custer.

In the 1940s, Disney Studios, in conjunction with the army, also designed a special Mickey Mouse–shaped gas mask for children, the thinking being that children would be more likely to wear them during envisioned civilian wartime emergencies if they looked "fun." The general consensus nowadays is that they look creepy. There are only three known examples left.

It's worth noting that during World War II, the City of Burbank Civil Defense Committee distributed boxed civilian gas masks ("Noncombatant, M1A2-1-1"); these came in sizes from child to large adult. The use of gas had been a common feature of World War I, and the city wanted to be fully prepared for any eventuality. They were given to concerned Burbank families and individuals. For many years after the war, these were common items at estate sales and yard sales.

BOGIE'S BABIES

The relationship of Humphrey Bogart and his "Baby," Lauren Bacall, was legendary, so it comes as a surprise to learn that Bogie had a longtime mistress. In her book *Bogie and Me: The Love Story of Humphrey Bogart and Verita Thompson*, Thompson describes the long-running affair the two had in the 1940s and '50s. They met at a 1942 party, and whenever Thompson's husband (who was in the military) was out of town, Bogie would visit her at her home at 722 Roselli Street in Burbank, not far from the Warner Bros. studios where he worked. At the time, he was married to Mayo Methot, but the relationship continued while he was married to Lauren Bacall and only ended in 1955, when Thompson remarried.

Verita Thompson was a wig maker, and Bogie wore toupees. Thompson is said to have slept with one of his toupees under her pillow. Hmmm.

OVER THE TOP

As the Vega Aircraft workers passed him by going to and from work, it's likely that only some of them knew the storied career of Arthur Guy Empey, who worked as a guard at the Burbank airplane plant in 1943. When World War I began in 1914, Empey was a professional soldier in the U.S. Cavalry and served as a recruiting sergeant for the New Jersey National Guard. Frustrated with the nation's neutrality in that conflict, he enlisted with the British army, where he saw combat until wounded in action at the beginning of the Battle of the Somme in 1916. When he returned to the United States, Empey wrote a book about his experiences, *Over the Top*; it became a publishing sensation, selling more than a quarter million copies. He attempted to enlist in the U.S. Army but was rejected because of his wounds. Instead, he toured and gave readings from his book in order to rally support for America's entrance into the war. The propaganda service he gave to the government resulted in his being made a captain in the army, but this commission was withdrawn three days later, reportedly due to a speech of his that President Woodrow Wilson disliked.

In 1918, Empey starred in a Vitagraph Film Company treatment of his book and took up composing patriotic songs with titles like "Our Country's in It Now, We've Got to Win It Now," "Your Lips Are No Man's Land but Mine" and "Liberty Statue Is Looking Right at You." Using the

Sheet music cover to Arthur Empey's song "Your Lips Are No Man's But Mine," written to cash in on the success of his World War I memoirs. By the time World War II arrived, he was a Lockheed-Vega employee. *Wikimedia Commons*.

money gained from his book's success, he started the Guy Empey Pictures Corporation and acted, produced, wrote and directed a series of silent films throughout the 1920s. However, changes wrought by increasing growth and professionalism of the film industry and the introduction of sound caused a revolution in Hollywood. By the 1930s, Empey's career in film was over.

Empey then became a pulp-fiction writer, eventually specializing in science-fiction stories. In 1935, he organized a unit of volunteer cavalrymen (dedicated to advancing American ideals) and called them the "Hollywood Hussars"; Empey served as colonel. Members included Gary Cooper, Ward Bond and Victor McLaglen.

Somehow, after that fascinating start as a soldier, novelist, film star and hussar, Empey took up employment with the Vega Aircraft Corporation during World War II. He died in a veteran's hospital in 1963 and was buried in Leavenworth National Cemetery.

MR. MAGOO, BURBANKER

Lovable, nearsighted Mr. Magoo, a UPA character. His catchphrase was a self-congratulatory, "Oh, Magoo, you've done it again!" *Wes Clark collection.*

It began with three Disney animators (Zack Schwartz, David Hilberman and Stephen Bosustow) who were unhappy with the studio's ultrarealistic style. They wanted to pursue a flatter and more stylized form of animation art. In 1943, they left Disney to found a studio of their own, at first called Industrial Film and Poster Service but later (and better) known as United Productions of America (UPA). In 1949, UPA was located at 4440 Olive Avenue. It later moved to facilities at 4440 Lakeside Drive near the Smoke House restaurant.

The company rapidly got work in the booming wartime economy and later found fame in the production of cartoons for theatrical release. Two of their house prohibitions were just as unusual as their simplified approach to animation: no talking animals and no cartoon violence. In 1949, the studio introduced its most

World War II

famous character, a bumbling, crotchety, near-sighted man voiced by Jim Backus: Mr. Magoo. He was instantly popular. A generation of Burbankers (and Americans) grew up with the annual rite of watching *Mr. Magoo's Christmas Carol* (1962) on television.

It is ironic that in 1997, Leslie Nielsen starred in a live-action Mr. Magoo feature film released by the Disney Studios—the source of the initial discontent.

MARILYN MONROE DOES HER PART

An account from the "Marilyn Monroe Forever in Our Hearts" Facebook group posting:

> *Norma Jeane Dougherty got a job at the Radioplane Company defense plant in Burbank, California in Spring 1944 through the influence of her mother in law, Ethel Dougherty, who worked at Radioplane as a nurse. It was Norma Jeane's first job. She proved to be a hard worker and was*

Norma Jeane Dougherty (later Marilyn Monroe) shown working in the Radioplane factory in Burbank, 1944. *David Conover, Yank magazine.*

awarded an "E" certificate from her employers, for excellence on the job. Some records state that she first worked as a typist, and as her typing speed was too slow, 35 wpm, she was transferred to inspect parachutes. She reported, "Not the kind of parachutes life depends on, but the little parachutes they use to float down the targets after the gunners are through with them. That was before I worked in the dope room, the hardest work I've ever done. The fuselage and various parts of the ship were made of cloth at the time, they use metal now, and we used to paint the cloth with stiffening preparation. It wasn't sprayed on; it was worked in with brushes, and it was very tiring and difficult. We used quick-drying preparation, a type of lacquer, I guess, but heavier. The smell was overpowering, very hard to take for eight hours a day. It was actually a twelve-hour day for the other workers, but I only did eight because I was underage. After the cloth dried, we sanded it down to glossy smoothness."

Note: The Radioplane Company, in Burbank, was founded by British actor Reginald Denny in 1940. (Before that, he owned a hobby shop business in Hollywood.) The company manufactured small, remote-controlled pilotless aircraft intended to help U.S. Army and Navy anti-aircraft gunners improve their targeting skills. During the war, Radioplane produced nearly fifteen thousand target drones for the army. The business was purchased by Northrop in 1952.

BRITAIN HONORS BURBANK MARINE

We consider the act of leaping on an enemy hand grenade in order to save the lives of one's fellow combatants the epitome of heroic self-sacrifice. One Burbank Marine actually did that—and survived. The March 13, 1945 *Los Angeles Times* described the incident:

Burbank, March 12—Throwing himself on a hand grenade tossed by a Jap[anese] into a group of his marine comrades on Tarawa, Cpl. Phillip Ray Burke, 21, risked his life to save theirs. Convalescing from injuries at the San Diego Naval Hospital, he today was awarded the British Distinguished Service Medal for "outstanding gallantry, initiative and devotion to duty shown in operations against the Japanese in Tarawa during the reconquest of the Gilbert Islands." The Gilberts are a British possession.

World War II

Honored Marine Phillip Ray Burke's Burbank High School photo. *Mike McDaniel collection.*

Cpl. Burke previously had been given the Navy Cross and the Purple Heart. He is the son of Mr. and Mrs. R.B. Burke, 143 S. Sparks Street, and is reported to be the first Burbank serviceman to receive the British citation and medal. He was graduated from Burbank High School where he was student body president. Cpl. Burke is one of a family of three fighting men. His father enlisted in the Seabees in 1942 and is a chief warrant officer who spent 14 months in the Aleutians and recently shipped out to the South Pacific. His brother, Roy E. Burke, 22, is a fire controlman on a destroyer in the Pacific and has served in the Navy since Pearl Harbor.

Phillip R. Burke died on January 1, 1962, at the too-young age of thirty-eight. His obituary in the *Burbank Review* notes that he was a 1941 graduate of Burbank High School and a 1948 graduate of USC. He had two sons and two daughters.

HAPPY BIRTHDAY, CHAMP!

This well-written poem was composed by Joe Griffen of 649 Lamer Street. It appeared in the April 12, 1945 edition of the *Barn News*, a newsletter from Jeffries Barn on Victory Boulevard and Buena Vista Street (where James J. Jeffries hosted boxing matches). That particular issue was dedicated to Jeffries's seventieth birthday. It gives readers an idea how admired former world heavyweight champion and Burbank businessman James J. Jeffries was during his lifetime.

Once again we've come to meet you,
Once again to shake your hand,
Once again to proudly greet you,
In the way you'll understand.

And re-tell each old-time story,
Of your victories in the ring,
Of your rise to fame and glory,
In that time of life called "Spring."

Tales of men long since departed,
From the pugilistic ken,
Famous fighters, lion hearted,
Leaders all, those fighting men.

Tales of Corbett, the Boxing Master,
Of Bob Fitzsimmons and his "shift,"
Tales that make the blood run faster,
Tales that give the heart a lift.

Ah, those were the days, old friend and neighbor,
When the sporting world stood still,
And men laid aside their labor,
When JIM JEFFRIES topped the bill.

Where, in all Fistiania's prattle,
May a counterpart be found,
Of Tom Sharkey's epic battle,
From the first to the final round?

World War II

Brothers Jack Jeffries (*left*) and Jim Jeffries (*right*) glower at the camera in this circa 1904 image. *PBS*.

So we've come again to cheer you,
Dean of all the fighting men,
And we feel that God's been near you,
Through your three score years and ten.

Jeffries died eight years later, in 1953.

Most folks are unaware that James Jeffries had a younger brother who also boxed. His name was Charles Monroe "Jack" Jeffries. Jack's short-lived career is nowhere as impressive as his older brother's, however. The brothers had one pugilistic thing in common: they both lost fights to Jack Johnson (Jack Jeffries on May 16, 1902, and Jim Jeffries in the celebrated July 4, 1910 "Fight of the Century").

JACK MOORMAN

As remembered by Wes Clark's father-in-law, Don Bilyeu, Burbank High School's big man on campus for the class of 1945 was Jack Moorman, an unusually handsome and personable fellow with wavy hair and glistening teeth. He made all the girls swoon—a matter of some annoyance to his male classmates. Decades later, when the class of 1945 held a reunion, Bilyeu heard that Jack Moorman would be in attendance. Isn't it understandable

Above: *Left*: The handsome Jack Moorman in the 1945 *Ceralbus*. *Right*: With his wife, Peaches, in 1970. *Don Bilyeu collection.*

Right: A photo that appeared in a 1944 *Lockheed-Vega Star* shows an auspicious "V" for Victory in snow on the Verdugo hillside, visible from the plant. Examination indicated that it was not man-made. *Mike McDaniel collection.*

that he hoped the former BMOC would have experienced the ravages of time, as we all do, and become fat, old and bald in the intervening years? Alas, no. Moorman showed up for the reunion somewhat aged, but still looking like a movie star, retaining his good looks and winning smile and accompanied by an attractive, middle-aged woman named Peaches—his wife.

The authors suspect that this scenario gets played out in high school class reunions all across America and that we all have our Jack Moormans (and they have their Peaches)!

4
FROM TRUMAN TO NIXON

The postwar period to the end of the 1960s is generally regarded as being the baby boomer era. We have covered this time extensively in our book *Growing Up in Burbank: Boomer Memories from The Akron to Zodys*, but there remain some stories we didn't have room for. Here they are:

POSTWAR BUBBLEGUM

Jim Voigt describes one of the delights of peacetime Burbank:

> *For most adults, Victory over Japan (VJ) Day signaled the end of war and, in 1946, the return to peacetime life without rationing. But for hundreds of students at Burbank's Bret Harte Elementary, the end of war meant the return of something delicious. Word spread like a Verdugo Hills brushfire. The little store just north of the school was about to sell a childhood staple enjoyed during wartime only by G.I.s. We stood in a block-long line to once again buy bubble gum for a few pennies a wad. The number available per buyer was severely limited to ensure fairness. I once thought the gum was Fleer's Dubble Bubble, but research revealed that the domestic production of that product didn't restart until 1951. Doesn't matter. All bubble gum was ambrosia, food from the gods.*

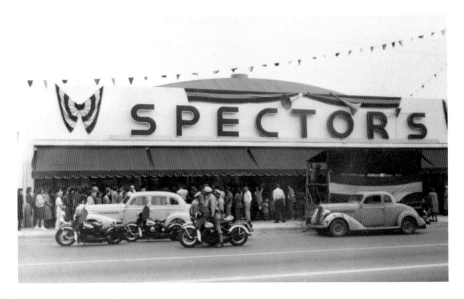

Grand opening of Spector's grocery store on Victory Boulevard and Buena Vista Street in 1949. The building is now a dollar store. *Burbank Historical Society.*

THE CIRCUS IS IN TOWN!

Jim Voigt describes how he discovered that the circus was in town:

> One of my fondest memories of Burbank occurred one day in 1945, 1946 or 1947. I don't remember the precise year. Our family owned a house at 1449 North Frederic Street on the west side of the dead end. (That was before such housing arrangements were called cul-de-sacs.) My bedroom faced a huge vacant lot once used by heavyweight boxing champ Jim Jeffries as a cattle ranch. One morning I was awakened by a loud belch at about five o'clock. Outside the window, right next to our property fence, was a tethered elephant munching on hay.
>
> My mother reluctantly let me venture into a quickly-forming circus community, where the cookhouse chef gave me four free tickets to the Big Top Show for helping him serve breakfast to the crew of tattooed roustabouts. I later enthralled my classmates at Bret Harte Elementary with vivid accounts of my unique adventure. And that evening, my parents, little sister and I got to sit near the center ring in the VIP section.

Local youth play some tetherball at Vickroy Park, 1950s. The wading pool is to the right; that may be a restroom in the back. *Burbank Historical Society*.

SCUFFLE DEATH AT BURBANK HIGH

Was anyone ever killed on the Burbank High School campus? Yes. The *Los Angeles Times*, in articles that ran on June 12 and 27, 1946, reported the accidental death of John C. Newsom III, seventeen, who lived at 525 South Tenth Street. A classmate, Keith Jensen, seventeen, and Newsom

were taking part at a commencement rehearsal. They had a scuffle at a water fountain on campus over who should drink first and, after some pushing and shoving, exchanged blows. (Jensen said later that there had been no previous quarrel with Newsom.) Newsom fell back against a wall, hitting his head, and then slumped to the ground. Efforts to revive him with an inhalator were futile. A coroner's jury was assembled days later and, after deliberation, determined that the death was accidental. Jensen was exonerated of blame.

CAPTAIN MINGAY, REVISITED

In our first book, *Lost Burbank*, we cited a *Burbank Daily Review* piece from April 24, 1947, describing the Civil War career of Henry M. Mingay, a former member of the Sixty-Ninth New York Regiment and a popular veteran who was honored by having a Burbank elementary school named for him. The piece reads: "He saw action in all the regiment's many battles and was mustered out as a sergeant. He was wounded in the right arm. Later he was commissioned a first lieutenant and was advanced to captain." Subsequent research shows some discrepancies in this account.

In an article entitled "Captain Henry Mingay: A Search for the Truth" by Tom Gilfoy that appeared in the April 2013 *Voice of the Village*, a check into Mingay's records show that he enlisted in Company D of the Sixty-Ninth New York in August 1864; he mustered out on June 30, 1865, ten months later. The war ended in April 1865. He simply could not have taken part in all of the regiment's battles. And his rank as a captain dates from his time in the New York National Guard, whence he retired in 1886. He was a sergeant in the Union army.

Did Mingay make these claims, or did some journalist? Or was it simply a case of sloppy or absent fact checking? We will probably never know for sure, but we are inclined to be kind to the old veteran. Given diseases, shoddy medical care and the viciousness of typical combat, the American Civil War was a hellacious experience for any stretch of time.

FROM TRUMAN TO NIXON

MABEL DINES OUT

Carol Hill Olmstead describes life living near Lockheed:

I grew up on Lamer Street between Victory Boulevard and Lockheed. I was just three years old in 1947. Lockheed had a public address system that we could hear from our house when the wind was right and, sometimes, just when the voices were very loud. Usually the calls were businesslike and pretty boring. Now and then, just before lunch time or the dinner hour, though, we'd hear ladies on the P.A. calling things like, "Mabel! Where're you goin' to eat?" or "Mabel! Where should I meet ya for lunch?" My parents told us they weren't really supposed to be using the P.A. system for that sort of thing so it was a special treat when we heard it. We always giggled!

We never found out who Mabel was, but a couple of ladies, like Blanche Ivy who lived on Keystone Street, the street behind ours, worked there as a "dimpler" putting indentations on the metal surface of the airplanes so the rivets would lie flush when they were added.

Vic Martino (*right*) and Shirley Rogers play with the frosting on the Burbank on Parade cake, May 19, 1954. *Burbank Historical Society.*

Train tracks ran about a block from our house between Pacific Avenue and Lockheed. There was a vacant lot and "The Wash" between us and the tracks. That house of ours was so old and poorly built, we could feel the trains coming down the track long before we could hear or see them!

Usually McCambridge Park Pool was the swim hole of choice for my brothers and me because Pickwick was more expensive. We'd arrive just about when the pool opened and stayed the whole day, "dining" on whatever junk food was for sale at the food spot in one corner by the pool. My brothers were on the boys' swim team at BHS so they were pretty strong swimmers, too. We'd have contests to see who could dive in at one shallow end and make it underwater on one breath to the other shallow end. Those were some of the best summers of my childhood.

EQUAL PAY FOR EQUAL WORK

The following is from an International Association of Machinists (IAM) Lodge 727 document from 1948. The lodge represented Lockheed workers. Does this topic sound timely?

Generally speaking women are paid lower wages than men, and this is true even when the women do the same kind of work as the men. Predominately women-employing industries are the low-wage industries. In fact, women's average wages are lower than the average wages of unskilled men....The IAM standards for women workers are equal pay for equal work, and that is a standard that all authentic women's organizations endorse. Union men can endorse this standard also for sound economic reasons. For example, if an employer is allowed to pay women a lower rate for the same kind and amount of work than he pays men, it follows that it would be in the employers' economic interest to employ women instead of men.

From Truman to Nixon

HAIL TO THE BLUE AND WHITE!

Joseph Brown recalls his days as a Burbank High School student in the late 1940s:

> *On weekends I rode my balloon-tired bike out to Santa Monica and back, usually having to stop and repair a flat tire now and then; once, I biked roundtrip to Castaic, about 30 miles away. I enjoyed my days as a Boy Scout in Burbank Troop 13, especially the times at summer camp at Camp Bill Lane in Big Tujunga Canyon. Fellow scout Dan Sites and I spent one Easter vacation backpacking into Big Santa Anita Canyon. From Burroughs, I had transferred to Burbank High School and there cemented many friendships, some of which remain to this day. BHS was also the place where my career as a writer began. I was editor of both the school newspaper and yearbook, having changed from a music class, in which I*

Bonnywood Way (California Route 99) and Magnolia Boulevard in the 1950s. An MJB Coffee ad is on the billboard at right, and, at back, the city power plant can be seen at left. *Burbank Historical Society.*

played the trumpet so poorly my teacher threatened expulsion, to journalism, at the suggestion of my newspaperman grandfather, Tom Brown of San Francisco.

While a student at BHS, I also was a "stringer" correspondent on school affairs, mostly sports, for the Burbank Daily Review. *We had many students of note to write about (of note later in life, anyway) such as Frank Sullivan, who became a leading pitcher after his school days for the Boston Red Sox (as well as one of the tallest playing in major league baseball), Vic Tayback, later of Mel's Diner fame, and a pert young student named Mary Frances Reynolds who, after winning a Burbank beauty/talent contest and Hollywood screen test, changed her name to Debbie Reynolds (at BHS she was simply "Frannie").*

Before Los Angeles Basin smog wreaked its havoc, I enjoyed hiking into the small hills just east of Burbank, sometimes camping overnight in Stough Park or traversing the six miles or so to the summit where a one-armed forest ranger stationed in a fire tower there always welcomed me warmly. Stough Park also remains a treasured oasis in my memory. Only now a large upscale restaurant, the Castaway, is located between it and the town where once there were only trees and brush. I went west from Maine to attend a 50th anniversary reunion of my high school class at the Castaway. Funny how many of the classmates I schooled with had turned so old. And when the then-present BHS marching band showed up and played the school alma mater ("Hail, Burbank High School, hail to the blue and white...") there were few dry eyes in the room, including mine.

WHIZZING IN THE SNOW

Bruce Foreman, via the *BHS Senior Bulldogs Newsletter*, describes his experience in the snowstorm of 1949.

I remember the snowstorm on January 13, 1949. I was in the middle of my first year at the University of Redlands, and that was the day, with the foolishness of youth, I decided to ride my Whizzer motor bike from Burbank back to the University, 72 miles away. It was a one cylinder, belt drive miracle on a reinforced bicycle frame and might go 35 mph on a level road with the wind behind me. I started about 2 PM, struggled over the hills in Eagle Rock, through the Pasadena traffic. It was getting cold and

A helpful Burbank police officer on an impressive Harley-Davidson directs motorists on Route 99, 1950. This is where Front Street is today. *Burbank Historical Society.*

dark and it began to snow! In Southern California? Who ever heard of such a thing? On Foothill Boulevard just beyond Upland some Bozo made an illegal U-turn in front of me and WHAM!, I smashed into driver's side door. (Did I mention that I had no lights? I'd burned out both generators about Covina but thinking myself invincible, I decided to keep going.) Well, after a delightful ambulance ride to the Fontana hospital, and a half dozen stitches to my forehead later, I called my family to tell them I was okay. "What do you mean okay? What happened? Where are you?" The upperclassman who lived across the hall came and drove me on to Redlands not too much the worse for wear. But that was the end of the Whizzer. It was trash. I lost my driver's license for a year and lost any desire to ever get on a two-wheeled motorized death trap again. My next vehicle and the first car I ever owned was a tank, a 1932 Oldsmobile!

True Tales from Burbank

A SOFTER SIDE OF LOCKHEED

In the February 2007 *Senior Bulldogs News*, Elinor Penry deSosa recalls:

> *For a few months between winter 1950 graduation and college in the fall, I was a "roller-skater" at Lockheed in Burbank. Three or four of us young ladies delivered plans (printed on blue linen) to draftsmen who worked in rows at their desks. We sped down long halls in a big upstairs room, our ponytails flying and our skirts flapping. We never wore shorts or trousers, and usually wore bobby sox and saddle shoes with our roller skates clamped tightly to the soles. I don't remember that any of us ever fell, nor did we ever lose our skate keys. (Remember skate keys?) The plans were blue, kept rolled up and filed on shelves in a cramped cubicle until needed. When several of us realized that unwanted plans were due to be destroyed, we decided we could make better use of them.*

A Lockheed Super Constellation, arguably the most beautiful and graceful airplane to ever fly the skies, is seen over Burbank, early 1950s. Valhalla Cemetery and the airport can be seen at left. Luther Burbank Junior High is at center lower edge, and that's the old nine-hole golf course on Victory Boulevard below the wing tip. Lockheed is below the rear of the plane. *Burbank Historical Society*.

The guards at the gate were quite used to us coming through with our tall, round knitting bags instead of purses, in case we needed something to do during the slow times. They didn't pay any attention to us as we left with the old, unwanted plans rolled tightly with our knitting at the end of a busy day...with a smile and a "Goodnight!" we were gone. After soaking our smuggled goods, boiling the old plans and applying some elbow grease, we were left with large pieces of the palest blue fine linen—which was hard to find in 1950. I sewed a summer dress from a few pieces and I still use a treetop Christmas angel I made, which I dressed in some of that Lockheed linen I obtained 56 years ago!

SHE JUST WANTED TO BE A GYM TEACHER

An excerpt from a November 21, 1974 *Los Angeles Times* article about Debbie Reynolds revealed that, as far as she was concerned, a multiyear MGM contract wasn't to be taken too seriously.

Mary Frances "Frannie" Reynolds with Burbank councilman (later mayor) Ralph H. Hilton and Mr. and Mrs. Reynolds, 1948. *Burbank Historical Society.*

> When she was at Burbank High School, Debbie was known as a tomboy who wanted to be a gym teacher. She really wanted to be in the Dramatic Group, but the closest she ever came to the footlights in high school was a job as a keeper of the wind machine. When she was named Miss Burbank at age 16, Debbie was spotted by a talent scout. Her first big role was in the 1949 MGM musical "Three Little Words" which led to a seven-year MGM contract. "At first I didn't take the contract seriously," Debbie remembers, "I thought it was a lark and great fun. They taught me how to walk, dress, use my hands, and how to make my tomboy actions more feminine. They even tried to make me a lady, but I don't know how well they succeeded. All the time I was stashing money away so that I could go back to college to become a gym teacher."

Things got very serious when, a year into her contract, Louis B. Mayer teamed Debbie—who could neither sing nor dance—with the fearsomely talented Gene Kelly and Donald O'Connor in *Singin' in the Rain* (1952). The former Miss Burbank rose to the challenge, however, and her dancing sequences with her costars are acknowledged to be movie musical classics.

Debbie never did become a gym teacher.

POOL OF DISCONTENT

Karen Hua, in a piece on Forbes.com from January 3, 2017, describes a funny bit of Reynolds family lore concerning their home and swimming pool at 1034 Evergreen Street:

> *Before* Singin' in the Rain *and silver-screen stardom, Debbie Reynolds lived in a modest home with her parents and older brother in Burbank, California. It was in that very town's pageant, at age 16, where Warner Brothers talent scouts first discovered the budding singer and actress.... Born in El Paso, Texas, Reynolds, along with her family, moved into the Burbank home in 1940, when she was eight years old.*
>
> *As Reynolds explained in her 1988 autobiography,* Debbie: My Life, *"Daddy paid $250 for the lot on Evergreen. With a $4,000 loan from the FHA, my parents built a small, simple house with three bedrooms, a bathroom, a living room, and a kitchen. Daddy did all the finishing, including the wiring and the plumbing, and of course the painting." In*

1950, Reynolds used her earnings from record sales and movie work to finance the construction of the home's original swimming pool while her father was away on vacation. She even customized the steps with colored tiles that spelled out Aba Daba Honeymoon, an ode to her 1951 hit song, and she frequently held backyard pool parties for her famous young friends. Though Reynolds adored the pool, her father, Ray, hated it so much that he filled it in after his daughter married Eddie Fisher in 1955. As Reynolds described in her 2013 autobiography, Unsinkable: A Memoir, "When Daddy returned from Texas, he wasn't happy about the pool that took up his whole yard.... He didn't like the idea of his little girl making improvements to the house without his knowledge or permission."

The pool would remain filled for 20 years until new owners discovered and resurfaced it.

COMMIES AND MINUTEMEN

The 1950s was the era of the Red Scare, and Burbank was in the forefront of keeping the communists from undoing the American way of life, disparaging apple pie and motherhood. In September 1950, the city council adopted emergency ordinances requiring the Burbank Police Department to register all communists living or working in Burbank—or even passing through the city. The punishment was a stiff $500 fine or six months in jail. And when the anti-red "Crusade for Freedom" got underway with the tour of a ten-ton Liberty Bell replica, Burbank was one of the host communities. In 1951, the Burbank City Council proposed setting up a book screening committee for identifying subversive or immoral books considered for purchase by the library system. Books that were considered to fall into these categories would receive title page stickers, and library personnel would be trained in the identification of communist propaganda. (Burbank spokesmen pointed out that this was not a "witch hunt" or a "book burning.")

In 1961, Burbank was also one of the twenty-six Southern California communities adopting an anti-communist resolution urging citizens and public officials to maintain "constant vigilance" against communism. And in 1964, where some were content to maintain nonviolent vigilance against reds, the Minutemen—a paramilitary, gun-bearing outfit—were more serious. Dedicated to "investigate, by means of our own secret memberships, the possible infiltration of Communist sympathizers into

American organizations of government, business, labor, religion and education," members occasionally ran afoul of the law. Burbanker and self-styled Minuteman Joseph Carey was arrested for the illegal possession of an automatic rifle and pistol in the back seat of his car. (Other weapons were found in the trunk.) Carey jumped bail and fled town. Another Burbanker and Minuteman was arrested for transporting concealed weapons and improperly transporting explosives in a national forest; twenty thousand rounds of ammunition, seven rifles, two shotguns and an automatic pistol were found in the trunk of his car.

WHAT TO DO WHEN THE BOMB BURSTS

Instructions from the 1951 "Civil Defense in Burbank" pamphlet for use in case the Russians drop "the Bomb": "If you are caught in the open when the flash comes, you will have only seconds to act. If there is a ditch, gutter, curb, wall or doorway within two jumps, fall flat on your face in or alongside it and cover your face with your hands. If you are in the car, stop and drop to the seat or floor, shielding your face with your arms. If you are in school, do what your teacher has told you."

This is also good advice for students when a bomb *isn't* dropped.

THOSE WHO WORK ON POWER LINES ALSO SERVE

We think of the police and firemen as being everyday heroes, but let's not forget the linemen. On April 23, 1952, a piece in the *Los Angeles Times* reported that William Thomas, a lineman for the City of Burbank who was then thirty-six, fell to his death while working on a power pole at Keystone Street and Winona Avenue. The police said he was apparently a victim of electrocution. Thomas lived in town at 321 West Alameda Avenue.

When Wes Clark was growing up on Lincoln Street, he fondly remembers Don "Duke" Gardemann, who worked for the city as a lineman. (He got the nickname because he seemed noble.) Whenever the weather was rotten, the Duke was out restoring the lights.

BEANYLAND

The following excerpt comes from *Pacific Ocean Park: The Rise and Fall of Los Angeles' Space Age Nautical Pleasure Pier* by Christopher Merritt and Dominic Priore:

> *Likely the strangest concept that Morehart considered was a collaboration with famed animator Bob Clampett and his characters "Beany & Cecil," who had originated on local television station KTLA in 1949 with* Time for Beany, *featuring Stan Freberg and Dave Butler behind the scenes. In early '62, Bob had aired an episode of his Beany & Cecil show with a plot centered on a scathing parody of Disneyland. The characters visited a very similar park on the moon, known as "Beanyland." Clampett had actually wanted to bring his version of "Beanyland" to fruition earlier, with plans in the mid-1950s to locate it at a park with a swimming pool in Burbank, albeit much smaller in scale than what was planned for P.O.P. (Pacific Ocean Park).*
>
> *Producer Ken Stack recalls briefly discussing the concept with Bob in the 1980s. "He mentioned it being a joint venture with a major television network," related Stack. "And I remember him pulling the papers from a file drawer and talking about contracts and such but it all fell apart...."*
>
> *In a rough sketch that survives, Clampett began assigning names to the various "lands" at P.O.P. he would rename—Jingle Jangle Jungle Land,*

Burbank at night, 1950s. That's Palm Avenue in front and Orange Grove Avenue in the back. At right edge is the Cookson Company, manufacturers of Rolling Doors. "Sales—Service—Erection." *Burbank Historical Society.*

Fun T See Land, Pre-Hysterical Land, Boo Hoo Bay, and Dizzy-Land (with an appearance by "Mickey Moose") were all on the boards. The deal was never consummated.

Wes Clark spoke to Rob Clampett, Bob Clampett's son, on the phone in 2016 and confirmed this information. When Wes asked about the location in Burbank with the swimming pool (*Beany and Cecil*, you may recall, had a sort of watery setting, Cecil being a sea serpent), Clampett added that it was also in conjunction with a drive-in movie theater. So the pool being considered was probably at Pickwick. Clampett didn't know which "major television network" was on board. NBC?

DYNAMIC DAMIANI

Leo Damiani, the founder of the Burbank Symphony Orchestra and the driving force that led to the construction of the Starlight Bowl in 1950, was an interesting fellow besides being a world-class musician. Born in St. Paul, Minnesota, in 1914, he owned his first violin when he was only nine and later became a graduate of the MacPhail School of Music in Minneapolis and the prestigious Juilliard School of Music in New York. During World War II, he was a judo instructor. Damiani was also a lifelong boxing fan. Damiani's interest in the violin was switched to conducting when he was injured and no longer able to perform consistently. He formed the Burbank Symphony Orchestra in 1944 and later premiered works by Ferde Grofé, David Rose and Lukas Foss. He also worked for the Disney Studios and Warner Bros., where he once taught Charlton Heston the basics of conducting an orchestra for *Counterpoint* (1967). His interest in musical education for youth was evident in his development of the Burbank Youth Symphony; Debbie Reynolds, a lifelong friend, once played French horn in the ensemble. The Damiani family story is that it was he who encouraged a young Frannie Reynolds to try out for the Miss Burbank competition, thereby launching a film career. Damiani also helped launch Annette Funicello's career when he staged a talent show for Walt Disney in 1955. Disney was seeking performers for his new *Mickey Mouse Club* and liked what he saw.

Leo Damiani and the Burbank Symphony Orchestra scored a technical triumph on December 24, 1956, when they were involved in the very first television stereo broadcast to homes, *Christmas in Stereo*, originating from

Top: Maestro Leo Damiani on the cover of a 1953 program. *Mike McDaniel collection.*

Bottom: A ticket from the historic first stereo television broadcast to homes, 1956. *Courtesy Joel Tator.*

Prisoner graffiti from the walls of the old jail in the basement of City Hall. It was used as such from 1941 to the early 1960s, when the new police services building was erected. The area is now used for records storage. *Mike McDaniel.*

the NBC studio. The scheme involved the regular television audio forming one channel and a simulcast to NBC radio affiliate KFI forming the other channel. Viewers set up a radio in the room some distance away from the television to produce the stereo effect.

In the 1950s and '60s, Damiani organized the "Battle of Jazz and Symphony," in which he pitted the famous Les Brown and His Band of Renown against the Burbank Symphony Orchestra. It drew packed crowds.

Maestro Leo Damiani died in Burbank in 1986, a legendary musician in a city containing many legendary musicians.

MR. AND MRS. ZILCH

Safety was the watchword in a series of dramatic cartoon "Are You Safe at Home?" vignettes featuring Mr. and Mrs. Zilch, produced in 1953 by the Burbank Association of Insurance Agents ("Speed Kills—Live a Long Time—in Burbank"). Mrs. Zilch was a somewhat careless housewife who seemed to live on the edge of bloody, bone-crunching disaster:

> *Mr. Zilch leaves for work and Mrs. Zilch reminds him to take his Goggles and Hard Hat with him.*
> *Mrs. Zilch starts her day…and whoops…she's about to slip on those scatter rugs that aren't properly secured!*
> *Look at that wash…but more important…look at that frayed iron cord—all kinds of danger there!*
> *And now, after surviving the start of her day, Mrs. Zilch puts up curtains…but with that method* [precariously balancing on a chair] *it'll be "curtains" for her!*
> *Ah, she's a busy little bee, isn't she…oily rags tossed into a corner are perfect for spontaneous combustion.*
> *Now we're not opposed to anybody taking a bath…but turning on a radio while in the tub could lead to electrocution.*
> [Mrs. Zilch chops lettuce with a knife]: *Almost time for Mr. Zilch to come home…and a finger is about to go into the carrot salad. Nothing like a carrot and finger salad!*
> *Well…they made it. Mr. Zilch owes his safety to his Goggles and Hard Hat. But will Mrs. Zilch's tomorrow end like this?* [She is shown in a hospital bed.]

It makes one wonder: how did a generation of Burbankers survive the domestic hazards of the 1950s?

WHY "THORNWALL?"

Old-time Burbankers remember that the city's telephone prefixes used to include CHarleston (24 on the dial), ROckwell (76), STonewall (84), VIctoria (84) and, the one the Clark and McDaniel families had, THornwall (84). But where did these names come from? In other words, why "THornwall?" The

answer is Ma Bell and her love of standards. THornwall was recommended in the 1955 Bell Telephone publication *Notes on Nationwide Dialing*. The names were chosen so that pronouncing them would easily identify the first two significant dialable letters of the word, as well as avoiding other like-sounding letters associated with different numbers on the dial. In other words, THornwall was distinctive. The names were phased out for all numeric systems by the end of the 1960s. In the United States, the demand for telephone service outpaced the scalability of the alphanumeric system, and after the introduction of area codes for direct-distance dialing, all-number calling became necessary.

Comedian Stan Freberg objected to the new system in his 1966 album *Freberg Underground*: "They took away our Murray Hills / They took away our Sycamores / They took away Tuxedo and State / They took away our Plaza, our Yukon, our Michigan / And left us with 47329768."

FOREVER LET US HOLD OUR BANNER HIGH

Given that the Disney Studios are in Burbank, it stands to reason that some Mouseketeers have Burbank connections. As stated earlier, Annette Funicello was discovered by Walt Disney when she was twelve, in 1955. The occasion was her dance performance as the Swan Queen in Tchaikovsky's *Swan Lake* (or in the *Nutcracker*—there is some disagreement) at a recital at the Starlight Bowl. The Disney Studios stage where the *Mickey Mouse Club* was filmed was named for her after her death. Mouseketeer Don Grady (Agrati), best known as one of television's *My Three Sons*, was a 1962 graduate of Burbank High School. Roy Williams—the somewhat crusty, older Mouseketeer—had a home in Burbank. A practical joker, he had a standing gag involving a heavy hunk of iron in a gift-wrapped box on his floor, a present for male visitors. The joke was that it was too heavy to lift, but most guys tried their hardest. Williams also designed more than one hundred aircraft insignia for Disney during World War II, as well as the famous Mouseketeer hats. Mouseketeers Cubby O'Brien, Mike Smith and Tommy Cole were all born in Burbank but raised elsewhere. Mouseketeer Doreen Tracey graduated from John Burroughs High School in 1961. Johnny Crawford, a Burbanker, is best known as Lucas McCain's son Mark in *The Rifleman*, but he was also one of the original Mouseketeers in 1955.

From Truman to Nixon

THE BURBANK OF 2009—AS ENVISIONED IN 1959

A time capsule was sealed into a niche of the Magnolia Boulevard Bridge in 1959, due to be opened in 2009, fifty years later. It was. Here are some of the highlights of Burbank's fabulous future as expressed by Kenneth E. Norwood of the city planning department:

The view is entirely free of overhead power lines, antennae, etc. Only partially distinguishable are the local street patterns of 1959, and only several small areas remain of the gridiron pattern.

The population is 150,000, with only 12 percent in single family houses and 88 percent in multiple units, such as family type, multi-level garden apartments, apartment towers made of plastic, and those living in the complexes. [Burbank's population in 2010 was 103,340.]

The several original business districts and industrial areas of 1959 have expanded and merged into almost continuous building complexes completely free of auto traffic. The San Fernando Mall, Magnolia Mall and Riverside-Toluca Mall are outstanding shopping and business centers. Industry is composed mostly of design and computation offices; research and testing laboratories; and control stations for automatic production plants, communication and air and space transportation systems. Moving sidewalks are widely used along the malls, and arcades interconnecting the building groups.

There is no visible evidence of power stations, substations, or power lines as underground atomic power units are located to serve each section of the city. Power is transmitted by waves rather than carried on poles, and the power line rights-of-way have been reclaimed for productive use. Water is abundant enough to maintain the mountains as year-round green recreation parks, and to provide all the needs of residents and commerce.

…30 hour (work)week…

Rapid mono-rail routes connect metro centers, with pick-up stations at the Lockheed Air Control Center, and at each of the main malls in Burbank. Unlike auto parking in 1959, there is no parking on streets or open lots, but in fully automatic parking units located at each main destination point.

…use of the vertical take-off (VTO) craft for business, pleasure and emergency work, is quite intense.

…the Lockheed Air Control Center serving as the intra-regional VTO Terminal, and the transfer point to the passenger rocket terminals.…Freight

The Pacific Electric Red Line trolley car of fond memory, shown at the intersection of Providencia and Glenoaks Avenues in June 1955. It ran from Burbank to Hill Street in downtown Los Angeles. *Ira Swett.*

> *traffic within Burbank has been replaced by the continuous belt system which travels through covered ducts passing under the building complexes, apartment towers, and through to other cities.*
> *Lockheed cannot be identified from the air.*

Well, he got that last one right.

In addition to all of the wonderful stuff envisioned here, the Burbank city fathers were hedging their bets in case the Russkies pushed the button with the planned 1960 construction of a twenty-five-foot by forty-eight-foot atomic radiation shelter buried three feet underground and capable of housing 150 persons for up to three weeks. (Ah, but *which* 150 Burbankers would receive shelter?) Like the passenger rocket terminals, it was never built.

From Truman to Nixon

21 OR OVER

It is true that the San Fernando Valley is (or was) considered the capital of the adult movie industry on the West Coast; Burbank played a part in that. What follows is the exuberant 1960 ad copy for a company called the Movie Club Guild, which marketed adult peep shows from a Magnolia Park Station address in Burbank:

> *Don't be confused! Send no money! Learn the facts! Only Movie Club Guild offers: Free movies or viewer-projector to new members! Receive, absolutely FREE, a big assortment of our finest, most sophisticated adult films OR an 8mm, precision viewing instrument! Then each month enjoy the most dynamic, action-packed films produced.... Only Hollywood's most beautiful and curvaceous models, starlets, strippers appear in Guild films. Why risk disappointment? Only the Guild offers those hard-to-get films you've always wanted. Perfect for sparking up your stag and poker parties!*
> *"Do not order adult films unless 21 or over."*

Four leggy candidates vie for Burbank on Parade honors, 1947. They are seated on a Salsbury scooter. The pool in the background is possibly the Pickwick Pool. *Burbank Historical Society.*

WANAMAKER'S ARK

Everyone in Burbank knew the name Wanamaker—as in Wanamaker Rents, the business on Olive Avenue where, it was claimed, you could rent anything. V.H. "Jack" Wanamaker started the business in town in 1939 and ran it until he sold the business to United Rentals in 1999. Wanamaker has the distinction of being the rental business's first major equipment supplier to the entertainment industry; it was a major customer for as long as he owned the company. Wanamaker, an avid conservationist, was also known for his big-game hunting trips; these took him to every continent on earth. He collected hundreds of animal species in his upstairs museum at Wanamaker Rents, one of Burbank's little secrets. As customers stood before the cash register signing checks, stuffed wild animals, with teeth bared, were frozen in midleap on the floor above. "My Dad rented a lot of equipment from Wanamaker's and he got to know Jack over the years," says Burbanker Rob Avery. "One day in 1965 when I was young, he took me up to the second floor to see the trophy room. It looked like Noah's Ark had run aground in Burbank and disgorged its living cargo."

Jack Wanamaker eventually donated the trophies to the Wanamaker Wing of the Northeastern Nevada Historical Society and Museum in Elko, Nevada, where they may be seen to this day.

SLIDING DOWN BARHAM IN A BEETLE

Burbanker James McGillis describes a near-death experience:

> One Friday evening in 1965 or 1966, a group of friends and I caravanned from Burbank to Hollywood. There, as underage youth, we could buy cigars without showing identification. The Crooks brand, with their, "Rum Soaked, Dipped in Wine" motto, were our favorites. With alcohol-soaked tobacco, we pretended that we were drinking and smoking at the same time; only our lack of access to alcohol kept us sober. That night, I rode shotgun in my friend Phil's Volkswagen Bug, which he called his "V-Dub."
>
> The only separation from opposing traffic on Barham Boulevard consisted of a double white line. On the downhill ride toward Burbank, the slope ended at an intersection with Forest Lawn Drive, better known to us as the River Road. On our return trip from Hollywood, the road rose over a

From Truman to Nixon

Burbank, the Smoke House and Warner Bros. as seen driving down Dark Canyon on Barham Boulevard, 1959. *Burbank Historical Society.*

hill, and then descended, while arcing slowly to the left for about a quarter mile. As Phil held his steering wheel to the left, the camber of the roadway sloped gently to the right.

In high school, we had learned some basic laws of chemistry and physics. For instance, "Oil and water do not mix," "An object in motion tends to stay in motion" and "The heavy end of any object will try to lead the parade." Pushing in the cigarette lighter at the top of the hill, Phil ignored all of those laws.

As we crested Barham Boulevard, a slight drizzle began to fall. While waiting for the cigarette lighter to pop out, Phil reached down to tune in the AM radio and activate the windshield wipers. With our friend's car ahead of us, Phil wanted good music and good visibility for his overtaking maneuver. In his exuberance to overtake, and in steadfast belief of his own immortality, Phil accelerated throughout the long downhill curve. Soon enough, all of the aforementioned laws of chemistry and physics went into play.

After months of dry weather, oil on the roadway glistened colorfully in the headlights of oncoming vehicles. The emulsion of oil and water on the roadway provided friction similar to a sheet of ice, and as the tires lost their grip on the road I found myself looking straight into the headlights of an

True Tales from Burbank

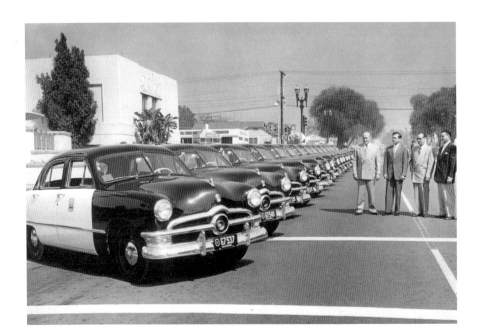

Burbank's new police car fleet, January 1950. *From left to right*: Paul Brown, Patrick Price, Walter Mansfield and Floyd Jolley. Note that the chrome Dagmars in the center of the bumpers have been replaced with the sirens. *Burbank Historical Society.*

oncoming car. With its rear-engine design, the V-Dub tried to swap ends and thus lead with its engine-heavy tail. In a vain attempt to slow down, Phil slammed his foot down on the brake pedal. As we swung once again towards oncoming traffic, I saw my Maker. Who would have believed that God drove a 1958 Cadillac? With unwavering speed, the heavy Caddy struck our little Bug, making contact aft of our driver-side door. Mercifully, the impact sent us back to our own side of the road. According to one witness, we spun around three times as we descended the hill. Facing uphill, windshield wipers still thumping, we stopped just short of the intersection with Forest Lawn Drive. Less than a half mile from our final resting place that night lay the largest cemetery in Los Angeles.

Staring straight ahead, with both hands clutching the steering wheel, Phil sat in shock. A telltale splatter of blood on the windshield told me that the impact had caused his nose to hit the steering wheel. Still gripping the grab-handle on the passenger-side of the dashboard, I exclaimed, "Phil, we f---ed your whole car." When I received nothing more than a blank stare from Phil, I got out and helped divert traffic around Phil and his badly broken V-Dub.

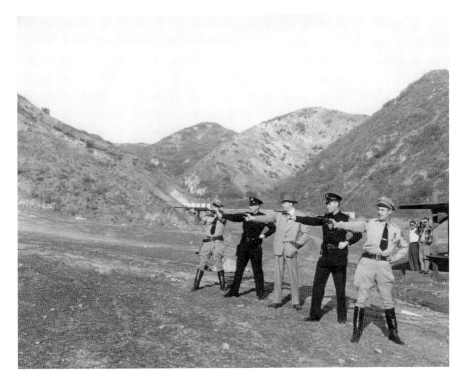

Members of Burbank's Finest brush up on their marksmanship at the police range, 1950s. *Burbank Historical Society.*

> *The whole event took less than a minute. Although my life did not flash before my eyes, as events unfolded I knew that my life might end at any moment. That I survived uninjured gave me a startling clarity that only such near-death experiences seem to bring. I was seventeen years old and blessed to be alive.*

Wes Clark's father had a similar occurrence on Barham Boulevard, driving into town on a wet night in the late 1950s. As he related to Wes Jr., he had executed a perfect 180-degree spin in the face of oncoming traffic but was unstruck. (Alcohol was involved.) He made it home okay.

TRUE TALES FROM BURBANK

WORDS TO LIVE BY

The John Muir Junior High School (now Middle School) creed, as recalled for us as adults by Eric Rosoff:

> As loyal John Muir students, we will always strive to be:
>
> **J**oyous in our endeavors
> **O**rderly in our conduct
> **H**onorable in all dealings
> **N**eat in our appearance
>
> **M**eticulous in projects
> **U**nselfish in our actions
> **I**ndustrious in our work, and
> **R**eliable in all things

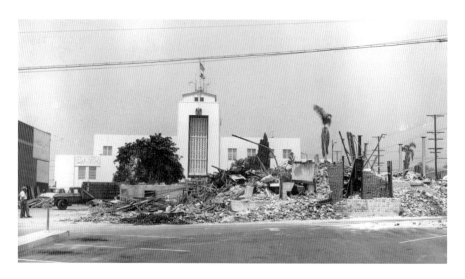

The old City Hall is demolished, early 1960s. *Burbank Historical Society.*

FROM TRUMAN TO NIXON

A NOTABLE BARREL ROLL

Lorene (Foreman) Branson, in the September 2007 *Senior Bulldogs News*, notes:

> *When Lockheed moved their flight test facility to Palmdale, they purchased a Beech Bonanza aircraft to ferry their pilots back and forth. One time when Tony LeVier and Fish Salmon were returning from Palmdale to Burbank in the Bonanza, they got a little close behind a Lockheed Constellation that was landing. At 50 feet off the runway the trailing vortex from the Connie flipped the Bonanza completely upside down. Fish Salmon was flying the Bonanza and, being an aerobatic pilot, he did not hesitate to roll the airplane in the direction the vortex had thrown him, completing a perfect barrel roll just as the wheels touched the runway. Tony LeVier told this story himself and claims that if he had been flying they both would be dead men. Only Fish Salmon, experienced as an aerobatic pilot, saved their lives. Needless to say, it was the talk of Lockheed for MANY years.*

WHEN IN BURBANK, JUST SHUT UP AND DO AS THE BURBANKERS DO

From an op-ed piece by Matt Weinstock in the *Los Angeles Times*, May 9, 1965:

> *A California-born lady, a resident of Burbank, asks what she should do about recently arrived people who make a career out of disparaging what they find here. She becomes irked especially when they refer to "Back East" as if it were the ultimate Utopia, where everything is standard and normal, and "Out Here" as a place that is unbelievably weird, gauche, uncultured, boorish, behind the times, unfriendly and generally awful. One day recently when the fire engines went by, a newcomer remarked bitterly, "They don't have those crazy air horns on fire trucks back East!" The Burbank lady has been Back East and happens to know that almost all fire engines now have them, unless, she added acidly, the critic was referring to the horse-drawn kind. Another recent arrival commented irritably, "People Back East don't put big fences around their homes like they do Out Here." The Burbank lady says she has been tempted to make the obvious retort, "If you don't like*

True Tales from Burbank

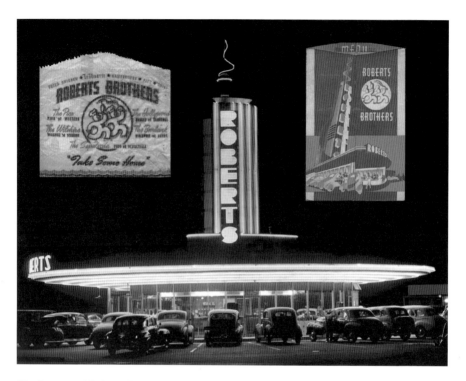

Glorious neon! Roberts Brothers Drive-In on Victory Boulevard and Olive Avenue, late 1940s/early 1950s. *Burbank Historical Society.*

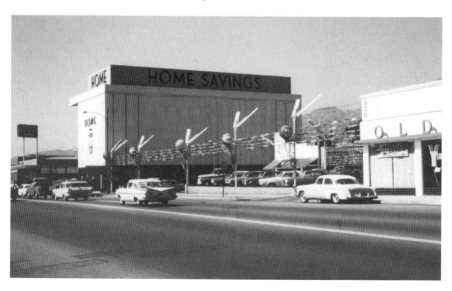

Home Savings and Tom Neal Oldsmobile on San Fernando Boulevard, 1966. *Burbank Historical Society.*

it here, why don't you go back there." So far she hasn't but she confided, "I'm getting closer all the time."

Don't do it. Just welcome them to Gripers Anonymous, the biggest club in town and part of the scenery.

MONKEES DOODLES

Burbankers are always amused when various places in town appear as stand-ins for far-flung locations in movies and television. Episode no. 30 of the television comedy *The Monkees* is entitled "The Monkees in Manhattan"; it was broadcast on April 10, 1967. Perhaps needless to say, the fountains the Monkees jump across and the tall pillars they cavort around during the song "The Girl I Knew Somewhere" aren't a part of Lincoln Center in New York City. They belong to Burbank's famous hilltop restaurant the Castaway, up in the Verdugo Hills. (The fountains were later removed from the restaurant grounds.) Monkees fans are aware that the show was often shot at Columbia Ranch in town. There's another Burbank connection in this particular episode: Burbanker Doodles Weaver costarred as a butler. Sadly, the well-known comic actor took his own life in Burbank in 1983.

Four guys in the City Hall fountain—we don't know when, we don't know why. But the fellow at top looks artistic. *Burbank Historical Society.*

BURBANK ENTERS THE BATTLE OF THE BUSTLINES

It's a story that seems like a relic from a different age. It began with Francine Gottfried, a zaftig (43-25-37) Brooklyn girl who, in September 1968, began attracting crowds as she walked to her office in New York City's financial district each day. The press dubbed her "Wall Street's Sweater Girl"; eventually, thousands gathered to watch. It got so bad that trading was halted and people were lined up on the rooftops and craning out of windows to ogle Ms. Gottfried. Ticker tape was thrown. The NYPD was forced to escort her through the traffic jam. "I think they're all crazy," said the down-to-earth lass. The *New York Daily News* (inevitably) came up with the headline "A Bust Panics Wall Street as the Tape Reads 43," and the story made the national news.

KABC disk jockey "Sweet Dick" Whittington, thinking that the West Coast ought to be represented, flew out with thirty-six-year-old Burbanker Geri Stotts (47-29-38) to visit Wall Street in early October. Her husband,

Valley gentility: the Fleur-de-Lys Women's Club, 1960. *Burbank Historical Society.*

a welding foreman, was all for the visit "as long as it remains a fun thing." Geri arrived in a flaming fuchsia minidress with black boots and, stepping out of a limousine, caused such a fuss that the police rescued her and rushed her away in a squad car. Other women also tried to bust Wall Street, but the sensation soon died down.

Who won? Clearly, Burbank, 47 to 43.

Burbanker Cathi Fitzpatrick comments: "Geri was my boss at Community Chevrolet. I worked there in high school…she was one of a kind, for sure! She was on *The Tonight Show* with Johnny Carson and he had one of his stammering moments. People used to come into the dealership just to grab a peek at Geri! She wore sweaters every day. I have great memories of Geri!"

Burbanker Melanie Santamaria had the best quote: "My mom called her Miss Community Chest."

PEPE JR.'S MACHINE GUN NEST

The building at 335 North Victory Boulevard is now the home of Martino's Bakery, but in 1968, when Mike McDaniel was twelve years old, the business located there was Pepe's Florist. On the second-floor balcony, a child we shall call Pepe Jr. held the intersection of Magnolia and Victory Boulevards terrified as he set up his toy machine gun (with belt) and gleefully mowed down cars and pedestrians (in his imagination). For a time, it seemed that whenever Mike went by with his parents on the way to some destination, the kid was up there with his toy gun. Mike's constant thought was, "Where did he get that cool toy machine gun?"

We wonder: Whatever became of Pepe Jr.? Did he grow up to be a law-abiding citizen, or is he serving time somewhere for the same stunt played with real weapons?

BIG JOHN AND CHEAP PAINT

In the 1960s, the Standard Brands Paint Company on Victory Boulevard was presided over by a guy Wes Clark's father identified as "Big John," an old dude who shaved his head and wore white painter's overalls. He bore more than a passing resemblance to Mr. Clean. Whenever Wes Clark Senior

and Junior walked in, there'd be a hale-fellow-well-met greeting, as if they were members of some club. Big John would then peer at Wes to see if he had gained any height since the last gallon of paint. Since he was growing like a weed at the time, there was always some comment.

Wes Clark Sr. would proceed to the left-hand side of the store, where the "Standard Brands" were located. He never paid more than five dollars a gallon for paint. In other words, even considering the lower cost of living in the 1960s and '70s, this was cheap paint. What's more, Wes's father used to thin the latex with some water. Wes has no idea why—it barely covered at full strength, and the practice used to rile Mrs. Clark to no end. Perhaps it was some vestigial trait of living during the Great Depression, when paint thickness had to be sacrificed to keep food on the table.

Mrs. Clark was never a fan of "that damn" Standard Brands and, finally, angrily took things in hand for one major painting project. She purchased a much better grade of paint somewhere else in Burbank. As Wes Clark Jr. did a considerable part of the painting, he greatly appreciated the better

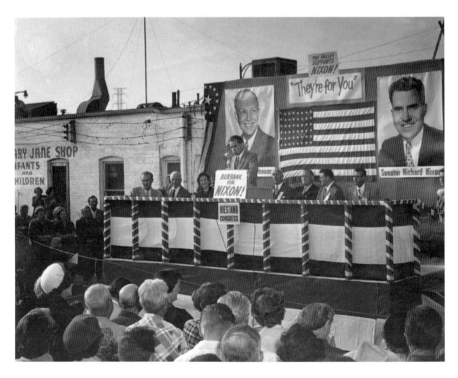

Richard Nixon campaigns for Ike, 1959. The retail background leaves something to be desired. *Burbank Historical Society.*

quality paint, which went on and covered much, much better than any of the Standard Brands ever did.

The Standard Brands Paint Company was a chain in Southern California, and whenever the Clarks went for a family ride and passed one, Wes always noticed the familiar sign and had a sort of mental "urp," as if wondering what this pretender store was doing in Torrance or Van Nuys. Was there a counterfeit Big John in residence?

Standard Brands filed for Chapter 11 bankruptcy in 1995. Perhaps people got tired of having to paint walls three or four times in order to get proper coverage.

FREIGHT HOPPING

Because Burbank has railroad lines and spurs leading to the industrial sections of town, it has always been an adventurous destination for hoboes and freight-hoppers. Barry Epstein recalls: "We hopped on trains from Chandler Boulevard at Fairview Street to Buena Vista Street a few times. Then a kid lost his leg or legs doing that. We opted out of that hobo lifestyle!"

Elizabeth Boysen Sirk recalls that her brother Tom rode the rails from the Bay Area to Burbank in March 1960. "I know because I was being born at St. Joseph Hospital and it was his spring break at Stanford University. Tom and his friends rode to Burbank while comfortably relaxing in automobiles that were being transported. It was back in the day when you could turn a radio on without starting the car, so there was entertainment."

Ron Gibson writes: "I got on a couple of trains that were loaded with sugar beets while they were switching and making up a train. This was at the end of Griffith Park Drive. I was scared. It's my Burbank conscience in action, that I never considered 'hoboing.'"

Burbanker Richard Taylor writes:

> We used to ride from Burbank to Glendale; we'd jump onboard just like you see in the old movies. We'd hop on around Magnolia Boulevard to around Pacific Avenue or further, but most often ride from Magnolia to Bill's Ranch Market, where we'd get watermelons for a penny a pound, then ride back. We spent a lot of time at the tracks, talking to hobos and just generally getting into trouble. I once accidentally set one of the boxcars next to the rails on fire playing with flares that were left around by the rail

Train 1, car 0 near the Andrew Jergens plant, 1940s or 1950s. The curious gather. *Burbank Historical Society.*

From the Burbank High *Hi-Life*, early 1960s. Can we all please agree that the surfer style is better than the standard butch? *Mike McDaniel collection.*

workers. This was before I was ten years old or so. I do remember a story of a guy getting sucked under and getting his legs all messed up.

Burbanker Jonathan Doe has memories of school programs: "In the late 1960s the teachers at McKinley Elementary School invited a black man who had lost his leg jumping freight trains to speak in an attempt to get us kids not to do it. It worked for many reasons." Burbanker Marilu Howard comments, "I just rode the freight train at Travel Town. Odd thing was, I went many a mile in mind but I'm pretty sure the old boxcar did not move!"

Jonathan Doe recounts the story of an inadvertent, uniformed freight-hopper:

> *In the 1940s or 1950s a Burbank policeman was investigating a fatal pedestrian accident on the tracks south of Buena Vista Street. He parked his unit on the street and walked south on the tracks to the scene. After investigating, he saw a northbound freight train that had slowed because of the incident. He thought he would hop on for a ride back to his unit, but instead the train started speeding up to the point where he could not safely jump off. After a while the other officers started looking for him. They finally got a phone call from the cop—who was in Bakersfield!*

5
THE DISCO DECADE

The 1970s! Our era! We remember Burbank very well from this time.

The following are some facts from this period as recorded by Jackson Mayers in his 1975 *Burbank History*: In January 1970, the total count of registered Democrats in Burbank was 20,441. The registered Republicans numbered 20,437, only four fewer. In 1972, the city began enforcing an ordinance requiring dog owners to clean up nuisances committed by their pets within one hour; in 1973, neighbors and the city objected to the more than four hundred birds kept by Laure Haile, the so-called Bird Woman of Burbank. Steve Stimpson, a former Boeing executive who is credited with introducing stewardesses to air travel service, died in Burbank in January 1974. In March, Prince Charles, the heir apparent to the throne of Great Britain, visited Disney Studios and enjoyed a beverage with Barbra Streisand. Also in March 1974, the Burbank police apprehended three streakers (a fad of the time involving nude sprints in public) and remanded them into the custody of their parents. In November 1974, the city eliminated the terms "Miss" and "Mrs." from city job application forms. Regarding the geothermal venture described later, when Wes Clark stepped off a plane in summer 1975 (the Marine Corps had stationed him in Texas) and greeted Mike McDaniel with questions about what had been going on in town, Mike gleefully responded, "Oh, man, Burbank's gonna crack into the earth and blow energy out of the rocks! It's in all the papers!" In March 1975, the Burbank Police Department busted a laboratory producing hallucinogenic materials.

The 1980s were more sedate (wives for us), with less polyester, and, mercifully and at last, disco died in this decade.

True Tales from Burbank

A CHRISTMAS DISPLAY LIKE NO OTHER

It all began in 1970, when accountant Richard Norton put a Santa Claus popping up out of a box in the front yard of his Pass Avenue house for Christmas. Every year, he and his wife, Pamela, increased the number of lights and items on the lawn to the point where, now, their house on Florence Street cannot be missed—it illuminates the avenue from far away. The display takes five weeks to assemble. Norton likes to include characters that kids like, so, over the decades, the display has grown to include Snoopy, Cabbage Patch Kids, Buzz Lightyear and Minions. When the bidirectional Ferris wheel was first erected, Norton discovered that the motor had enough torque to launch Cabbage Patch Kids across the yard when it changed direction; a little girl once knocked on their door and insisted that a baby was lying on the ground.

Norton sold the various display items in the yard in 2004 but bought most of them back in 2008 when people wanted to see them again. And the partridge doesn't fall far from the pear tree: Norton's son and daughter both erect elaborate displays every Christmas at their homes.

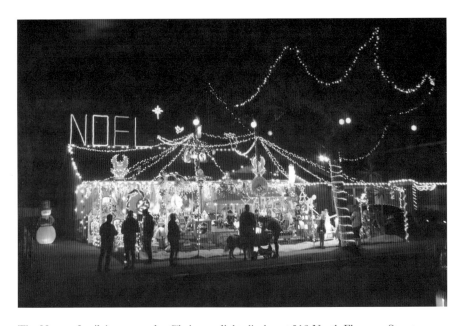

The Norton family's spectacular Christmas light display at 513 North Florence Street—since 1970! *Dick Norton.*

On the Burbank Boulevard bridge on November 28, 1972, about to take a right onto the Golden State Freeway to go to L.A. The Toyota dealership across the street from Home Savings can be seen. *Burbank Historical Society*.

WHEN BIGFOOT CAME TO TOWN

A piece in the *Los Angeles Times* on May 20, 1970, gleefully described the moment when an eight-foot-tall, seven-hundred-pound artificial stone and hair representation of the Pacific Northwest's Bigfoot made its way via hoist from the Burbank home of John Chambers on 330 South Myers Street to a truck destined for Visalia, California. The hirsute figure was created to be displayed at state fairs and sideshows. "People around here have seen an awful lot of strange things go in and out of my garage," Chambers said. (John Chambers was the Oscar-winning makeup man who created the masks and appliances for the 1968 film *Planet of the Apes*.) A seventeen-foot King Kong exited his garage six years earlier, in 1964.

THANKS FOR YOUR SERVICE ANYWAY, AUDIE

In a series of pieces from October 1970, the *Los Angeles Times* reported a distressing story about Medal of Honor recipient and the most decorated soldier of World War II, Audie Murphy, being acquitted of feloniously assaulting a Burbank dog trainer. (The charges were assault with intent to commit murder, battery and two counts of possession of a blackjack.) While Murphy admitted that he took a punch at David Gofstein, he said it was in self-defense after Gofstein pushed a trash cart into the hero. The fracas involved the treatment of a dog owned by a female friend of Murphy's. After the trial, Murphy was asked what his immediate plans were. He responded, "Stay out of Burbank!" Another quote: "I'm too tough for this damned town. It can't break my heart!"

SHOPPING CART RAID

Shopping carts—one takes them for granted. But in an eye-opening article by Robert A. Wright in the December 12, 1971 *Chicago Tribune*, the economics of those hefty metal accessories of everyday life was examined in a story about a raid on a Burbank grocery store lot by a contract business led by a former South Korean CIA agent. In 1971, the average shopping cart was worth about $30–$40. A grocery store probably paid about $10,000 initially for the carts for each store. Factor in that between 15 and 25 percent of their stock disappeared each year (the Southern California Grocers Association estimated about $1 million in aggregate loss each year), and one can see an economic opportunity in starting a business returning carts to stores. Which leads us to…

EQUAL TIME WITH JOHNNY

Burbank's local politics made print in the *New York Times* on March 19, 1971: Before Johnny Carson and his *Tonight Show* made the 1972 move from New York City to "Hollywood" (Burbank), he invited Burbank mayor Dr. Jarvey Gilbert onto the show for a gag appearance, wearing a paper hat. The idea was that Gilbert would extoll the virtues

The Disco Decade

On the Burbank Boulevard bridge again, this time facing the other direction and waiting forever for the light to change at the old Five Points, 1973. The AMC Matador billboard reminds you of how unimpressive 1970s cars could be. *Burbank Historical Society*.

A patient policeman instructs visiting Cub Scouts about BPD radio protocol, 1970. The den leader at left looks especially intrigued. Remember those Cub Scout caps? *Burbank Historical Society*.

of "Beautiful Downtown Burbank" to Carson. Innocent, right? The problem was that the appearance of the political figure preceded, by a few days, an election of Burbank councilmen. (The councilmen, in turn, choose the mayor.) One of the candidates for councilman, Joseph Stay, saw the sequence and demanded equal time under Section 315 of the Communications Act. (Can you guess what line of business Stay was in? That's right, a business that recovered shopping carts for grocery stores.) NBC consulted its legal department, which concluded that, yes, the Federal Communications Commission rules did indeed apply and Stay would have to have his equal time—as would the other nine candidates for Burbank City Council!

The law is the law. Two nights after Mayor Gilbert's appearance, the first half hour of the *Tonight Show* was preempted by the appearance of the ten councilmen candidates, few of whom kept straight faces. Gilbert, who was running, won easily with thousands of votes. Stay went back to collecting shopping carts.

NBC expected a ratings drop for the gonna-be-boring segment, but, no. Amused viewers gave the evening to Carson and the councilmen candidates, who beat out Dick Cavett and Merv Griffin. Broadcasters concluded that "apparently almost anything can happen in Burbank."

WHEN "BEAUTIFUL DOWNTOWN BURBANK" GOT OLD

Every Burbanker knows that the immortal phrase "Beautiful Downtown Burbank" was introduced by *Rowan and Martin's Laugh-In*, which premiered in 1968. It caught on so well that, for a time, the city telephone operators were instructed to answer calls with the slogan. But, as reported in a piece by the *Los Angeles Times* on February 26, 1973, some operators thought it unbusinesslike and were happy to receive the instruction to discontinue it by City Manager Joseph N. Baker, who recognized that by 1973 the phrase had become passé and old hat. *Laugh-In* was canceled in 1973, but it returned. (Read on.)

THE DAWN OF GEEK CULTURE

Geek culture may be said to have first appeared in Burbank in January 1968, when an assemblage of about three hundred Caltech and Berkeley scholars and tech students from other colleges and high schools mounted a torchlight march protesting the rumored cancelation of *Star Trek* after its second season. The protestors marched from Verdugo Park to the streets in front of NBC studios. Picket signs read, "Vulcan Power," "It Is Totally Illogical to Cancel *Star Trek*," "Mister Spock for President" and "Save *Star Trek*!" Another named names: "Send General Sarnoff to Vietnam!" (David Sarnoff was, at the time, the head of NBC.) As might be expected from the slide rule set, the protest was peaceful and was accompanied by the Burbank police; an NBC official, joined by press agents and photographers, addressed the protestors, assuring them that a decision was "still pending." The network got more than 100,000 pieces of mail containing in excess of one million signatures. One Burbanker, David Hillman, wrote, "Dear Peacock: If the *Enterprise* leaves its Hollywood orbit, I'll pluck out your feathers—one by one." Some of the petitions were signed by prestigious scientific groups like Werner von Braun's White Sands staff.

In fact, independent of the protests, NBC executives were in favor of renewing the show and announced that a third season would be filmed. Series creator Gene Roddenberry was accused by the network of soliciting and encouraging protests by the groups, but he was as surprised as anyone and denied it. Well, that's what he said at the time. In fact, he was involved in what he called "Twisting the Peacock's Tail." The effort to generate interest for the show may have also stemmed from a 1966 letter by science-fiction writer Harlan Ellison encouraging a letter-writing campaign.

A second letter-writing campaign (in which a thirteen-year-old Wes Clark took part) to protest cancelation of *Star Trek* after the third season failed, and the series ended in 1969.

But a new culture, composed primarily of scientifically well-educated individuals, first came to the attention of the media in 1968 in Burbank.

TRAVIS BEAN GUITARS

We know the names Les Paul, Leo Fender and Paul Reed Smith—all famous electric guitar makers. Add to that list Travis Bean, who, in 1974, set up shop

in Burbank to manufacture innovative, game-changing instruments still played and prized despite his relatively short career in the industry. Bean's idea was to use solid aluminum for the neck and headstock instead of wood, to improve string vibration (and therefore sustain). Heavy koa wood was used for the bodies of Travis Bean guitars, also to improve tone and sustain. Jerry Garcia of the Grateful Dead was an enthusiast of the guitars—his Travis Bean guitar was auctioned off for $312,000 in 2007. Other players included Keith Richards, Greg Lake, Joe Perry, Slash, Rick Nielsen, Ace Frehley and Ron Wood.

Approximately 3,600 guitars were manufactured by Bean from 1974 to 1979; these remain prized for their tonal qualities and durability. Bean died in Burbank in 2011 after a long battle with cancer; he was sixty-three.

NEIL'S NIGHT IN WARNER'S WESTERN STREET

Every Burbanker in the 1970s knew about the existence of the Warner Bros. Record Group, but few of us understood the pressure and insanity of dealing with the entitlement and whims involved with the rock 'n' roll recording world. In the book *Exploding: The Highs, Hits, Hype, Heroes, and Hustlers of the Warner Music Group* by Stan Cornyn with Paul Scanlon (Harper Entertainment, 2002), Stan Cornyn explains the responsibilities of higher office within Warner Bros., circa 1974. Who knew such wackiness was going on?

> It quickly became clear to me what the real duties of a senior VP were when I got a call from Neil Young's office. There'd arisen this certain knowledge within California's less-scientific hippie community that, during the upcoming weekend, the state's San Andreas Fault would spasm once again, plopping western California (including Beverly Hills, Burbank, and Neil) into the Pacific Ocean. Neil was, he said, very scared. As senior VP, my job was not to laugh. Neil wanted to ride out the quake, but he would feel most comfortable if, over the weekend, he could park and stay in his trailer (it's inside a marvel of ornately carved filigree redwood) on the movie lot's Western Street, the very street on which Clint Eastwood and the Maverick Brothers had shot it out. "I'll get right on it, Neil," I replied.
>
> This involved a call to the studio police. "No way," they answered, explaining that Neil would fall into the category of property hazard. My

It's true: Wanamaker (Olive Avenue and Lake Street) rented everything, 1970. *Mike McDaniel collection.*

second call was up the ladder to the studio production manager. "No way," he answered, claiming with all the insight of a DMV clerk that a lack of toilets on Western Street violated OSHA rules. My third call was to Frank Wells, who administered the whole damn studio. "Frank," I said, "we have a contract with Neil Young, who brings to Warner Bros. Records maybe thirty million dollars in sales a year. I permit no questions to follow what I'm about to say. I need Neil Young in his trailer on the back lot, Western Street, this weekend. Will you do it?" Frank got my point. I called Neil back with the directions. This, I later saw, was what senior vice presidents do.

VETERAN TAKES NEWS OF OWN DEATH CALMLY

The occasional (or frequent) idiocy of the federal government is a joke of long standing. On August 18, 1974, the *Los Angeles Times* reported one such story concerning the bartender of Burbank's famous Blue Room. (At the time, it was a notorious dive, but it has since become fashionable.) Tommy Monette received a letter from the Veterans Administration notifying him of his death and telling him that his seventy-seven-dollar monthly disability payments (received since 1949) were being halted. What's more, his (claimed) widow, Ciela, would have to cough up reimbursements for any checks she cashed. Angry phone calls were made, to no avail. When Monette brought it to the attention of the VA that he was very much walking among the living,

the VA representative had the nerve to tell him that the agency very seldom makes mistakes of this nature and that he was possibly mixed up about his identity. (Such things frequently happen to vets, he was told by a solemn government agent.)

When word of this made its way to the clientele of the Blue Room, they predictably made plans for a funeral party. Tommy Monette has the best quote in the article: "My friends, particularly at the bar, are amused by it all, especially since I still don't have the damn money."

STUDIO FIRES

The program cover for the 1974 Burbank Community Fair, held at the old Columbia Ranch. *Tony Trotta collection.*

The local papers carried dramatic news and photos of the big fire in the backlot of Burbank (formerly Columbia) Studios, on September 8, 1974, during the Burbank Community Fair. The flames took out the Boston Street brownstone sets and about a quarter of the backlot facilities; the cause of the fire was attributed to sparks from an electrical cord. Problem: When the Burbank Fire Department arrived, it discovered that the hydrants it was attempting to connect to were nonworking props. (Afterward, the actual, functioning hydrants were made more obvious to the BFD.)

This fire followed a 1970 studio fire that was believed to have been deliberately set. Among entertainment industry Burbankers, studio fires were suspicious and what might be called "Targeted Economic Arson." Burbanker Curt Conant writes: "Among the union construction workers I knew, this was common knowledge. I knew a prop builder who said these 'accidents' always happen at a time when no one is there. Nobody gets hurt. Fires are much easier, cheaper and faster than tearing sets all apart and hauling them away."

THE MALTESE FALCON ONCE ROOSTED IN BURBANK

A *Los Angeles Times* article from August 4, 1974, described an auction of movie memorabilia from the Burbank Studios property department to benefit a motion picture and television charity. (The Burbank Studios was the result of the merger of Columbia, Screen Gems and Warner Bros.) One of the items was the famous Maltese Falcon statuette from the classic 1941 thriller *The Maltese Falcon*. Collector Edward G. Bordner was the auction winner of the rare item (Humphrey Bogart called it "the stuff that dreams are made of"); he paid $475 for the plaster of Paris bird. Other items from the six-acre Burbank lot included Bette Davis's opulent clothing from *The Private Lives of Elizabeth and Essex* (1939), items from *Camelot* (1967) and *My Fair Lady* (1964) and Errol Flynn's fencing sword.

ANCIENT OYSTERS

You can probably get oysters in any number of modern Burbank restaurants, but the one a crew dug up in Burbanker Don Zennaiter's backyard while constructing a swimming pool in 1974 was unique: it was twenty million years old and fossilized! Zennaiter took the football-sized object to Page Museum at the LaBrea Tar Pits in Los Angeles and got the find confirmed. One scientific staffer was puzzled, however: the giant oyster belonged in San Luis Obispo or Santa Barbara, certainly not in Burbank. And thereby hangs a twenty-million-year-old tale—which won't be told here.

In his 1975 book *Burbank History*, Jackson Meyers describes saber-toothed tiger, mammoth and lion bones found in the dirt. But those more interesting things were found in the San Fernando Valley generally, not Burbank. He also mentions that fossilized seashells have been located on the hilltops, which suggests that the valley was anciently part of a shallow ocean trough.

REBEL REBEL

In September 1974, David Bowie played at the Universal Amphitheater, a common concert destination for Burbankers. Everyone knew about it, because a gigantic billboard was pasted up on Sunset Boulevard on

the way to Tower Records: there Bowie reclined in his Diamond Dogs incarnation, half man, half hound. Since the authors, newly graduated Burbank High students, were fans of Bowie, they were anxious to see the show. But rather than buy tickets, they hit upon a cunning plan: they would crash the show. On the appointed evening, Wes and Mike parked on the street near the wooded area on the corner of Barham Boulevard and the 110 Freeway and hiked over to the woods surrounding the amphitheater, using their ears for guidance. Emerging from the woods into a flat, lit area and almost making it into the amphitheater seating, they encountered a couple of stocky men in black T-shirts who escorted them into the security office. Wes and Mike weren't arrested for trespassing but, instead, were escorted out of the area to make the long hike back to the car. Led away to the sound of Bowie's "Cracked Actor," it occurred to them that if they had simply stayed put they could have heard the show just fine. But no—they had wanted to get closer.

Wes would finally attend a David Bowie concert thirty years later in Virginia with his wife—this time as a respectable, ticket-holding concertgoer. Mike never did.

GEOTHERMAL ENERGY

One of the big stories in Burbank during the first half of the 1970s was the exploration of geothermal energy, or the practice of finding wells in the Imperial Valley with water at a temperature high enough to create steam, which can power turbines. The idea was an outgrowth of the 1973 energy crisis, when the city's fuel oil supplier abruptly canceled its contract to provide the city with the low-sulphur fuel oil needed to fire the steam boilers in its power plant on Lake Street. A power rate increase was proposed to help finance the effort, and millions of dollars were spent developing sources of hot water. The city calendar from 1975 contained promotional language like, "For Burbank citizens, 1975 will be remembered as the year their city entered the Geothermal Age," and "The Geothermal Age is here." As it turned out, it wasn't. Numerous digs failed to turn up naturally occurring hot-water wells of the necessary temperature, and the final word on the subject appears to have been a *Los Angeles Times* article from August 8, 1976, describing the resignation of Warren Hinchee, the architect of the geothermal venture. We cannot

One of the pages from the 1975 City of Burbank Calendar. Geothermal power is where it's at! Or so it seemed at the time. *Wes Clark collection.*

resist the temptation to conclude that the only thing heated about the whole multi-million-dollar effort were the city council hearings with the public, who were unenthused about the rate hikes.

BEING MICKEY MOUSE

It's not as easy as you think, that high voice. In a *Chicago Times* piece from May 15, 1975, by Bruce Vilanch, Walt Disney Studios professional voice artist James MacDonald described the challenge of a man in his early sixties channeling The Mouse first thing in the morning: "Doing Mickey can really take it out of you. Some days I wonder if I can get up there. It takes a lot of coffee on cold mornings." MacDonald got the job when he was overheard making bird calls, waterfalls and other weird utterances by none other than Walt Disney during a recording gig (MacDonald was a drummer). He was

given the voice job. In *Snow White and the Seven Dwarves* (1939), MacDonald was a rainstorm, a calliope, thunder and the yodeling voices of the titular dwarves. Years later, he was presented with the challenge of voicing a penguin in the Burbank studios for a *True-Life Adventure* feature set in the Antarctic: "I went ahead and created this penguin sound. It sounded authentic, all right. And no one has ever got one of those animals to check it out. For all we know, that's how they sound. I mean—as far as we know, that is the sound they make. No one's ever come up with a better one. The record stands."

(Does it sound like he's trying to convince himself there?)

TWO YEARS IN THE SHAG

Shag carpeting was a designer must-have for Burbank homes in the 1970s. It was delightful to walk upon in bare feet but had a tendency to flatten, gravity being the law an inch or so off the ground as it is everywhere else on the planet. The Clark family used a small rake to keep the shag fibers fluffy and uplifted in their Burbank home on Lincoln Street, so not only did Wes Clark's household chores involve raking away eucalyptus leaves in the back yard—he also had to occasionally rake the living room carpet. Burbanker Kelly Clark Ludlum has a funny tale about how shag carpets could seem like the Sargasso Sea: "I once lost an earring in the shag carpet and it rose to the surface two years later. It's in my ear now—40 years after that!"

R.I.P. SEYMOUR

Los Angeles television's hippest late-night horror show host, Larry "Seymour" Vincent, died of cancer in March 1975, age fifty, in St. Joseph Hospital in Burbank. He was known for his demeanor and dismissive attitude for his viewers, whom he called "fringies." Dressed in a tuxedo and wide-brimmed hat, he was a favorite as he crept from behind the slimiest of walls to comment sarcastically during the action scenes in cheap horror films. Seymour said, "I'd like to thank you for remembering me....I'd like to, but it's not my style!"

The Disco Decade

PORN ON THE STREETS!

It's hard to believe these days, but there once was a time when a Burbanker could walk down the street and be confronted by hard-core porn at a newsstand. That time was prior to March 28, 1976, when the *Los Angeles Times*, in a piece by James Quinn, reported that the city council had approved an ordinance, based upon one passed by Glendale, requiring that an adult attend all racks selling material judged by city officials to be harmful to minors. The ordinance also provided for the confiscation of all racks not abiding by the law. Burbank's law also put into effect regulations that prohibited more than three news racks at a single location and required at least three feet between groups of three racks. Burbank's first attempt to rid the sidewalks of lewd publications was an outright ban on all news racks, but that was struck down in California Superior Court in 1974. Mike McDaniel remembers when, almost suddenly, the covers of the lewd magazines in stores were covered by demure wooden panels. (Wes was in the Marines at the time, stationed at Camp Pendleton, where the word "demure" was not in the lexicon.)

Trailer park view, 1974. The city fathers were delighted to finally get rid of these. The great majority of the non-trailer-dwelling citizens were, too. *Burbank Historical Society*.

The action was taken because *most* residents were opposed to the spread of hard-core pornography. As is always the case with such things, there were some who fought back. In this case, it was the Socialist Labor Party, which had obtained a preliminary injunction against enforcement of the limit on the number of racks. The proletariat wanted its porn!

"BEAUTIFUL DOWNTOWN BURBANK"-AGAIN

In a June 15, 1977 column by the *Chicago Times* TV-radio critic Gary Deeb, Burbank is described this way:

> *Beautiful Downtown Burbank hasn't changed a bit. The place is still over-run with cows and goats. Boy Scouts constantly are trying to help nuns across the street. The local massage parlor is featuring a special on floor models. And the barber shop has a sign in front that says; "Haircuts While You Wait—In by 9, out by 5." On the day I visited everybody was over at the "First Farrah Fawcett Look-a-Like Contest." Later on, the folks were expecting a harmonica concert by Lester Maddox, former segregationist governor of Georgia.*

What's all this about? There was an ill-fated *Laugh-In* revival as a series of specials, sans Rowan and Martin. While it was nominated for two primetime Emmys and gave initial national exposure to a pre–*Mork and Mindy* Robin Williams, it bombed. The winners were Rowan and Martin, who owned part of the franchise. They sued producer George Schlatter for not obtaining permission from them to revive the format and won a judgement of $4.6 million in 1980.

And as long as we're on the subject of George Schlatter, the question might come up: Why did he decide to start making fun of Burbank by coining the phrase "Beautiful Downtown Burbank" in the first place? He came clean in a *Los Angeles Times* article from April 12, 1979—it's because of traffic tickets. "I got three tickets on the same corner on three successive days. Tom Sarnoff [then executive vice president of NBC] said, 'No way will we let you do jokes about Burbank.' But the mayor thought it was funny. So did the people. Finally, I even became friends with the cop who gave me the tickets. There's nothing wrong with Burbank that can't be told in a good Polish joke."

San Fernando Boulevard, 1970s. Denny's has changed hands, and so has Zodys. The Cornell Theater sign is seen in the distance. Taco Rey is but a memory. The IHOP is still there—sadly, no longer with a chalet-roofed interior. *Burbank Historical Society.*

It is interesting to note that thanks to *Rowan and Martin's Laugh-In*, the phrase "Beautiful Downtown Burbank" lent itself to no less than three novelty songs from about 1969: one by the Curtain Calls on Dot Records (written by Les Szarvas, who would later operate a recording research and archive business in town); one by the Harper Valley PTA on Plantation Records (written by Tom T. Hall, writer of the hit single "Harper Valley PTA"); and a third by Freddie "Boom Boom" Cannon on Sire Records (written by Roberts and Cannon). The authors are familiar with all three. You haven't missed a thing by not hearing them—trust us.

INDUSTRIAL LIFE AT LOCKHEED

Wes Clark, like his father before him, worked at Lockheed. His 1979 duties involved squaring away a reclamation yard (where various bits of metal, wood and scrap items were brought) and performing various types of as-needed maintenance jobs. One task required that Wes wear rubber hip waders into a pool of heaven-knows-what-chemical to manually peel off big, accumulated hunks of plastic from the surroundings. This was below

a device that carried big sheets of aluminum along a track and sprayed a very thin coat of the yellow chemical and the plastic onto the sheets, the excess falling into the pool. Wes recalls thinking when he was standing in the chemical mix, "Well, it doesn't get much more industrial than this!" How wrong he was.

The task that really caused Wes intense mental reflection was the day he had to scrub down a big, greasy, computer-controlled milling machine with methyl ethyl ketone (MEK), an industrial-strength solvent. The machine was a nasty mess because the milling process threw large amounts of oil and aluminum shavings all over the device. Obviously, in order to paint the machine, the oil had to be thoroughly removed. Wes had the good sense to wear thick rubber gloves, but he didn't wear a respirator. Being a young, tough and immortal former Marine, he figured he didn't need it. (Real men are not intimidated by industrial solvents.) The job took Wes about an hour. He didn't notice the MEK fumes as being especially objectionable at first, but the longer he worked, the worse he felt. Finished, he removed the gloves and staggered outside for some fresh air. As he sat on some big pipes feeling his brain cells dying off one by one, he could see the Lockheed plant rotating crazily around and had to grip the pipes in order to keep from falling over. At that point, a thought came into his head: "If you attempt to make a career out of this job you will be a drooling idiot by the time you are thirty." It was then

In Burbank, a man's home is his castle—and so is his industrial building. A sweet 1976 Monte Carlo is parked in front of this location off Empire Avenue. *Burbank Historical Society*.

that Wes decided to quit Lockheed and go to college to gain a degree in electrical engineering, which he achieved four years later. While sitting at a desk has its hazards, they are nothing like wading in a pool of unknown chemicals or huffing MEK.

THE PRICE OF THEIR TOYS

Did you know that Burbank was once a center for not only model railroading but also entertainment industry and ride-able backyard ("live steam") railroads? An article by Loretta Kuklinsky Huerta in the April 30, 1979 *Los Angeles Times* described the career and business of Chester "Chet" Peterson, who ran the Railroad Supply Corporation at 115 South Victory Boulevard in Burbank. (The company, founded in 1970, still exists but is now located in Nashua, New Hampshire.) A former marketing executive with the Garrett Corporation, Peterson identified a market niche that he, as a miniature railroader, was happy to fill. It led to his company's building specialized and expensive prop trains for the television shows *Supertrain* (a sort of *Love Boat* on rails that ran for one season in 1979) and *Time Express* (four episodes in 1979). The company also owned and maintained the popular miniature steam train at Griffith Park, formerly owned by cowboy star Gene Autry. Peterson's company became famed for the construction of ride-able live steam locomotives and cars. How popular were these? More popular than you think. There were at least thirty miniature railroads on estates between Burbank and Calabasas, causing Peterson to (inevitably) quote the famous saying, "The only difference between men and boys is the price of their toys."

BEST HAUNTED HOUSE EVER

The authors have been to many Halloween haunted houses and seen many special effects therein. An especially memorable one was the series of rooms Campus Life (a nonprofit Christian organization) organized at 303 North Glenoaks Boulevard in October 1979. The most striking effect involved a room with walls painted entirely in black-and-white squares and lit by the flash of a strobe light. Strobe lighting makes for an unsettling environment,

as it apparently freezes time and movement in quantum steps, but the effect was greatly heightened by having staff dress entirely in leotards painted with black-and-white squares to match the environment. As the human squares moved around and approached the guests, it appeared the walls were bulging out and bending in places. It was surreal in the extreme.

THE GOLDEN MALL'S CHICKEN LADY AND PARANOID LADY

Mike McDaniel recounts this tale from the declining days of the Golden Mall in the 1980s:

> *There were several interesting characters who were present on a daily basis; I would encounter them a number of times each week. One lady had a chicken which would follow her around like a dog. She would feed it with corn and other seeds and it would hop up on the back of the bench she usually claimed as her own, and looked over her shoulder as if it were reading her paper.*
>
> *Also there was a lady who would yell at anyone who got close to her. I was walking with my wife to lunch once and this lady came around the*

Harry's Burgers in the Golden Mall (across from Pep Boys), a favorite eatery of Mike McDaniel and his soon-to-be wife. *Mike McDaniel collection.*

corner right in front of us, so we slowed down as not to engage her—to no avail. She wheeled around, looked right at me and yelled, "I know who you are! You Feds will never get anything on me!" Seeing my opportunity I fired back, "We will too get you! You can't escape! We have people watching you every day!" At this point my wife hit me and told me to stop, so I did. The lady ran off in the other direction. She never targeted me like that again, but I saw her ambush other unsuspecting people over the years.

RUTH ROLAND'S VAULT

Ruth Roland, notable silent-era film star, died of cancer in her Los Angeles home in 1937 at the young age of forty-five. As she was a shrewd real estate investor, Fatty Arbuckle once introduced her thus: "The woman who was buying real estate while the rest of them were buying gin!" In 1927, she built an English Tudor Revival home at 923 East Magnolia Boulevard that is now one of Burbank's Designated Historic Resources; members of Roland's

Left: Silent-film star and Burbank film archivist Ruth Roland (1892–1937). *Wikimedia Commons.*

Right: Nothing screams 1970s elegance like shoulder-length hair and beards, sideburns, frilly shirts, wallpaper-patterned coats, canes and shag carpeting in a place called "Casa de Tuxedo." From the 1972 Burbank High *Ceralbus*. *Wes Clark collection.*

family lived there for decades. This particular home had a special feature in the backyard: a concrete vault filled with nitrate copies of Roland's films, stored there for more than forty years. In March 1980, the family commendably donated them to the UCLA Film Archives. Included in the treasure-trove was a complete thirty-six-reel set of the 1915 series *Who Pays?*; a Todd Browning–directed film from 1925, *Dollar Down*; and a rare talkie from 1930, *Reno*. Ruth Roland's film legacy lives on!

THREE BURTON BULLDOGS

Everyone knows about Burbanker film director Tim Burton (BHS class of 1976); his cinematic achievements need no elaboration. *Pee-Wee's Big Adventure* is, for Wes Clark and his son Ethan, one of the glories of Western civilization. Did you know that his father, Bill, and his uncle Russ are in the Burbank Parks and Recreation Athletics Walk of Fame?

Bill Burton (BHS class of 1948) was raised in Burbank and, in 1951, played for the St. Louis Cardinals' minor league affiliate, the Fresno Cardinals. He started his career with the Burbank Sports Office in 1957, when his baseball career ended. He retired in 1990; Izay Ballfield no. 2 is named in his honor. He developed many of the adult and youth sports programs in town (including Ultimate Frisbee) and created the California tie-breaker system in fast-pitch softball. He was recognized by the Southern California Municipal Athletic Federation (SCMAF) in 1991 with a Lifetime Membership Award and by the Associated Industrial Recreation Council (AIRC) with an Outstanding Contribution Award. Bill died in 2000.

Russ Burton grew up in Burbank and played baseball at Burbank High, then Glendale College. In 1944, at the age of fifteen, he played in the first-ever youth baseball program in town. For the next sixty-seven years, Russ was involved in Burbank sports programs as a coach, manager and player. The father of five boys, he coached his oldest son Rich in the Hap Minor Baseball program. Russ was also very active with the Bluebirds, Burbank's senior softball program.

The Disco Decade

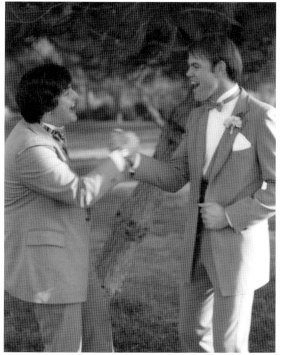

Above: An aerial view of Burbank, circa 1980. The Golden Mall (*center*) is limping along, Zero Halliburton is still in business near the railroad tracks and the first of the Holiday Inn towers stands. That curved off-ramp is Burbank Boulevard. *Burbank Historical Society*.

Left: The 1980s have arrived, and for the authors, progress means wives. It's March 1980, and Mike is married; Wes is his best man. They'd trade roles in December, when Wes got married. *Wes Clark collection*.

CHECKMATES

Sophomores Wes Clark and Chris Hays and junior Mike Acord used to meet in a homeroom at Burbank High School nearly every school day in 1972 to play chess on a small, pocket-sized set. Mike Acord was a hearty, bluff, bearish fellow of generous impulse who was a jock but possessed none of the egotism of a big man on campus. He was well on his way toward being what all males want to be: a "man's man." Chris Hays was quiet, friendly, reserved and, unique among young people in a high school, walked with the assistance of a cane. Despite this, he seemed to be content with the hand life dealt him. The chess matches among the three were always happy, conversational occasions, and there was never a sense of who the best player was. There was just a fun daily rite and shared company.

Chris Hays died in 1999; Mike Acord died in 2010. That left Wes to memorialize his two classmates. The high school experience takes place at a special time in life; few other of our endeavors result in decennial reunions. We know that many former Burbank students have fond stories about friends now departed—these can be shared with those who are still with us.

Come and get your photo taken in a Pacific Electric Red Car for the Burbank Golden Anniversary! *Burbank Historical Society*.

BIBLIOGRAPHY

Books

Burbank Centennial History, 1911–2011: Celebrating Our Past and Embracing Our Future. St. Louis, MO: Reedy Press, 2011.
Burbank High School. *The Blue and White Wave High*. Burbank, CA: Burbank High School, 2008.
Burbank Unified School District. *A History of Burbank*. Burbank, CA: City of Burbank, 1967.
Clark, Wesley H., and Michael B. McDaniel. *Growing Up in Burbank: Boomer Memories from The Akron to Zodys*. Charleston, SC: The History Press, 2017.
———. *Lost Burbank*. Charleston, SC: The History Press, 2016.
Mayers, Jackson. *Burbank History*. Burbank, CA: James W. Anderson, 1975.
McDaniel, Michael B. *Burbank Veterans Memorial Book*. Burbank, CA: self-published, 2015.
Michel, Renée Sharlene. *Michel's Record City*. San Francisco, CA: Blurb.com, 2014.
Monroe, George Lynn. *Burbank Community Book*. Burbank, CA: A.H. Cawston, 1944.
Perry, E. Caswell. *Burbank: An Illustrated History*. Northridge, CA: Windsor Publications, 1987.
Rich, Ben R., and Leo Janos. *Skunk Works*. New York: Little, Brown, 1994.
Schonauer, Erin K., and Jamie C. Schonauer. Images of America: *Early Burbank*. Charleston, SC: Arcadia Publishing, 2014.

Bibliography

Strickland, Mary Jane, and Theodore X. Garcia. *A History of Burbank: A Special Place in History*. Burbank, CA: Burbank Historical Society, 2000.
Tator, Joel. *Los Angeles Television*. Charleston, SC: Arcadia Publishing, 2015.
Umland, Samuel J. *The Tim Burton Encyclopedia*. Lanham, MD: Rowman & Littlefield, 2015.

Newspapers

Burbank Times
Chicago Times
Denver Post
Los Angeles Herald
Los Angeles Times
New York Daily News
New York Times
The Voice of the Village

Pamphlets and Booklets

Burbank Senior High School. "BHS 70th Memories." Burbank, CA: Burbank Senior High School, 1978.
The City of Burbank Public Information Office. "Burbank: City of Pride and Progress." Burbank, CA: City of Burbank, 1981.

Websites

Abandoned Trails. "The Burbank Branch." http://www.abandonedrails.com/Burbank_Branch.
Burbank Parks and Rec Walk of Fame. http://www.burbankca.gov/departments/parks-and-recreation/sports/walk-of-fame.
Burbank Tribune. "My Grandfather, Earl Loy White." https://theburbanktribune.wordpress.com/2013/02/21/my-grandfather-earl-loy-white.
Burial Ground. https://www.kcet.org/history-society/valhalla-memorial-park-and-portal-of-the-folded-wings-the-criminal-beginnings-of-a.

Bibliography

California Digital Newspaper Collection, Center for Bibliographic Studies and Research, University of California, Riverside. http://cdnc.ucr.edu.

Clark, Wes, and Mike McDaniel. "Burbankia." http://wesclark.com/burbank.

Downed Officers Program. https://burbankpolicefoundation.org/programs-events/bpf-programs/downed-officers-program.

Frontier Days. "Bonnie Gray Biography." http://www.wyomingtalesandtrails.com/frontierdays6.html.

Hilliker, Jim, and David Ricquish. "Early Tejano Music Heard in New Zealand." http://www.radioheritage.net/Story36.asp.

Joseff of Hollywood. https://www.joseff-hollywood.com.

Meares, Hadley. "Valhalla Memorial Park and Portal of the Folded Wings: The Criminal Beginnings of a Burbank

———. "Phantom Fast Lanes: Whitnall Highway and the Footprint of Best Laid Plans." https://www.kcet.org/history-society/phantom-fast-lanes-whitnall-highway-and-the-footprint-of-best-laid-plans.

Norton's Winter Wonderland. http://nortonswinterwonderland.com.

INDEX

A

Acord, Mike 188
Ainsworth, Ed 80
Andrew Jergens Co. 70
Avery, Robert C. 150

B

baby boomers 127
Bacall, Lauren 116
Backus, Jim 119
Baker, Joseph N. 170
Baldwin, Elias Jackson 18
Baldwin, Marti 74
Baldwin, Verona 17
Banks, Edgard James 47
barbeque (1911) 40
Barham Boulevard 150, 151, 153
Barn News, the 122
Bartok, Dennis 49
Beach, Eora C. 42

Beany & Cecil 141
Beanyland 141
Beautiful Downtown Burbank
 (phrase) 170, 180
"Beautiful Downtown Burbank"
 (songs) 181
Benmar Hills 58, 111
Bigfoot 167
Big John (Standard Brands) 159
Bill's Ranch Market 161
Bilyeu, Don 123
Blanchard, Porter 58
blueprints (Lockheed) 136
Blue Room 173
Bogart, Humphrey 116
Bordner, Edward G. 175
Bosustow, Stephen 118
Bowie, David 175
Boy Scouts 133
Branson, Lorene (Foreman) 155
Bret Harte Elementary School 127
Brown, Joseph 108, 133

INDEX

Bryan, Arthur Q. 108
Burbank
 1959 time capsule 147
 air-raid alarms (World War II) 101
 animal shelter 14
 as the "White Spot" 72
 backyard incinerators 111
 blackouts (World War II) 99, 108
 Bluebirds (Senior softball team) 186
 Burbank Parks and Rec Athletics Walk of Fame 186
 Burbank Symphony Orchestra 142, 144
 cemetery (desire for) 17
 Chamber of Commerce 60
 City Council 170
 City Planning Department 147
 Civil Defense 140
 Department of Water and Power 140
 economic boom times 51
 electrical phenomena in 24
 Fire Department 65, 105, 174
 geothermal energy project 176
 herds of sheep 39
 Memorial Fund Spectacle (1921) 55
 pepper trees 37
 Police Department 61, 69, 71, 73, 75, 80, 165
 political parties in 165
 power change 50 Hz to 60 Hz 85
 Public Works Department 85
 railroads 24, 70, 83, 90, 104, 105, 106, 161
 reservoir 16
 Rodeo 55, 68, 76
 sea breezes in 18
 sleepy nature of 16
 storm channel 105, 132
 street names origins 29
 temperatures 109
 Women's Club 95
Burbank Association of Insurance Agents 145
Burbank Bar & Grille 14
Burbank Block Building 13
Burbank, California (Santa Clara Co.) 89
Burbank Community Fair (1974) 174
Burbank Community Hospital 207
Burbank Daily Review 108, 134
Burbank, David 17, 19, 39, 89
Burbank High School 41, 62, 74, 78, 90, 121, 123, 129, 133, 134, 138, 146, 188, 191
Burbank Historical Society 47, 192
Burbank, Luther 89
Burbank Memorial Association 55
Burbank Military Academy 87
Burbank streets
 Academically named 60
 Alameda Avenue 140
 Amherst Drive 47
 Andover Drive 81
 Buena Vista Street 76, 106, 122, 161, 163
 Burbank Boulevard 104
 Chandler Boulevard 28, 161
 Doan Drive 75
 Empire Avenue 106
 Evergreen Street 138
 Fairmount Road 111
 Fairview Street 108, 161
 Florence Street 166
 Flower Street 72, 73

INDEX

Frederic Street 128
Front Street 17, 57
Glenoaks Boulevard 112, 183
Grismer Street 104
Hollywood Way 66
Kenneth Road 107
Keystone Street 104, 131, 140
Lake Street 23, 176
Lamer Street 104, 105, 107, 122, 131
Lincoln Street 140, 178
Lockheed View Drive 29
Magnolia Boulevard 58, 63, 66, 147, 161, 185
Maple Street 58
Mariposa Street 29
Myers Street 29, 104, 167
Myrtle Avenue 47
Oak Street 69
Olive Avenue 13, 32, 63, 71, 74, 95, 99, 105, 118, 150
Orange Grove Avenue 80
Pacific Avenue 105, 107, 132, 161
Parish Place 87
Pass Avenue 166
Providencia Avenue 92
Roselli Street 116
San Fernando Boulevard 13, 27, 39, 40, 51, 63, 90, 94, 105
San Jose Avenue 107
Scott Road 81
Second Street 17
Sixth Street 47
Sunset Canyon Drive 94
Tenth Street 129
Third Street 63, 99, 105
Verdugo Avenue 73
Victory Boulevard 36, 106, 122, 131, 159, 183

Victory Place 14, 23
Walnut Avenue 111
Whitnall Highway 57
Winona Avenue 87, 140
Burbank Studios 174, 175
Burbank Villa Hotel 19, 20
Burke, Billie 63
Burke, Cpl. Phillip Ray 120
Burke, Roy E. 121
Burroughs High School 90, 108, 133, 146
Burton, Bill 186
Burton, Russ 186
Burton, Tim 186
bustlines 158

C

Cabrini Chapel 90
cactus patches 27
California Vegetable Products Corporation 80
Campus Life 183
Carey, Joseph 140
Carhart, Hacker & Co. 25
Carhart, Mary 25
Carson, Johnny 159, 168
Castaway, the 134, 157
Ceralbus 41
Chacon, Julian 72
Chambers, John 167
Chandler Bikeway 29
Chandler, Harry 29
Chandler's ranch 21
Chili John's 105
Chinese in Burbank 17
Christmas lights 166
Church, Ralph 39
Civil War (1861–1865) 130

INDEX

Clampett, Bob 141
Clampett, Rob 142
Clark, Wes Sr. 159, 160
Coates, Paul 89
Coffman, William 13
Cole, Tommy 146
Colson, Luther 23
Communists 139
Community Chevrolet 159
Conant, Curt 174
Conrad, A.W. 82
constipation 57
Cornyn, Stan 172
Crawford, Johnny 146
Cummins, Theron 87
Curtain Calls, The (musical group) 181

D

Damiani, Leo 142, 144
Debbie: My Life 138
Deeb, Gary 180
Degado, Marcelino 72
Denny, Reginald 120
deSosa, Elinor Penry 136
disco 165
Disney insignia art 112
Disney Studios 51, 115, 119, 142, 146, 165, 177
Disney, Walt 112, 115, 142, 146, 177
distilling plant (illegal) 69
Doe, Jonathan 163
Dollar, Mrs. 78
Dooley, James H. 89
Dougherty, Norma Jeane. *See* Monroe, Marilyn
Druids, Ancient Order of 63

E

Ehn, John (Old Trapper) 102
Eisele, Darryl 104
Elizabeth Hotel 63
Ellis, Tom 25
Elmer Fudd 108
Empey, Arthur Guy 116
Epstein, Barry 161
equal pay for equal work 132
Ertle, E.R. 34

F

Fawkes, Constable H.B. 20, 26
Fawkes, Frank 21
Fawkes, J.W. 32
fire, canyon 1927 64, 71
Fitzpatrick, Cathi 159
Fitzpatrick, C.C. 52
floods (1938) 92
Foreman, Bruce 134
Forest Lawn Drive 150
Freberg, Stan 146
Fredericksen, Willard "Mister Fred" 5
Frederiksen, Sigurd 67
freight hopping 24
Funicello, Annette 142, 146

G

Garard, E.A. 81
Garard, Mary 62
Gardemann, Don "Duke" 140
Garland, Judy 78
garlic smells 80
gas masks 115
geek culture 171

INDEX

Genevieve Jackson Company 57
Gibson, Ron 161
Gilbert, Jarvey Mayor 168
Gilfoy, Tom 130
Gilmore the lion 85
Glendale 17, 31, 41, 66, 68, 69, 86, 106, 161, 179
Glendale Airport 31
Gofstein, David 168
Golden Mall 184
Gonzalez, Pedro 66
Gottfried, Francine 158
Grady (Agrati), Don 146
Gray, Bonnie 75
Gray, Firman 85
Great Depression 51, 60, 82, 83, 86, 160
Greer, Douglas "Speck" 78
Gregg Building 74
Griffen, Joe 122
Griffin, J.W. 19
Griffith Park 183
Gross, Courtlandt 99

H

Haile, Laure 165
Halloween 74, 104, 183
Harper Valley P.T.A., The (musical group) 181
Harris, Donald W. 75
Hays, Chris 188
Heminway, Jan 32
Henderson, Finley 68
Henry, Azonia 44
Henry, Harper Beach 44
Henry, Jay 61
Henry, Leroy "Freedom Hill" 42
Heston, Charlton 142

Hilberman, David 118
Hinchee, Warren 176
History Channel, the 89
hoboes 20, 21, 22, 45, 106, 161
Holiday Inn (Burbank) 107
Hooverville 51, 83
Howard, Marilu 163
Hua, Karen 138
Huddleson, Virginia 69
Huerta, Loretta Kuklinsky 183
Huntington, Harwood 47

I

influenza pandemic (1918) 75
insanity 17, 21, 38
International Association of Machinists (IAM) 132
Ivy, Blanche 131

J

Jackson, Genevieve 58
Jeffries Barn 106, 122
Jeffries, Frieda 36
Jeffries, James J. 35, 55, 122, 128
Jeffries Ranch 76
Jensen, Keith 129
John Muir Junior High School 154
Johnson, Clarence L., Mrs. 85
Joseff of Hollywood 92

K

KABC 158
Keinath, A.E. 82
Keller, Eldridge Ballew 104
Kelly, Gene 138
KELW 66, 67, 68

INDEX

Kettinger, George 71
Kieslich, Otto 25
King, Carl 94
King, David F. 94
King, Maude 82
Kirkwood, Pam Zipfel 90
KTLA 141

L

Les Brown and His Band of Renown 144
LeVier, Tony 155
Lewis, Joanne Sears 111
Lewis, Keomoku 67
lioness, escaped 78
Little Rascals 78
Lockheed Aircraft Company 29, 51, 78, 83, 85, 97, 98, 99, 104, 105, 106, 108, 111, 131, 132, 136, 137, 147, 148, 155, 181, 182, 183
Lockheed reclamation yard 181
Longo, Martin 78
Los Angeles River 27
Ludlum, Kelly Clark 178
Lunacy Commission 45
Luttge, George 64

M

Magnolia Park Chamber of Commerce 97
Magoo, Mr. 118
Maltese Falcon, The 175
Marks, Ben 58, 60
Marston, Mott H. 94
Martino's bakery 159
Mayer, Louis B. 138

Mayers, Jackson 165, 191
McCambridge Park 132
McCoy, "Ashfeldt" 75
McGillis, James 150
McKinley Elementary School 163
Meeker, Earl 67
Merritt, Christopher 141
methyl ethyl ketone (MEK) 182
Mickey Mouse 177
Mickey Mouse Club 142, 146
Mickey Mouse gasmasks 115
Mingay, Henry M. 130
Minutemen, the 139
Monette, Tommy 173
Monkees, The 157
Monroe, Marilyn 119
Monterey Avenue School 105
Moorman, Jack and Peaches 123
Moreland Motor Truck Company 54
Moreland, Watt L. 54
Mormons (LDS Church) 94, 95, 105
Movie Club Guild, the 149
Munger, M. 64
Murphy, Audie 168

N

NBC 170, 180
Newsom, John C., III 129
New York Times 168
Nielsen, Leslie 119
Night Riders, the 61, 62
Nix, Lloyd S. 67
Norton, Richard and Pamela 166
Norwood, Kenneth E. 147

Index

O

O'Brien, Cubby 146
O'Connor, Donald 138
Odens, Glen M. 93
Of Men and Stars 83, 98
Ogborn, Jerry 81
Oldfield, Barney 40
Old Trapper's Lodge 102
Olmstead, Carol Hill 131
Osborne, John E. 53
Osborne, John R. 52
Our Gang 78
outhouses 51
Over the Top 116
oyster (prehistoric) 175

P

Pacific Electric trolley line 40
Pepe's Florist 159
Peterson, Chester "Chet" 183
Peterson, Roland "Pete" 5
Pickwick pool 132, 142
Pickwick Stables 98
Poco Tiempo, The Land of (1921 event) 55
pornography 149, 179
Priore, Dominic 141
Providencia Land and Water Company 16, 39

Q

Quiet Day in Burbank, A 47
Quinn, James 179

R

Radcliff, John D. 31
Radioplane Company, The 120
railroad (Burbank Branch) 28
railroading, model 183
Railroad Supply Corporation 183
Ray, Dwain 105
red scare 139
Reynolds, Debbie 134, 137, 138, 142
Rittenhouse, David 82
River Road 150
Roland, Ruth 185
Rooney, Mickey 78
Roosevelt, Theodore, President 31
Roscoe, CA 43, 83, 85, 90, 93, 109
Rose Theater 47
Rosie the Riveter 109
Rosoff, Eric 154
Rowan and Martin's Laugh-In 170, 180

S

Sacred Films, Inc. 47, 56
Salmon, Fish 155
Salt Lake City, UT 95, 96
Santamaria, Melanie 159
Santa Rosa Hotel 63
Santi, Tony 62
Sarnoff, Tom 180
Scanlon, Paul 172
Schlatter, George 180
Schumann, Elmer 98
Schwartz, Zack 118
Selby, Desmond 61
Senior Bulldogs Newsletter 104, 111, 134, 136, 155

INDEX

shag carpeting 178
shopping carts (return of) 168
Shuler, Robert P. 67
silversmithing 58
Singin' in the Rain 138
Sirk, Elizabeth Boysen 161
Sites, Dan 133
Smith, Mike 146
snow 135
Snyder, Clifford 78
Socialist Labor Party 180
Spector's Market 106
Stack, Ken 141
Stancliff ranch 38
Standard Brands Paint Company 159
Starlight Bowl 29, 142, 146
Star Trek (cancellation) 171
Stay, Joseph 170
Stimpson, Steve 165
St. Joseph Hospital 161, 178
Story Plumbing 90
Stotts, Geri 158
Stough Park 134
Strader, Fred 38
streakers 165
Streisand, Barbra 165
suffrage, women's 40
Sullivan, Frank 134
Sunset Canyon Country Club 66, 94
Supertrain 183
Szarvas, Les 181

T

Tayback, Vic 134
Taylor, Richard 161
Thomas A. Edison School 105
Thomas, William 140
Thompson, Verita 116
Thompson, William and Ida 45
THornwall (telephone prefix) 146
Time Express 183
Tolman, Howard 95
Tonight Show, the 159, 170
Tracey, Doreen 146
Travis Bean Guitars 171
Turner, Roscoe 83

U

United Productions of America (UPA) 118
United States Marine Corps 120, 165
Universal Amphitheater 175
Unsinkable: A Memoir 139
U.S. Geological Survey 14

V

Valhalla Cemetery 52, 66, 107
Vega Aircraft Company 108, 116, 118
Vega Ventura 99
Verdugo Hills 24, 55, 65, 90, 127
vertical take-off aircraft 147
Veterans Administration 173
Vickroy Park 106
Vilanch, Bruce 177
Vincent, Larry "Seymour" 178
Vitagraph Film Company 116
Voigt, Jim 127, 128

W

Waite, Dan 87

INDEX

Wall Street 158
Wanamaker Rents 150
Wanamaker, V.H. "Jack" 150
Warner Bros. 51, 73, 93, 95, 108, 138, 142, 175
Warner Bros. Record Group 172
Waters, Eldon 70
water wars 31
Wayne, John 78
Weaver, Doodles 157
Weinstock, Matt 155
Wells, Frank 173
White, Captain 34
White, Earl L. 66, 68
Whitnall, George Gordon 57
Whittington, "Sweet Dick" 158
Whizzer motor bike 134
Wilhelm Scream 73
Williams, Bob 93
Williams, Roy 146
Willows, the 23
Windsor, Prince Charles 165
women workers 109
Wright, Robert A. 168

Y

Young, Neil 172

Z

Zennaiter, Don 175
Zilch, Mr. and Mrs. 145
Zipfel, Rowen 90

OFFICE OF THE CITY MARSHAL
BURBANK, CALIFORNIA

BEN TILLEY

30 years old; 5 feet 6 or 7 inches in height; weight about 140 pounds; medium complexion; dark blue eyes. Has been missing about four years. When last seen he was working around moving picture studios in Los Angeles, California.

Mr. Tilley is wanted at Tower Hill, Illinois, in order to settle an estate. A liberal reward will be paid for information leading to his present location. Communicate with

CITY MARSHAL'S OFFICE, BURBANK, CAL. OR SAM TILLEY, DOLLVILLE, ILL.

Ben Tilley: The city marshal can probably find him in the company of Spanky, Darla, Porky and Buckwheat, badly crooning love songs. *Burbank Historical Society*.

Mike McDaniel (*left*) and Wes Clark (*right*), November 30, 2016, at the *Lost Burbank* slideshow. *Ross A. Benson Photography*.

ABOUT THE AUTHORS

Wes Clark was born in Los Angeles, but his family moved to Burbank when he was eight; he was educated mostly in Burbank schools. He met Mike McDaniel in 1972, and they graduated from Burbank Senior High School in 1974. They have always been intensely interested in history. Clark lives in Springfield, Virginia, with his wife of thirty-eight years; they have three kids and six grandchildren. An electrical engineer, he works for the United States Patent and Trademark Office in Alexandria, Virginia. His website is www.wesclark.com. Retirement beckons.

Mike McDaniel was born at the Burbank Community Hospital (now gone) and has lived in Burbank in the same house for sixty-two years. He was educated in Burbank schools. Mike has been married for thirty-nine years; he and his wife have five children. Mike has worked for the City of Burbank for thirty years and is the supervisor of the City Print Shop (printing being a vocation he learned in high school). Retirement beckons for him, too.

Visit us at
www.historypress.com